IN MEMORY

OF

BARBARA WHIPPLE HEILMAN

PRESENTED

BY

ECHO VALLEY ART GROUP
1990

WATER MEDIA:
PROCESSES AND
POSSIBILITIES

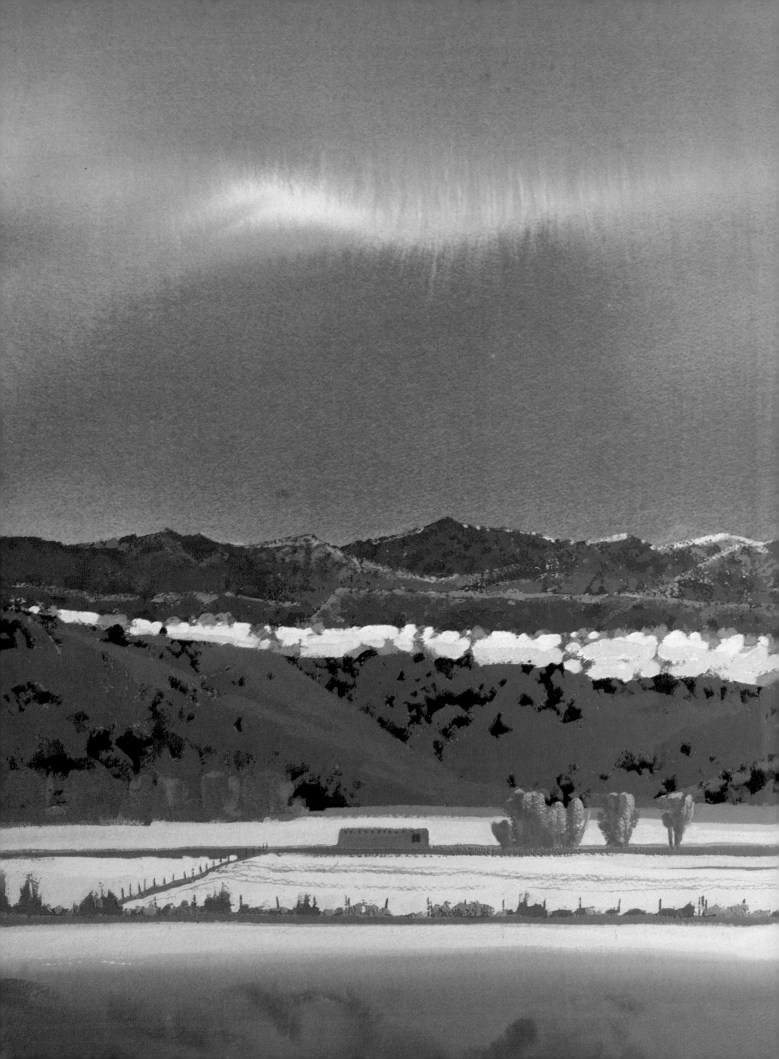

WATER MEDIA: PROCESSES AND POSSIBILITIES

Stephen Quiller and Barbara Whipple

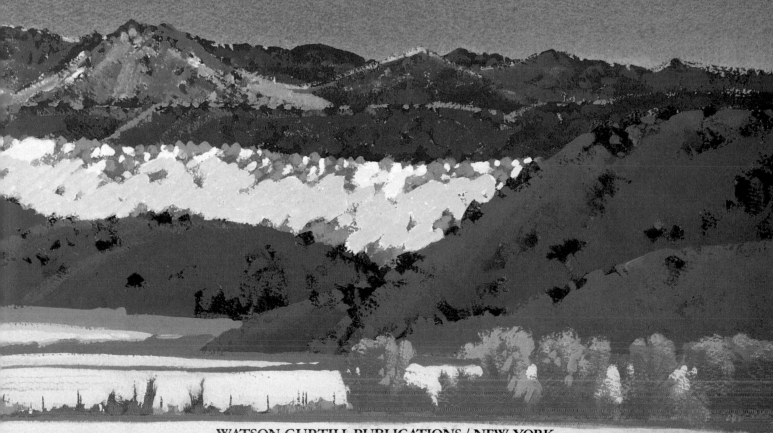

WATSON-GUPTILL PUBLICATIONS / NEW YORK

Art on first page:
OREGON JETTY

Acrylic and casein on Crescent no. 100 illustration board
29" × 17" (73.7 × 43.2 cm)
Collection of the artist

Art on title page:
DECEMBER LIGHT,
SAN ANTONIO VALLEY

Acrylic and casein on Arches 300 lb. rough paper
Collection of Don and Dorothy McFadden

Edited by Sue Heinemann and Bonnie Silverstein
Designed by Bob Fillie
Graphic production by Ellen Greene
Text set in 11-point Garamond

All the art in this book, unless otherwise noted, is by Stephen Quiller.

First published 1986 in New York by Watson-Guptill Publications,
a division of Billboard Publications, Inc., 1515 Broadway,
New York, N.Y. 10036

Library of Congress Cataloging-in-Publication Data

Quiller, Stephen.
 Water media, processes and possibilities.

 Includes index.
 1. Watercolor painting—Technique. I. Whipple,
Barbara. II. Title.
ND2420.Q55 1986 751.42 86-13252
ISBN 0-8230-5695-3

Distributed in the United Kingdom by Phaidon Press Ltd.,
Littlegate House, St. Ebbe's St., Oxford

Manufactured in Japan

First printing, 1986
2 3 4 5 6 7 8 9 10/91 90 89 88

For my son Christopher—STEPHEN QUILLER

For Grant—BARBARA WHIPPLE

ACKNOWLEDGMENTS
We would like to thank Bonnie Silverstein,
Senior Editor at Watson-Guptill Publications,
for all her assistance; Grant Heilman, for his
good-humored support and photographic ex-
pertise; Barbara Oderseff, Registrar, Wichita
Art Museum, Wichita, Kansas; Linda A.
Goldstein, Curator and Registrar, Museum of
Western Art, Denver, Colorado; and all of the
artists represented in this book who have
contributed their work and their time in
answering the questionnaire. Without the
assistance of all these people, this collabora-
tion would have been impossible.

Contents

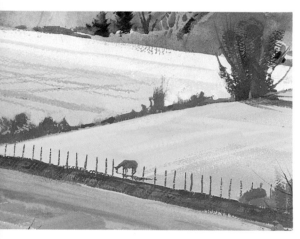

Introduction

Today there are more exhibitions, more societies, and more water media painters than ever before—the whole field seems to be exploding. One of the things I've noticed in all these exhibitions is how important technique has become. Certainly, technique is important to painting, for the quality of the craftsmanship determines whether the painting is pleasant to look at and whether it can be understood. But, to my way of thinking, technique should always follow the emotional content of the painting. The feeling or mood should be primary, and the technique should be chosen to enhance that feeling—not the other way around. Indeed, that is a major emphasis of this book: how to design exciting paintings and how to best express what you want to express.

Unfortunately, many people have rigid ideas about what a watercolor painting should and should not be. Some feel no opaques should be used; others feel that any traditional approach is passé. Personally, I feel that the painting always comes first. The artist should feel free to select any medium or any combination of media that seems best suited to the subject. The artist should also feel free to handle the paint in any way that will emphasize and enhance the emotional or aesthetic content.

Even the nineteenth-century British colorists, considered by many to be the most traditional watercolor artists of all, frequently combined gouache, or "body color," with transparent watercolor, as in the lovely painting by Jacob Paul Naftel (1817–1891) shown here. Nearly two-thirds of this painting uses opaque gouache, and the combination of transparent watercolor with opaque gouache enhances the illusion of depth. Winslow Homer, John Singer Sargent, and J.M.W. Turner are also among the many well-known artists who combined opaque and translucent gouache with transparent watercolor. These artists did not hesitate to attack their paper with knives, razors, and brush handles to scrape and gouge the paint off the paper. Anything was all right, as long as it produced the effect they wanted.

The idea of this book, then, is to remove any limitations from your thinking and to open your mind to the many expressive possibilities of the water media. Like my first book, *Water Media Techniques*, it deals with the four water media: transparent watercolor, gouache, acrylic, and casein. In Chapter One, I review the main handling and visual characteristics of each medium through my own paintings and works by other artists, both living and dead, who are masters in their medium. Then I examine different ways of developing interesting compositions in Chapter Two. There is advice on choosing your subject, focusing in on it, working up thumbnail sketches, and trying out various formats to convey different moods. I also discuss positive and negative space, as well as the use of geometric motifs, rhythm, value, and color.

Sometimes artists limit themselves to one or two ways of developing a painting. They may, for example, always work from the background to the foreground—developing a landscape by first washing in the sky, then the distant mountain in front of the sky, then the tree in front of the mountain. This is the traditional, positive method of applying paint. Chapter Three shows you how to develop your ability to visualize and create forms by painting around them in what I call the Reverse Negative Shape Approach. This approach will add variety and excitement to your paintings.

Chapter Four shows how I incorporate different approaches in a dozen paintings. Preliminary sketches and color studies allow you to see how each painting develops from the initial idea through to completion. Then, in Chapter Five, I present the work of twenty

outstanding contemporary artists. In their own words, these artists describe the source of their inspiration, as well as their processes and techniques. The discussion also highlights important aspects of each painting, such as interesting compositional devices, exciting uses of negative space, or unusual textures. Because these artists come from all over the country and work in highly individual styles, their paintings should suggest a variety of directions for your own work.

Frequently I'm asked how one can grow as an artist. First, I want to encourage you to paint what is close to you, to paint subjects that you know and that interest you. If you know your subject well, you will be better able to honestly express your feelings about it in your painting. Don't, for example, try to paint waves if you've never seen the ocean. And don't think you have to go out and hunt for some picturesque subject. Let the subject come to you. The subjects that attract you will inevitably reflect your own interests. Consider, for example, Vincent Van Gogh's paintings of cypress trees and sunflowers, which express his fascination with curvilinear forms. If you not only know your subject well, but are also interested in it and love it, your painting will have a better chance at success.

Second, to grow as an artist, it is important to study paintings by other artists, both past and present. Go to museums and exhibitions to study their work. Learn how they paint; borrow ideas. Also get to know the work of contemporary artists and, if possible, become acquainted with some of these artists in person; share the pleasures and problems you have in common.

There are other ways to grow as an artist. Of course, you must be committed to your art. By painting often, with a burning desire to express yourself well, you will improve. Don't be satisfied with mediocrity—set your sights high. Learn all you can about the media you are interested in, as well as color and composition.

Learn from every painting you do; from the disasters as well as the successes. Remember, while a painting usually begins with a lot of hopeful energy, most go through a kind of painful adolescence, where nothing at all seems possible. You may feel like quitting, but if you keep at it, the painting will probably begin to regenerate itself and develop to its full potential. Discipline yourself to stay with it. Listen to the painting. Learn from it. And over the years you will develop your own personal style.

Never forget the importance of drawing. I know from my workshops that people want to paint before they can draw. Drawing helps you to see. It sharpens your vision and teaches you how to be selective. Painting is an extension of drawing, and, as your drawing improves, so will your painting.

Finally, I'd like to mention that when I was in high school and first became interested in watercolor, I was introduced to two books by Ted Kautsky, *Ways with Watercolor* and *Trees and Landscapes*. These two books really opened my eyes; I became excited by reading and learning about someone else's paintings and thoughts. The joy I received from those books is still with me, and it is my hope that this book will affect others in the same way Kautsky's books affected me.

Jacob Paul Naftel
UNTITLED

1864, watercolor and gouache over graphite on paper 7⅞" × 21½" (20 × 54.6 cm) Courtesy of Wichita Art Museum, Wichita, Kansas

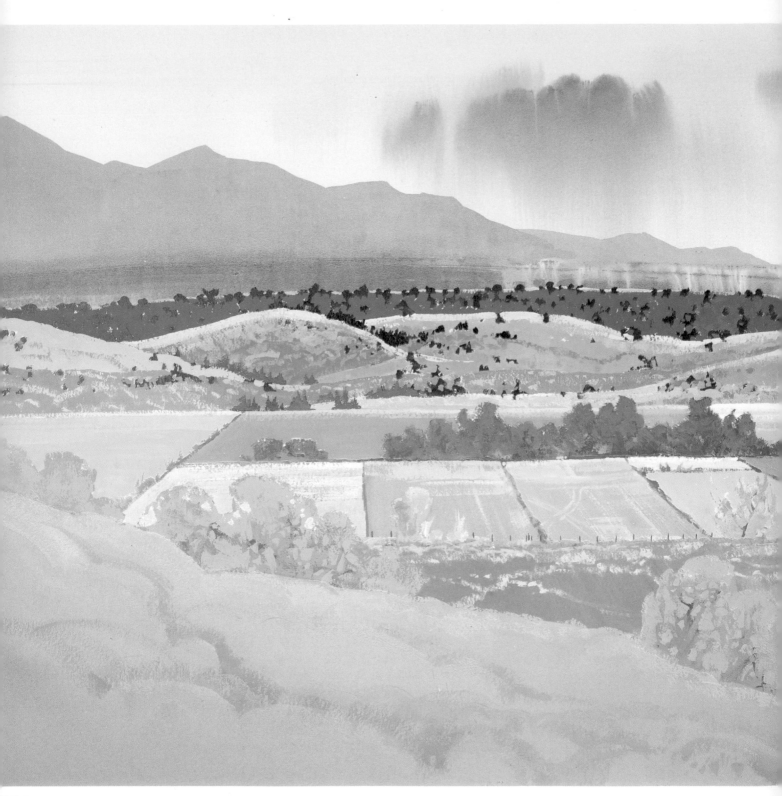

OCTOBER PATTERNS, TALPA

Acrylic and casein on Arches
300 lb. cold-pressed paper
24" × 32" (61 × 81.3 cm)
Collection of the artist

CHARACTERISTICS OF THE FOUR WATER MEDIA

STEPHEN QUILLEI
© '85

A tremendous change has occurred recently in national water media exhibitions. Experimentation can be seen everywhere. Some artists use airbrush; others build collage surfaces of unusual materials; still others combine two or more of the four water media: transparent watercolor, gouache, acrylic, and casein. Before, however, you consider experimenting and combining two of the water media, it is important to know the characteristics of each and something about their advantages and disadvantages. That is what this chapter is all about.

Transparent watercolor is still the fundamental water medium and thus the best starting point. It has a direct, spontaneous quality and a luminous glow that are particularly appealing. It also shares many properties with the other water media, so once you know something about the handling of watercolor, it becomes easier to move on to the others.

The logical medium to follow watercolor is gouache, which basically has the same composition. Like watercolor, it is highly soluble, so you can use fine sable brushes. The main difference between gouache and transparent watercolor is that gouache can be used opaquely. It covers well, although—because it is water-soluble—the color may lift and muddy an overlayer of paint.

Acrylic is both the newest and the most

versatile of the water media. Introduced commercially in the 1950s, it has become highly popular. In my opinion, acrylic is very nearly the perfect medium. Since its inception, it has been associated with oil painting techniques; it can, for example, be used to develop opaque impastos and be applied with bristle brushes or a palette knife. More recently, artists have explored its potential as a transparent water medium. Because of its adhesive qualities and its versatility, acrylic offers unlimited possibilities, especially when combined with other media.

Although casein is probably the least known of the four water media, it is a sensitive and subtle medium, worthy of your attention. The soft, matte quality of a finished casein painting is unique. Casein is also highly versatile and can be used for transparent, translucent, and opaque effects. In many ways it is my favorite of all the water media, although it does have limitations.

This chapter should give you an overview of the main handling and visual characteristics of each of the four water media, as well as the materials appropriate to each. Those of you who would like more detailed information, especially about ways to combine the water media, should refer to my first book, *Water Media Techniques* (co-authored with Barbara Whipple and published by Watson-Guptill Publications).

Watercolor

Of all the water media, transparent watercolor is the easiest and yet, paradoxically, the most difficult to handle. It flows readily on any painting surface, without resisting or dragging. The primary visual characteristic of watercolor is, of course, its transparency. Its luminosity, however, depends on the reflection of light from the painting surface up through the paint, so the surface you choose is very important. Whether your support is rough or smooth, white or slightly toned, absorbent or nonabsorbent, it will affect the final result.

All the water media use the same pigments—it is the binder that is different. The binder is what holds the pigment together and makes it adhere to the painting surface. With transparent watercolor, the binder is gum arabic. Honey can be added to keep the paint from becoming brittle if it is used thickly. But, since transparent watercolor is usually applied thinly, this is seldom needed.

Different watercolor pigments behave differently. Some colors, such as the earthtones and cadmiums, have a normal pigmentation. Others, like alizarin crimson, phthalo blue, and sap green, have staining qualities. Still others—Naples yellow, Davy's gray, and cerulean blue, for example—are heavily pigmented and form interesting granular patterns when the pigment sinks into pockets of the paper. You can also add Chinese white or opaque gouache to any transparent watercolor pigment to create translucent or opaque effects—although care must be taken to avoid a jarring note in the painting as a whole.

It is important to remember that watercolor pigments fade as they dry, so they must be applied densely to avoid a washed-out appearance. At the same time the paint must not be applied too thickly. It is best to build up the color with successive washes, laying one wash over another after the first wash has dried. Also keep in mind that, because the paint is water-soluble even when dry, it can be lifted off the surface with brushes, tissues, or sponges to create interesting textures. This solubility, however, means that watercolor paintings must be framed under glass for protection.

MATERIALS

Paint: Select artist quality paints rather than the student grade, if possible. Also choose colors suited to your subject. When I am painting in Taos, for example, I add Naples yellow and sap green to my palette; for the San Juan mountains, I need Hooker's green dark, Prussian blue, and cerulean blue.

Palette: Most artists use an opaque white palette made of china, metal, or plastic. I prefer the Jones plastic palette, which has depressions around the outer edge, a brush holder, and a tight-fitting lid. If I close it up with a damp sponge or towel inside, the paint stays moist for a week or more.

Painting Surface: Choose a non-yellowing, heavy paper that will not buckle. My favorite all-around surface is Arches 300 lb. cold-pressed or rough paper. For a rigid surface, try Crescent or Strathmore illustration board. Or use watercolor board, which combines the qualities of paper with the rigidity of illustration board. You might also experiment with Japanese rice papers, which can be adhered to illustration board with acrylic matte medium and then used to build a textured collage surface or painted on directly.

Brushes: Because of transparent watercolor's solubility, you can use your finest sable brushes. I prefer single-stroke sables for washes and rounds for details. For very large washes, I often use a 2- or 3-inch squirrel-hair brush or the Japanese Hake. You might also experiment with pointed Chinese pencil brushes, as well as different synthetic brushes. Be sure, however, to clean your brushes well after use. First gently wash them in warm, soapy water; then rinse them thoroughly, stroke them back into shape, and place them in a container—handle-first—to dry.

Additional Tools: Today, anything goes with watercolor. Experiment with housepainting brushes, sponge brushes, and rollers in applying the paint. Try knives and razors to scrape off paint, or use towels, tissues, and sponges to lift paint and form intriguing textures. A toothbrush makes a good spattering tool; various solvents or even table salt will also create exciting effects. In addition, you can use masking fluid or other resists to block out an area so it remains unpainted.

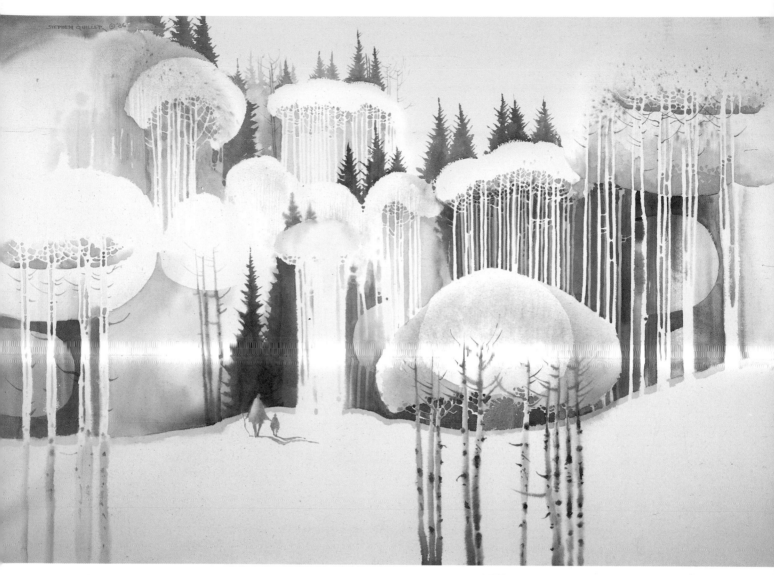

AUTUMN WALK, FATHER AND SON

Watercolor on Arches 300 lb. cold-pressed paper
25" × 34" (63.5 × 86.4 cm)
Collection of the artist

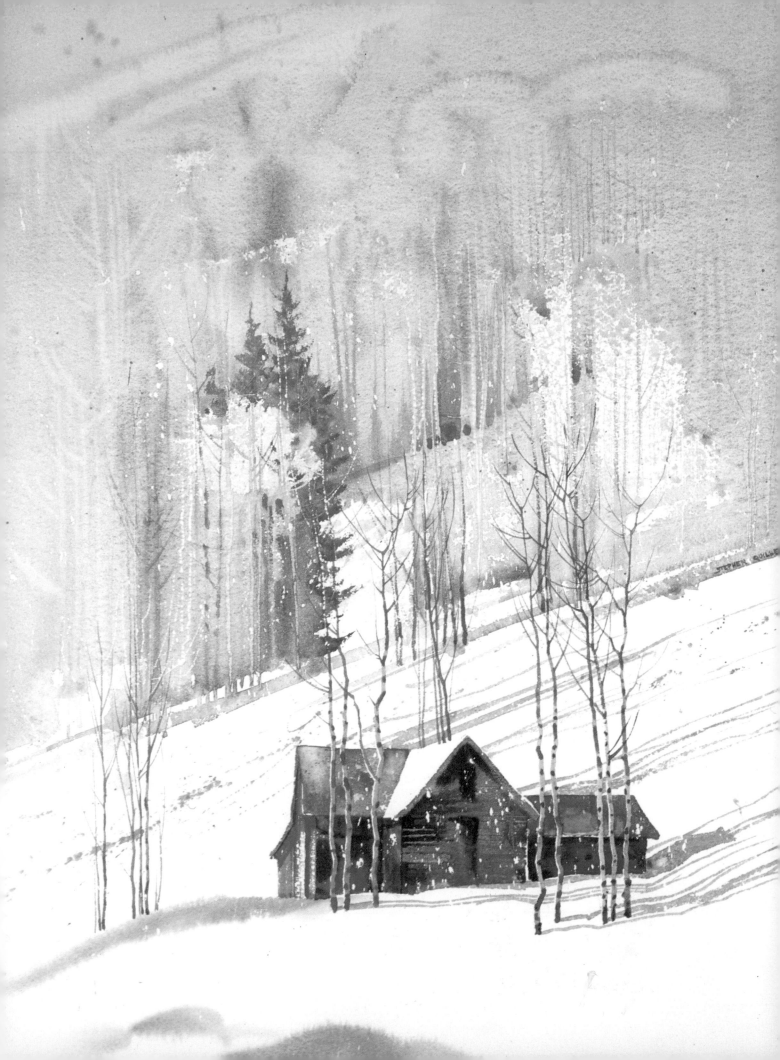

Watercolor

WINTER CABIN, HIGH COUNTRY

Watercolor on Arches 300 lb. rough paper
29" × 21" (73.7 × 53.3 cm)
Collection of Rick and Terri Inman

This painting of a barren, raw winter scene incorporates all the watercolor techniques I use: drybrush, controlled washes, and the wet-on-wet method, as well as spattering, scraping, and an approach I call "ballooning" (see the first detail).

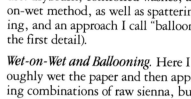

Wet-on-Wet and Ballooning. Here I first thoroughly wet the paper and then applied varying combinations of raw sienna, burnt sienna, and ultramarine with a 2-inch squirrel-hair brush to create a soft, blurry look. The key to controlling this wet-on-wet technique is to keep the brush a bit less damp than the paper. For the balloon effect—which you can see in the light tip of the tree and some of the light background shapes—I loaded a no. 8 round sable with clear water and drew it into the semi-damp area of color. The clear water pushed the color away from it, leaving a lighter form.

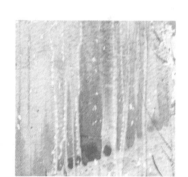

Scraping and Controlled Washes. While the first application of color was still damp, I used a pocket knife, holding it like a butter knife, and scraped off some of the paint to create the lighter tree forms. For the darker blue areas around the trees, I used a controlled wash, applying a wet brush to dry paper. The paint then remained exactly where it was laid.

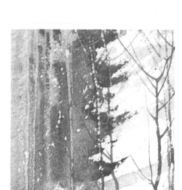

Painting around Whites. Almost half this painting is untouched white paper. The light tree shape in the center was created by what I call the Reverse Negative Shape Approach. Essentially I painted around the light tree shape and at the same time formed the dark spruces behind it.

Spatter and Drybrush. Here I used a directional spatter for the blue paint behind the trees. Over dry paper I struck my loaded brush over the forefinger of the opposite hand, in the direction I wanted the paint to go. For the trees themselves, I used a drybrush technique. Working on dry paper, I squeezed all excess color from the brush, so I could make thin, dry lines.

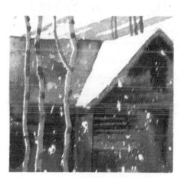

Masking Fluid. Maskoid, a fluid form of rubber cement, was spattered over the painting. After the Maskoid had dried, I applied a controlled wash with darker colors. When the color was thoroughly dry, I rubbed off the Maskoid with my fingers or a paper towel. This left a pattern of white paper suggesting snow.

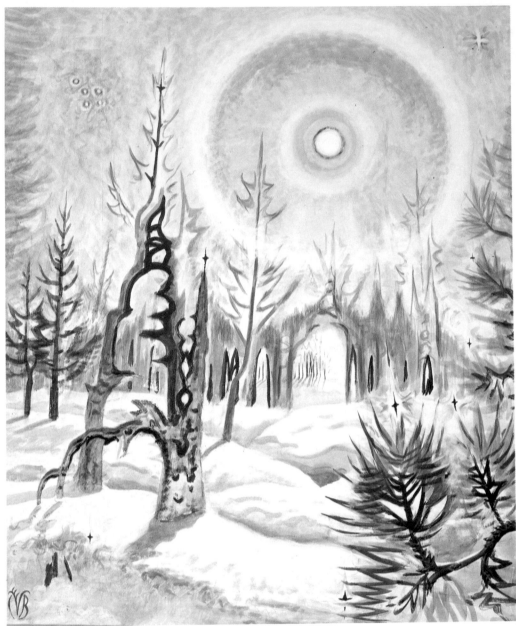

Charles Burchfield
WINTER MOONLIGHT

1951, watercolor on paper
40" × 33" (101.6 × 83.8 cm)
Courtesy of Wichita Art Museum, Wichita, Kansas
Roland P. Murdock Collection

Charles Burchfield (1893–1967) is known for his watercolors of western New York. Never interested in photographic realism, Burchfield wrote: "it is not what a place is that makes for art—it is what the artist feels."

Winter Moonlight was developed from sketches done in 1917, when Burchfield was living in Ohio. He had been out hunting, and while returning home on a cold winter night, saw the ring around the moon and sketched it. More than thirty years later, the artist painted the scene in his studio. A typical

Burchfield, the painting evokes a magical mood found in nature. The trees seem to have a life of their own, and their curvilinear forms repeat those found in the snow, the circle of the moon, and the ring surrounding it.

Burchfield left much of the paper white, and this helps give the painting its radiance. The transparent watercolor is almost drawn on the paper; it is easy to see the many layers of transparent paint. Sometimes a succession of washes is used, sometimes drybrush, to create a texture evoking a shimmering, icy scene.

Edward Hopper
ADAM'S HOUSE

1928, watercolor on paper
16" × 25" (40.6 × 63.5 cm)
Courtesy of Wichita Art Museum, Wichita, Kansas
Roland P. Murdock Collection

Edward Hopper (1882–1967), a student of William Merritt Chase and Robert Henri, has always been closely identified with the Ash Can School. All his work is well designed and makes use of strong value contrasts. Often his scenes of urban and rural American express a sense of loneliness or solitude.

Adam's House was done directly from nature and probably finished in one sitting. Hopper's eye for composition is very evident. The painting is skillfully balanced, creating a sense of stillness. But also notice how the telephone pole breaks up the negative space.

In this painting Hopper used a series of controlled washes with touches of drybrush. Never timid about using color, Hopper applied plenty of pigment to build his rich darks. Much of the paper, however, is left white or only lightly washed with very pale colors. This contrasts with the shadowed areas to give a strong feeling of low autumn sunlight.

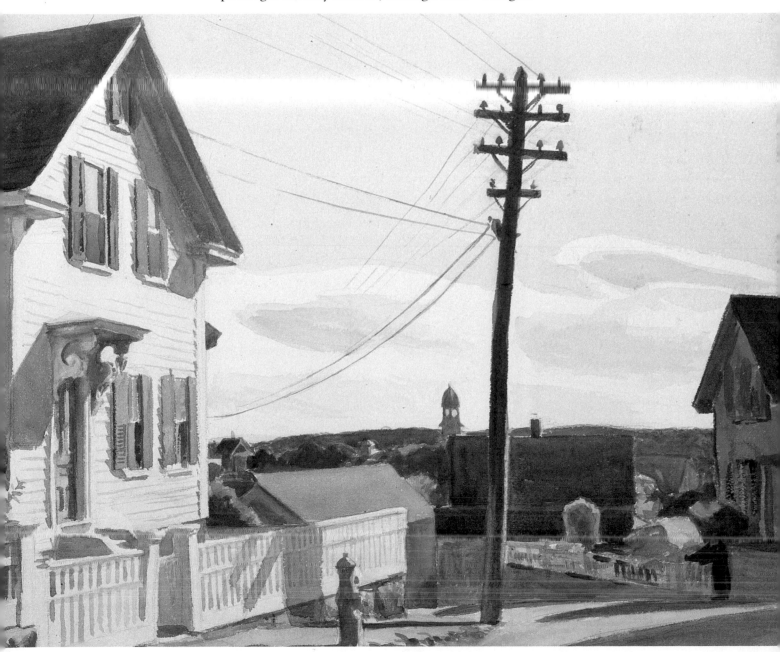

Gouache

The term *gouache* simply means opaque watercolor, and it is sometimes used to describe any transparent watercolor mixed with Chinese white. It is also referred to as tempera, showcard color, designer's color, and body color. Adding to the confusion, many museum curators identify paintings done in gouache, whether entirely or in part, as "watercolor."

The gouache paint used today is an aqueous solution of pigment with a binder of gum arabic, to which precipitated white chalk has been added. The presence of white pigment in the paint gives gouache an attractive translucent quality. The soft, matte character of gouache colors has a subtle feeling, and gouache washes can appear more diffuse than watercolor washes. In applying the paint, however, remember that light colors dry darker, while dark colors dry lighter.

Because gouache, like watercolor, flows easily from the brush it is excellent for fine details, as well as for large, flat areas of opaque color. Do not apply gouache too thickly or it will crack; it is best to build up thickness with successive layers of paint. It is possible to fuse colors while working wet-on-wet, but this becomes difficult after the paint dries. At the same time correcting mistakes can be difficult, because, like watercolor, gouache is very soluble and color is picked up from the first layer. It helps to keep your brush as dry as possible, or you can make the first layer insoluble by mixing it with acrylic matte medium diluted with water in a ratio of 1:10:

MATERIALS

Paint: To experiment with gouache initially, you can buy a tube of white gouache and mix it with transparent watercolors. In purchasing gouache paints, take care to select only permanent pigments as often colors designed specifically for commercial work do not last. Winsor & Newton make excellent gouache paints, graded according to permanence (A, very permanent; B, moderately permanent; C, fugitive). Their colors are also graded for opacity (O, totally opaque; R, moderately opaque; P, partly transparent; T, transparent) and for staining ability (N, do not stain; M, stain moderately and bleed through lighter colors; S, stain somewhat; SS, stain strongly).

Palette: I use two different palettes—the same Jones plastic palette I use for watercolor and a heavy piece of glass with white paper taped underneath so I can better judge my colors.

Painting Surface: You can use white watercolor paper or a toned paper, which contributes a middle value. If you want to build impasto, choose a rigid surface such as illustration board.

Brushes: Because gouache is very water-soluble, you can use good sable brushes. As with watercolor, I like single-stroke sables for washes and round red sables for details. Natural bristle brights work well for impasto, scumbled, and textured effects.

Additional Tools: Nearly anything can be used to apply gouache—from scraps of matboard to your fingers. Actual textures can be created by drawing a coping saw through the paint before it dries. You can also lift paint with towels and tissues, spatter with a toothbrush, or use stencils and masking fluid. When lifting masking fluid, however, take special care, as the paint smudges easily. Use a kneaded eraser or tissue and change it frequently.

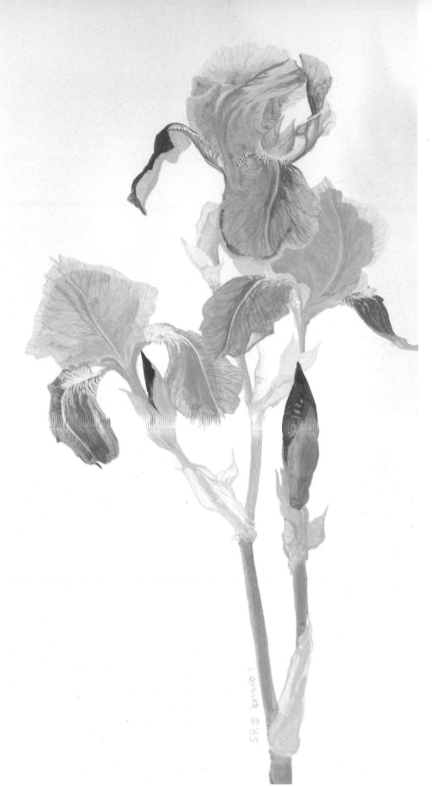

Light over Dark. Here you can see the soft visual quality so characteristic of gouache, which is due to the white chalk in the pigment. Notice the fine yellow lines painted over the dark violet of the petal. Although gouache is the most opaque of the water media, great care must be taken when painting light over dark. The dark underlayer must be completely dry, and your brush must not be too moist for the light layer, or it will pick up the dark underlayer.

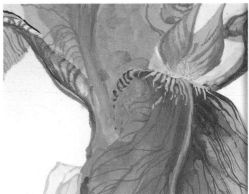

Wet-on-Wet. Gouache is an excellent medium for textures and very fine lines. Observe the soft, blurry violet lines on the underside of the upper left petal. These have been applied wet-on-wet, in much the same way that watercolor might be used, with similar results.

Transparent, Translucent, and Opaque. Look at the range of effects gouache can produce. An initial wash of transparent yellow covers the entire illustration board. The dried sheath and the greenish leaf form are painted translucently, allowing the background color to glow through. The stem is totally opaque, while the contours of the bud are formed by gently lifting the pigment with a small, damp brush after the paint has dried.

IRIS

Gouache on Crescent cold-pressed illustration board
14½" × 8" (36.8 × 20.3 cm)
Collection of the artist

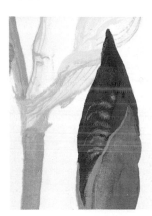

Looking at several clumps of iris in my backyard, I was attracted by the flowers' soft translucence. Gouache seemed the perfect medium for capturing this effect. After picking a few, I spent considerable time arranging them, until I was satisfied with the interaction of the flowers and the negative spaces around them. When I drew the flowers, I made sure to put the main stem a bit off-center for a more interesting composition.

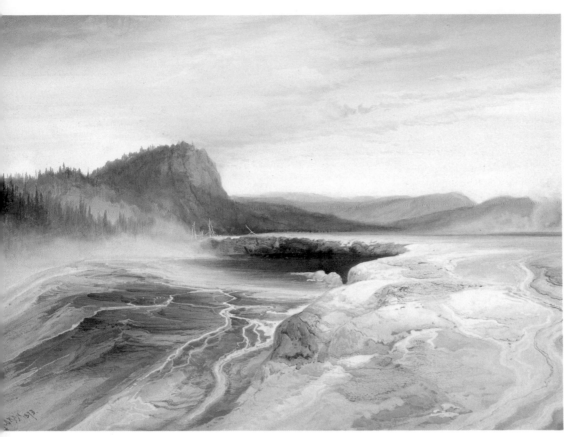

Thomas Moran
GIANT BLUE SPRING

Watercolor and gouache on toned paper
10" × 14" (25.4 × 35.6 cm)
Courtesy of Museum of Western Art, Denver, Colorado
Photograph by James O. Milmoe

Although born in England, Thomas Moran (1837–1926) became a prominent American landscape painter of the Hudson River School. In 1871 he joined the Hayden expedition to Yellowstone, and it is largely due to his paintings that this area became our first National Park. Moran also traveled to the Colorado River, Yosemite, the Grand Tetons, and the Grand Canyon.

Moran considered himself a translator of the landscape. "What I ask," he explained, "is to see a man's brains as evidenced in his work. I want to know what his opinions are. He is the arbiter of his own pictures and of nature. Zola's definition of art exactly fills my demands when he said that 'Art is nature seen through a temperament.' The old idea that art is best defined as 'Painting nature as it looks, and not as it is' will not satisfy me. An artist's business is to produce for the spectator of his picture the impression produced by nature on himself."

Moran's *Giant Blue Spring* is an excellent example of how transparent watercolor and gouache can be combined to create a range of effects, from transparent through translucent to opaque. It also reveals the influence on Moran of J.M.W. Turner, who was fascinated by the effects of light. In Moran's painting, the various value changes and the strong diagonal lines of the water move our eyes through the piece. The strongest value contrast is at the Giant Spring—the center of interest.

To give his painting its overall warm tone, Moran chose a yellowish paper, which is visible through the transparent washes, as well as in the many unpainted areas. Working in the traditional English way, he washed on transparent warm and cool tones for the sky, as well as the mountains. Notice that the distant mountains lack detail, while the closer ones reveal trees as well as texture. The opaque foreground, done in a combination of opaque and translucent gouache, heightens the sense of depth. The steam is a translucent white glaze, while the dead trees in the center are opaque white gouache painted over darks. The soft, chalky look of gouache is also ideal for the tuff of the geyser formations.

Henry Farny
BY THE SIDE OF A STREAM

Gouache on paper 8¾″ × 13¾″ (22.2 × 34.9 cm)
Courtesy of Museum of Western Art, Denver, Colorado
Photograph by James O. Milmoe

Henry Farny (1874–1916) was born in France but emigrated to the United States with his family. As an adult, he traveled throughout the West, often on assignment for *Harper's* magazine. Back home, in his studio in Cincinnati, he developed his sketches using watercolor and gouache. He was especially interested in portraying the daily life of the American Indian with great detail and accuracy.

Farny's *By the Side of a Stream* is a fine example of a skillfully composed gouache painting. The horizontal format is broken into three horizontal planes. The central plane is the active, positive space, while the upper and lower areas provide quiet, negative space. As a whole, these three strong horizontals create a restful feeling.

Within the painting, you can see the versatility of gouache. Farny used a transparent golden wash for the water and sky areas, and then painted the landforms and figures in a totally opaque manner. In some areas of the trees he worked light over dark, but to create the strokes of light gold on the foreground shore, he lifted the opaque color to expose the underlying warm, transparent layer. The reflections, as well as the trees projecting into the sky area, are painted directly. To capture the translucent quality of the smoke, however, he washed a thin, translucent glaze over the landforms. Also notice the extraordinary detail in this small painting, describing the tree branches, teepees, horses, and clothing. Gouache is excellent for this purpose.

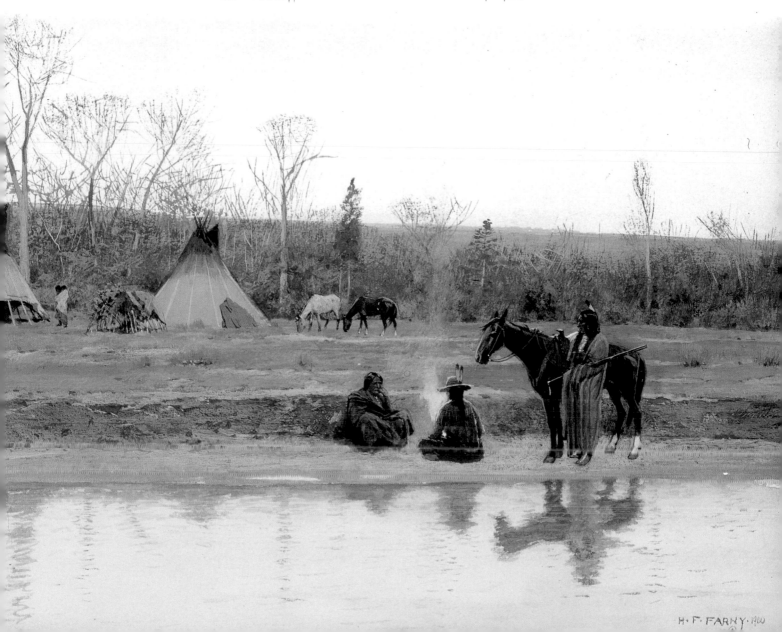

Acrylic

Acrylic combines the durability, strength, and versatility of oil paint with the fluidity, luminosity, and immediacy of expression found in watercolor. Its binder is a nontoxic plastic resin, suspended in water, which looks milky in the bottle but dries into a tough, clear, flexible film. Pigments can be bonded to nearly any surface with this elastic film, which is not only highly adhesive but also waterproof. The medium is also highly resistant to sunlight.

Acrylic colors are noted for their intensity, and they do not change when dry. Care must be taken, however, to avoid a garish quality. Overall, acrylic paintings have a distinctive "plastic" appearance as there seems to be a sheen covering the opaque paint.

Acrylic is extremely versatile and can be handled in many different ways. Its adhesive qualities, for example, make it an excellent material for collages. Thinned with a lot of water, it can be used like transparent watercolor, but it leaves a richer color, which will not lift when dry. If acrylic is diluted with somewhat less water and some opaque white, effects similar to gouache or casein can be achieved. By thinning it with water and acrylic matte medium, you can create veils of color, similar to those formed by egg tempera. And used very thickly, acrylic can be applied very much like oil paint, with palette knives or stiff brushes. Heavy impastos are possible and do not require a rigid support, but they should be allowed to dry overnight before being painted over.

One disadvantage of acrylic is its tendency to streak when used for transparent or translucent effects. It also lacks real covering power unless used very thickly in an impasto. Because the paint does not have a flowing quality, it is less useful than other water media for details. Moreover, its plastic quality takes some getting used to.

MATERIALS

Paint: Acrylic offers some colors not usually available in the other water media, such as dioxazine purple, Acra violet, and Indo orange-red. There are many different manufacturers of acrylic paints; because each uses a somewhat different formula, it is important not to combine different brands.

Palette: Acrylic paint is totally insoluble when dry, so use either a disposable or an easily cleaned palette. You might try a throw-away piece of matboard or a glass palette with white board taped underneath. Some artists use enamel butcher trays.

Painting Surface: Because of acrylic's adhesive qualities, you can use nearly anything you want as a surface. Don't, however, work on an oily surface, as the paint will crack. Generally, I let my choice be determined by the technique I intend to use. When working small, with a wet-on-wet approach, I use Arches 300 lb. cold-pressed paper. For larger paintings, I may select a heavier paper or illustration board. Other artists use canvas. You might also try adhering delicate rice papers to an illustration board using acrylic matte medium, diluted in equal parts with water, as a glue. Adhering rice papers over a previous acrylic wash can soften the color and add texture.

Brushes: Keep in mind that acrylic paint is insoluble when dry. Never use expensive sables, as they will lose their flexibility through paint buildup. Instead, use less expensive synthetics. Keep them wet while working and clean them thoroughly after use. Use soap and water, working the brush into the soap until all traces of paint have been removed. I prefer ½- and 1½-inch single-stroke synthetics for most of my work; I also use rounds (nos. 1–8) for details and brights (nos. 4–20) for thick paint applications.

Additional Tools: Use razor blades, a pocket knife, scraps of matboard, or palette knives to lift wet paint, apply thick paint to a transparent wet wash, or create impasto effects. To add more texture, roll a brayer or drag a coping saw through thick paint before it's completely dry. Toothbrushes are good for spattering. Crumpled paper towels and tissues can be applied to wet or damp washes for textured effects. Or dip a towel into a basin of acrylic paint, wring it out a bit, and use it to apply color directly. Also explore stencils and masking fluid. Because acrylic does not smudge or lift when dry, you can mask areas and apply transparent washes, repeating this process many times, to create an unusual batik effect.

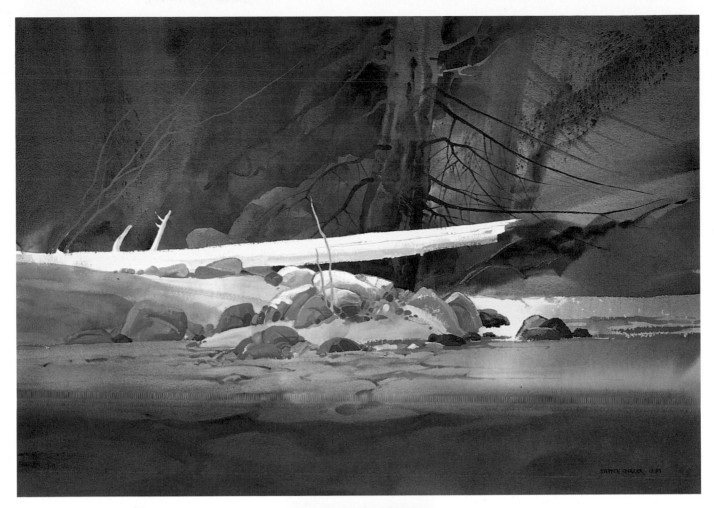

SHALLOW CREEK SHADOWS

Acrylic on Arches 550 lb. cold-pressed paper
32" × 39" (81.3 × 99 cm)
Collection of Mark and Molly Merry

This painting began on a camping trip. While I was idling the afternoon away, I experienced what the Navajos call "soft eyes"—a condition of unfocused attention, when, instead of looking hard for an animal they are hunting, they relax and let the game be discovered without searching. Seated beside this mountain stream, I suddenly recognized its beauty and knew it was something I wanted to paint.

Back in my studio, I gave some thought to the approach and medium I should use. I wanted rich color and strong contrast between the dark shadows and bright sunlight on the rock forms. I also wanted the water to be transparent, while the logs and rocks were opaque. For all this variety, acrylic seemed the logical choice.

Wet-on-Wet and Spatter. After flooding the paper with water, using a 3-inch squirrel hair, I flowed on a mixture of cobalt blue, red oxide, and dioxazine purple, using a 1½-inch single-stroke synthetic. Then I loaded my brush with cobalt blue and applied some directional spatter by hitting the loaded brush across the finger of my opposite hand. Because the surface was wet, the acrylic spatter separated in an unusual way. While the surface was still wet, I suggested the tree form.

Opaque versus Transparent. Here you can see the contrast between opaque and transparent acrylic. Because acrylic is not totally opaque, I had to apply two coats of the light color to block out the underlying color. Notice also the intensity of color so characteristic of acrylic.

Transparent Washes. To create the illusion of rocks under the water, I used two washes. The first was done wet-on-wet, using a mixture of cobalt blue, dioxazine purple, and Acra violet. When this had dried, I used dioxazine purple and Acra violet to give the impression of transparent, flowing water. Acrylic paint is perfect for applying transparent washes over previous washes that have dried, as it will not lift.

23

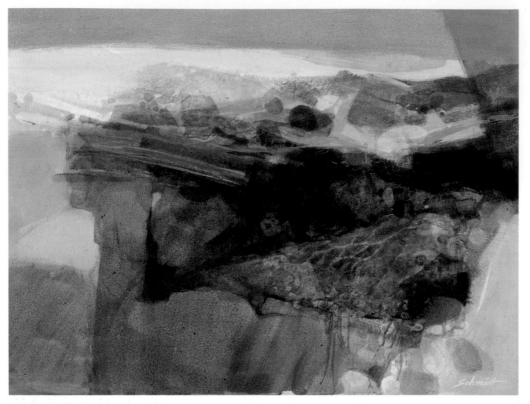

Mary Jane Schmidt
ROOKERY

Acrylic on Arches 140 lb. cold-pressed paper
21" × 28½" (53.3 × 72.4 cm)
Collection of the artist

Mary Jane Schmidt, a contemporary Colorado artist, works exclusively in acrylic, deriving most of her abstract images from nature. "In the painting *Rookery*," she comments, "I hoped to capture the feeling and essence of a watery reserve—the seclusion and tranquility contrasting with the openness and power of a wide expanse of water; the soft, bleached color of dead wood contrasting with the rich brilliance of sunlit pebbles and rippling shallow water; and the tangle and linear quality of snags contrasting with the flatness of sand and water."

When she begins, Schmidt generally selects her colors at random, without a definite color scheme. Because acrylic allows her to layer warm over cool, cool over warm, and translucent over opaque, she can wait until the final stages of the painting to select her key colors. Notice how, at the very top of the painting, the warm initial layer barely shows, but adds richness to the final cool gray color. Also observe the small areas of warm orange that lead the eye through the painting.

Schmidt uses Hake brushes, which are composed of extremely fine hairs. Because acrylic is a plastic paint, it shows the brush texture. You can see this in the lower center and left, where the directional brushstrokes move the eye into the composition. In the same area, Schmidt has used "controlled drips," made by blowing on the wet paint, to add movement to her composition. In other areas, she lifts paint with crumpled tissue to expose an underlying color in a textured pattern. She does this while the paint is wet, as once acrylic dries, it will not lift.

Overall, the strong patterns of dark and light in this painting immediately capture our attention. On closer inspection, however, many small surprises appear. The palette is subtle and rich, combining both warm and cool colors. There are also intriguing textures and patterns, which suggest different things to different people. The interplay between the tense drama of the immediate impact and the fascination of the details is exactly what the artist intended.

Robert R. Vickrey
CARRIE IN THE RAIN

Acrylic on Whatman board
30" × 38" (76.2 × 96.5 cm)
Collection of the artist

Robert Vickrey, a prominent East Coast artist, is well known for his magic realist paintings in acrylic and in egg tempera. Discussing this painting, he notes, "Recently, I have been experimenting with work in which the characters are lost in a shimmering maze of lights and forms." The idea for this composition came during a rainy evening in Times Square. Photographs provided a starting point, but Vickrey developed his painting intuitively. Based on his years of experience, he felt that acrylic would be the best medium.

There is a popular misconception that acrylic color is gaudy, but as Vickrey demonstrates, it can also create soft and subtle effects. At first glance his painting appears to be done mostly in tones of blue. Actually, however, there are also many small strokes of warm color. Vickrey has exploited the translucent quality of acrylic by developing forms through many layers of spatter, followed by more translucent layers with intricate brushwork. The application of translucent and opaque acrylic, in both warm and cool tones, produces the shimmering effect.

Value is vital to this painting. If you squint your eyes and consider only the lights and darks, you suddenly become aware of the dramatic, totally abstract pattern they create. This adds another layer of interest to a painting whose first appeal seems based on soft, diffuse forms, lost in shimmering light.

Casein

Casein is an extremely strong adhesive, which has been used for centuries by cabinetmakers and joiners. When combined with lime, it becomes weatherproof and, for this reason, was used by medieval fresco painters—although care had to be taken not to make the casein mixture too powerful, lest it pull the plaster off the wall.

For many years, casein was somewhat neglected by artists because of formidable problems having to do with proper mixing and spoilage. The basic binder for casein pigments is the curd from milk protein, and it is only relatively recently that a durable emulsion-binder mixture has been manufactured.

Although casein is water-soluble when first applied, after it has dried for about a month, it is totally insoluble. When completely dry, however, it gives the surface a unique matte or semi-matte finish. This can be polished with a ball of soft cotton to give the painting a subtle luster.

Casein flows easily from the brush and is excellent for details. It can be used very thin and applied smoothly for transparent and translucent effects, but keep in mind that when it is highly diluted, the colors are more muted than transparent watercolor. Casein can also be used as an opaque wash and built up into an impasto. Don't, however, apply the paint too thickly, as it will crack.

Casein permits, but does not demand, spontaneity. It allows you to make changes and corrections; it is also possible to build on the painting for a long time, creating translucent glazes and interesting scumbled effects.

MATERIALS

Paint: Although casein paints may not be available in your local art supply store, they can be obtained from art stores in large cities or mail-order catalogs. The Shiva Company is the only manufacturer of artist's casein paints in the United States.

Palette: Because casein paints dry up, choose a palette that you can scrape off and wash. Sometimes I use a sheet of glass with white paper taped underneath; sometimes, an enamel tray. To keep the paint moist while you're working, add a few drops of water. To keep a palette full of color moist for half an hour or so, simply cover it with a damp towel.

Painting Surface: Watercolor paper and illustration board are both good surfaces for casein. For thicker applications, use a rigid surface, as the paint is brittle. To make a thin surface rigid, mount it on illustration board before painting.

Brushes: Because casein becomes insoluble when dry and will build up in the heel of your brush, I prefer synthetic brushes. I use ½- and 1½-inch single-stroke synthetics, as well as rounds (nos. 1–8) for details and brights (nos. 4–20) for juicy impastos. Be sure to clean your brushes thoroughly with soap and water; I've also discovered that an overnight soak in ammonia helps to loosen any buildup of paint.

Additional Tools: With razor blades, pocket or palette knives, scraps of matboard, or even a fingernail, you can both lift and apply paint. Also explore painting with a roller or printing brayer: squeeze some casein onto a glass surface, roll the brayer back and forth, then roll it over the painting surface. When this dries, brush on additional layers of color, allowing the brayer texture to show through. For spatter textures, use a toothbrush; try, for example, spattering opaque white casein into a transparent watercolor wash. As with acrylic, you can use crumpled towel and tissues to pick up pigment while it is damp or to apply it directly. Although stencils and masking fluid can be used, casein is apt to smudge when the resist is removed. I use a kneaded eraser or clean paper towels, constantly changing them as they pick up pigment.

Wet-on-Wet. After wetting the surface completely, I applied a layer of titanium white, using a 1½-inch single-stroke synthetic. While the white paint was still very wet, I washed in an opaque mixture of raw sienna, cadmium yellow medium, Shiva violet, and a touch of cadmium orange. Then I tilted the surface upward to let the colors fuse and interact—an effect I find tremendously exciting.

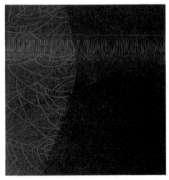

Spatters and Glazes. Here I washed on an opaque red-brown and, while it was wet, applied a spatter in an analogous range of colors, from deep reds to lighter gray-blues. After this had dried completely, I applied a thin, transparent glaze of alizarin crimson, cobalt blue, and a bit of burnt sienna to landform near the tree branches. Similar glazes were added to other areas to separate the forms. Notice, in this detail, the soft, matte quality characteristic of casein.

Opaque Spatters and Overpainting. After blocking out the sky area, I loaded a 1½-inch single-stroke synthetic with various warm and cool pigments and applied a series of opaque spatters over the entire lower portion of the painting. This gave depth and richness to the surface. To define the sheep forms, I used a no. 8 round and a dark mixture of Shiva violet, cobalt blue, and alizarin crimson. Then I developed the contours by overpainting with lighter shades of the same colors. Finally, with a no. 3 round, I added the red accents. Note the fine detail possible with casein. Then compare the smooth application of casein in the large, opaque area behind the sheep.

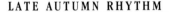

LATE AUTUMN RHYTHM

Casein on Crescent no. 100 cold-pressed illustration board
34″ × 26″ (86.4 × 66 cm)
Collection of Mr. and Mrs. Doak Sullivan

The idea for this painting came from the feeling of late autumn in Colorado, when the leaves have fallen and intriguing rhythms are set up by successive layers of aspen forms. I chose casein as my medium because it seemed suited to this late autumn feeling and the dry quality of both the air and the landscape. Although many of my paintings require a lot of planning, here just a few curved lines served to get me started. As I put down the first washes of color, I let the flow determine where the forms would be. I really listened to this painting to let it find its own direction.

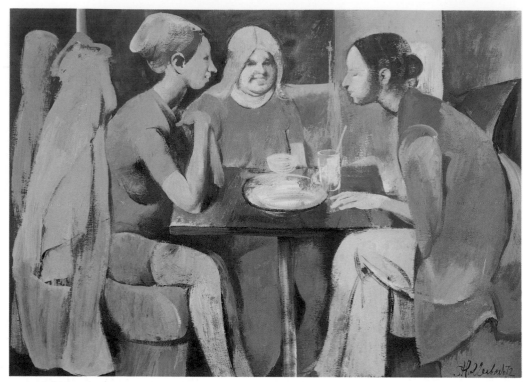

Serge Hollerbach
THREE GIRLS

Casein on 140 lb. cold-pressed paper
26" × 38" (66 × 96.5 cm)
Collection of the artist

Serge Hollerbach, a contemporary East Coast artist, paints people in everyday situations—eating, walking, and resting. "People's aspirations, hopes, joys, and sorrows," he explains, "are expressed in their gestures, in the very build of their bodies. I am trying to go beyond the illustrative aspects of the situation and search for certain universal and lasting elements in it; human existence in general. But all this should be achieved through shape and forms, balances and tensions of colors, structure and composition, not through facial expression or psychological detail. Form and content are one, but content grows out of form, not the other way around."

As an artist who favors casein above all other media, Hollerbach is acutely aware of its characteristics: "I like its opaque, velvety surface, subtle nuances of color, and a certain drybrush roughness. Casein seems to combine the qualities of gouache, oil, and pastel without the messiness of oil mediums or pastel dust."

At the time *Three Girls* was painted, Hollerbach was exploring subtle grayish and brownish tonalities. With a minimum of water, and using bristle and pointed sable brushes, he applied opaque layers of casein, working from dark to light and deliberately producing rich, drybrush effects. Although he based the painting on numerous sketches done from life, in restaurants and cafeterias, he composed it freely, changing the gestures of the figures, as well as adding, eliminating, and balancing shapes and colors to achieve the desired expression.

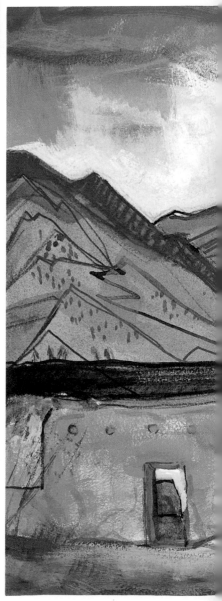

Doel Reed
MOUNTAIN PASS

Casein on Arches 140 lb. cold-pressed paper
15¾" × 27¾" (40 × 70.5 cm)
Courtesy of Mission Gallery,
Taos, New Mexico

Doel Reed (1894–1985) was a master painter and printmaker, who specialized in oil, casein, and aquatint intaglio. His primary subjects were the landscapes of northern New Mexico. About this painting, he commented drily: "Well, first I think I am interested in the geological form, then color, then light effects."

Using a limited palette of Indian red, cadmium red deep, raw sienna, cadmium yellow light, ultramarine blue deep, viridian, burnt umber, ivory black, and titanium white, Reed found he could convey every nuance of the landscape surrounding him. He worked with casein in much the same way as oil, choosing bristle brushes for large passages and small sables for details.

Mountain Pass was based on a drawing Reed made on location, outside the village of Questa, New Mexico. He began with sweeping washes of transparent and translucent color to establish the overall design and then used flowing lines to further define the forms. Drybrush texture and scumbling can be seen in the building and foreground areas, as well as in certain light areas of the sky. By overpainting, Reed emphasized the geometric forms of the sky, mountains, trees, and adobe building, adding rhythm and continuity to the painting.

The finished painting combines the visual effects of transparent, translucent, and opaque paint. It also has a soft, earthy, matte quality, unique to casein and typical of northern New Mexico.

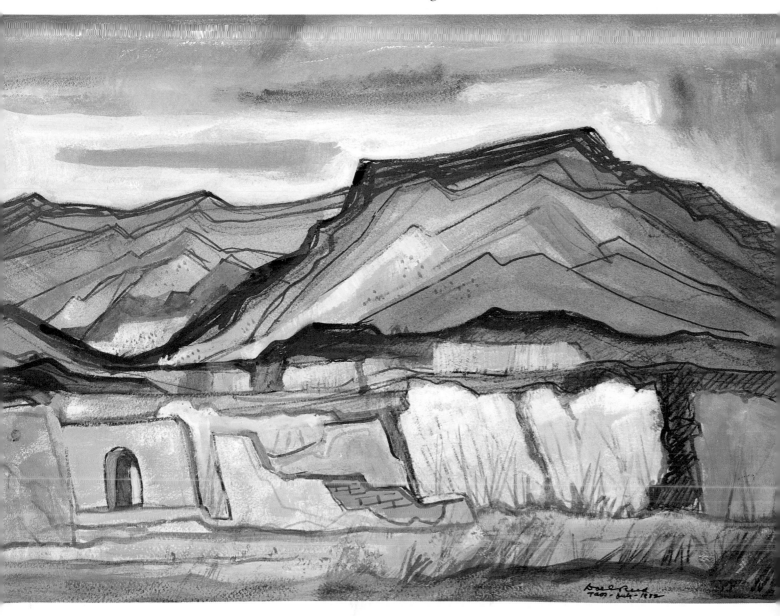

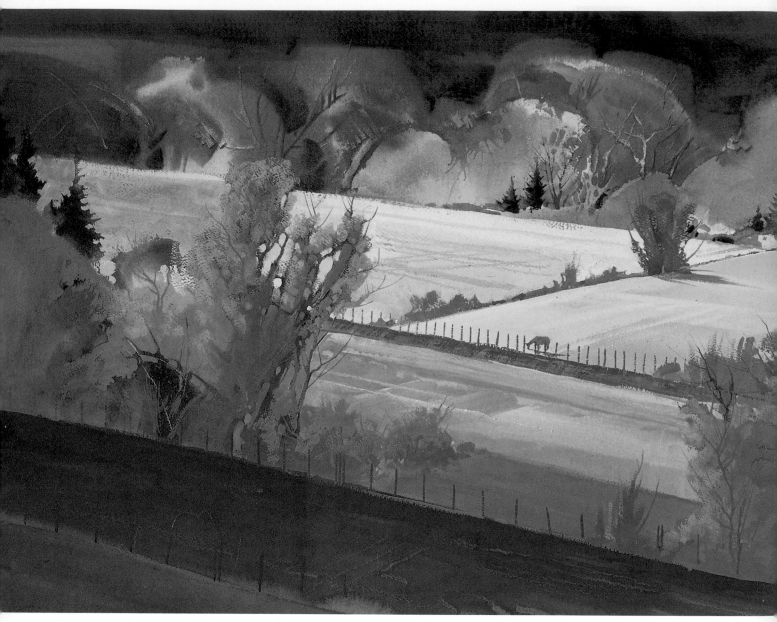

AUTUMN LIGHT, DIXON

Acrylic and casein on Arches 300 lb. rough paper
24" × 35" (61 × 90 cm)
Collection of the artist

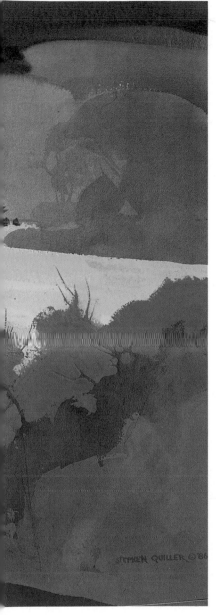

GENERATING EXCITEMENT IN YOUR COMPOSITIONS

Before you pick up your brush and start to paint, there are many questions you must answer. This chapter suggests some of the things you should think about and decide on before you actually begin. It takes time to work up a composition that emphasizes whatever excites you about your subject in the first place. If you neglect or hurry the preliminary planning stages, the composition will not work and the painting will not be as successful. Moreover, the thinking and decision-making process must continue as you move beyond the initial selection of subject matter through to the finishing touches.

It is especially important to consider your subject as an abstract shape, to be arranged with other shapes on the picture plane. If you focus only on the object and surround it with empty space, the result will be what I call a "halo effect." Instead, all the shapes in your painting should relate to one another in an interesting way. To produce an exciting composition, you must pay attention to the interaction of positive and negative space, the use of line and overlapping forms, as well as the repetition of geometric motifs. Balance, rhythm, texture, value, and color must also be considered.

All these elements are discussed in this chapter. Understanding them should help you make a major breakthrough in the way you develop a composition. Instead of trying to duplicate a photograph or merely illustrate a scene, you will begin to see your object as an abstract form interacting with other abstract forms. You will be able to think about it in terms of color, shape, value, and line. This is the point where you will begin to compose exciting paintings that reflect your own ideas. And that, after all, is the ultimate goal.

Understanding Positive and Negative Space

Because positive and negative space is a vital ingredient in all compositions and absolutely essential to my way of seeing, I've chosen it as the beginning point. Understanding the concept of positive and negative space will enable you to perceive form in new and different ways and thus affect your entire thinking about composition.

In Chinese philosophy, the positive, bright, masculine principle is referred to as Yang, while the negative, dark, feminine principle is called Yin. The interaction of these two principles influences the destinies of all living creatures, and this can be compared to the way the interaction of positive and negative space influences the destiny of a painting.

In a painting, the positive space generally is the object itself—that which is drawn or painted. Positive space is "active" and generally contains the greatest contrast, texture, and color. Negative space is usually the area surrounding the object. It may be characterized as "passive," as quiet and restful, for it generally lacks detail, offers less contrast and texture, and makes use of subtle colors. Both the positive and the negative areas are equally important in a composition, as you can see in the examples here.

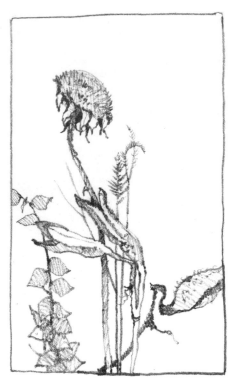

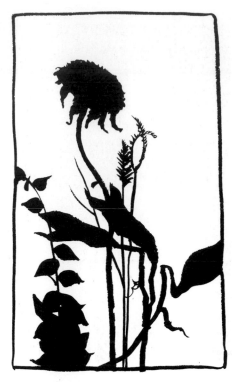

CREATE RHYTHMIC ARRANGEMENTS

In this straightforward pencil drawing of familiar weed forms, both the positive space (the shapes of the weeds themselves) and the negative, or empty, space (the areas around them) are carefully considered. The arrangement of the weeds sets up a rhythm that unifies the composition. Although in part this rhythm is generated by the curving shapes of the weeds, it also depends on the unequal division of positive and negative space. Keep in mind that an equal amount of positive and negative space is apt to cause confusion, as the areas compete with each other. Here you can also see how overlapping the weed forms creates exciting small pockets of negative space.

SIMPLIFY THE POSITIVE SHAPES

When the same arrangement is shown as a silhouette, it is easier to see the overall shape and pattern of the forms. To create a similar simplification of the forms you see, simply squint your eyes so you lose the details of structure. Notice here how the large form of the milkweed helps to balance the sunflower above. There's a unity from the repetition of curving forms in the stems and heads. But there is also variation in size and texture, which prevents monotony.

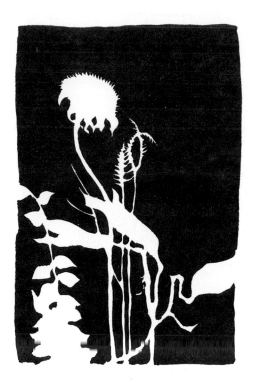

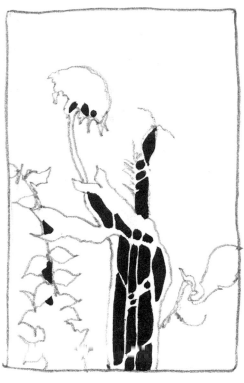

REVERSE POSITIVE INTO NEGATIVE

In this reversal of the previous figure, the weeds become the negative area. Now you can see how a shape can be developed by drawing or painting around it. What is usually considered empty space becomes the active, painted area, and it could be handled in a far more complicated manner than here. Leaving the subject underdeveloped and painting around it can be a challenging new way of visualizing and realizing forms.

DEVELOP INTERLOCKING RELATIONSHIPS

Although someone once said, "There are no lines in nature," you can use lines to define the boundaries between the positive and negative areas and articulate a strong interlocking pattern. Notice where the shapes extend beyond the edge of the picture plane. When designing a composition, always consider the way your shapes relate to the edges of your paper or canvas. Here, by extending beyond the frame, the forms create new and exciting areas of negative space.

USE ENCLOSED NEGATIVE SPACE FOR EXCITEMENT

Tiny pockets of negative space can generate visual excitement through variations in size and shape. Here I have made the pockets dark so they are easy to locate. But negative pockets could also be areas of light perceived beyond a dark, positive form, such as a tree, and could serve to create the form of the tree itself. Negative space can work for you in many different ways; here it interacts with other, positive spaces and helps the eye dance through the composition.

Choosing and Sketching Your Subject

When deciding on a subject, remain open to all ideas. If you go back to sketch a subject you noticed the day before, keep your mind open—something else along the way may be even more interesting. Once, for example, I set out on skis, intending to sketch a subject I'd seen previously. Something about the rhythm of the motion set my mind idling in neutral. I wasn't particularly looking for a subject at this point. Suddenly, the beauty of a long shadow across a pocket of water in the melting snow seemed to jump at me. I immediately stopped and sketched it, and later the sketch became a painting. I never did get back to my original subject, but it didn't really matter. I accomplished what I wanted to because I was adaptable and receptive to a different subject.

Once you discover a subject, ask yourself what makes this particular subject important to *you*. This may take some soul-searching.

Does the appeal lie in the color? the mood? a suggestion of movement or power? Only you will know the answer. After you have decided what the appeal is, focus on that, do all you can to emphasize it, and eliminate everything else.

At this point you're ready to do some preliminary sketches of your subject. Don't rely on one sketch; instead, do a series of sketches. Move the subject around, pulling it forward or pushing it back, and adjust the values. Also change the format—making it horizontal, vertical, square, perhaps even oval or circular. From this series of sketches, you will be able to choose the one that best emphasizes what you want to say about your subject.

The three sketches of apple pickers here are all done on toned paper, which is helpful when you are deciding on values. I used pencil for the darks, permanent white gouache for

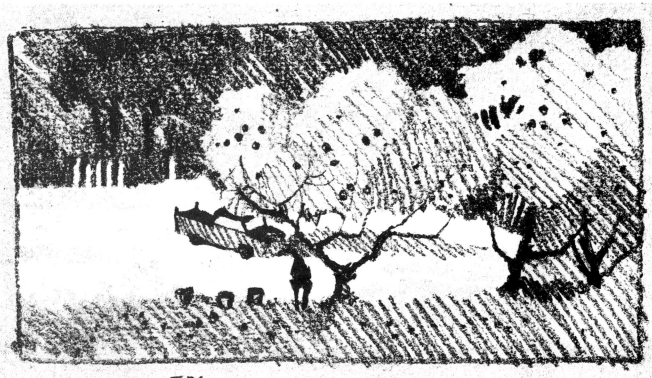

APPLE PICKERS

the lights, and dots of cadmium red light gouache for the apples (although the color is not reproduced here). There is no one "correct" format among these sketches; all of them could be used for a finished painting. But, making these sketches in different formats gave me a better idea of what would work best for what I wanted to say about this subject. The same procedure will work for you.

HORIZONTAL FORMAT
The first study gives a broad view of the apple trees, baskets, pickup truck, pickers, and apples on the ground as well as in the trees. The long light cast across the composition is what I emphasized.

NEARLY SQUARE FORMAT
In the next study I've included a ladder with a figure at the top. There is a nice balance between the figures on the ground, the figure on the ladder, and the left branch of the tree. But there is a lot going on, almost too much. It would be important to decide what to emphasize before beginning a painting based on this sketch. The figure on the ladder might have to be suppressed in some way, perhaps by losing it in a shadowed area. The nearly square format, however, is necessary; if more space were added above the tree, in the foreground, or at one side or the other, the composition would have far less impact.

VERTICAL FORMAT
Finally, I've moved in closer and eliminated the ladder entirely. The truck becomes important, as well as the contrast and texture in the tree branches. Although the area of brilliant light has become larger, the shadowed leaves and branches in the upper part of the composition make the overall feeling somewhat somber and moody.

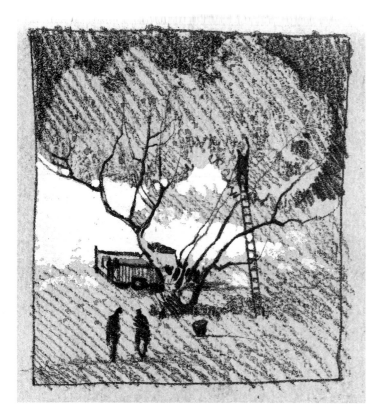

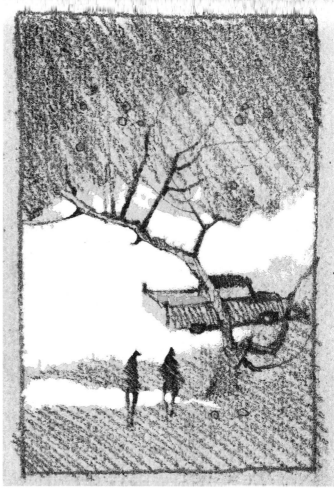

Overlapping Forms

These two simple line drawings both contain the same elements: mountains, a building, trees, and foreground shrubs. One, however, is clearly more interesting than the other. Why do you suppose this is so?

The first study is flat and dull because each element stands separately, isolated in its own space. There is little illusion of three-dimensional space, so essential in a landscape.

The second drawing shows what can be gained by overlapping the forms. The foreground shrubs extend above the middle distance; the building stands in front of spruce tree and cottonwood; and the tree branches project over distant mountain ridges. Overlapping helps to create unity and adds depth and excitement to this composition, as it can to yours.

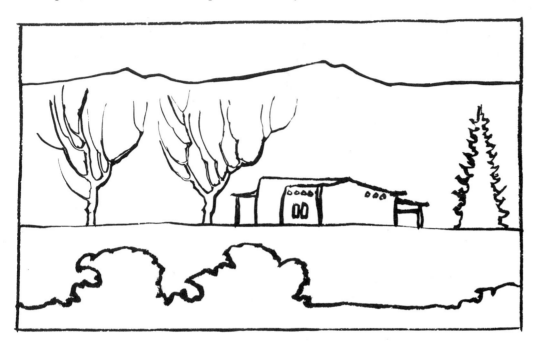

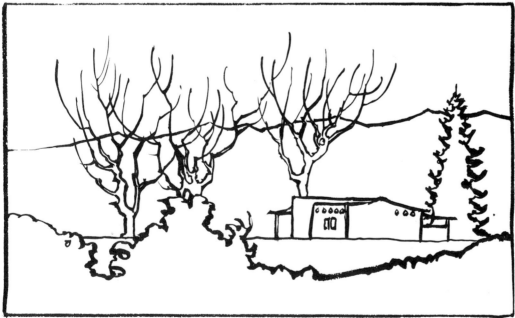

Adding Rhythm

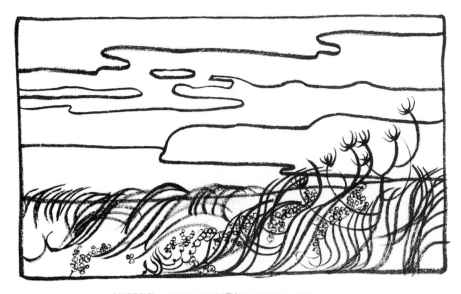

Musicians aren't the only ones who use rhythm; it's used by painters and graphic artists as well. A beat can be felt in a painting just as clearly as in music. It's important, however, to select the kind of rhythm that will enhance the effect you desire. Soft curves can lend a restful or carefree feeling, while jagged shapes and broken lines can suggest energy or hostility. Certain subjects lend themselves to particular rhythms, as you can see in the examples here.

In the drawing of a seascape with dunes, the repeated curves of the grass, dunes, larger landforms, and clouds set up an even flowing beat. I've added some small, intricate shapes for variety, which accent and enhance the flowing rhythm.

The second drawing, with its vertical format, emphasizes the irregular angles of the dead spruce: I've created agitation by using small negative spaces and by making the shapes outside the branches, for the most part, sharply triangular. The texture of the bark, created by small, jagged strokes of the brush, adds variety and at the same time echoes the basic triangular shapes. Overall, the staccato rhythm of this drawing generates a feeling of restlessness.

To learn more about rhythm and how to emphasize it, study the work of well-known artists in books and museums. Compare, for example, the curved forms and flowing rhythms in the paintings of Thomas Hart Benton and Charles Burchfield. Then look at how Piet Mondrian suggested animated movement in his painting *Broadway Boogie-Woogie*.

Laying the Value Foundation

The term *value* refers to the lights and darks in a painting. Value is closely related to color, but it is not the same (see pages 52–53). Values form the foundation of a painting; they might be described as the bone and muscle holding a painting together, while color serves as the skin. Originally, oil painters used a technique called *grisaille*, in which they made an underpainting of gray-green tones, concentrating on the lights and darks to establish the forms. When this dried, color was glazed over the grisaille layer. The old masters knew how confusing it can be to work in both color and value at the same time.

To avoid this confusion, I recommend that you do a series of value studies like the ones shown here. My subject is an interesting pattern of churches and buildings near Truchas, New Mexico. In each study, the arrangement of the forms and the focus are the same. But the different handling of darks and lights suggests three very different paintings.

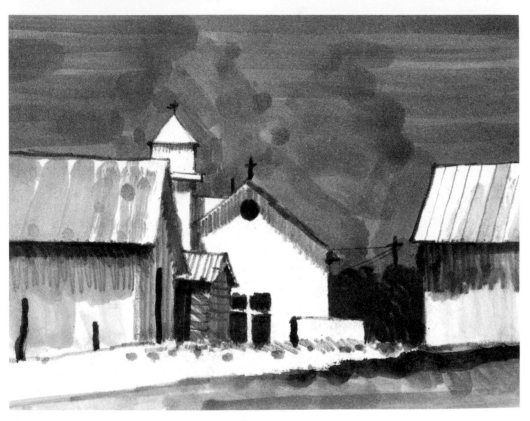

TONED SKY WITH LIGHT SUBJECT

Although my value studies are reproduced in black and white here, I often use a wash of burnt sienna, mixed from oil paint and turpentine, plus an ordinary drawing pencil for line. The oil wash can be used to dissolve the pencil lines if very dark areas are desired. In the first study here, I've used a middle-value wash for the sky and foreground and a somewhat paler wash for the buildings at the side. This keeps the greatest concentration of contrasting lights and darks around the church, the center of interest.

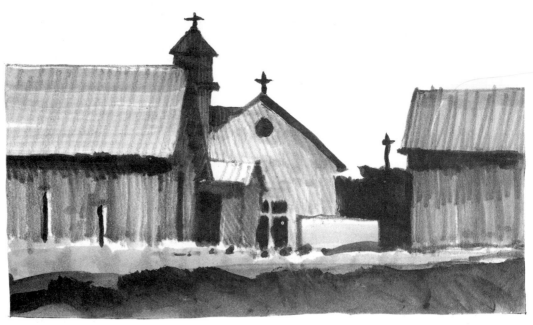

LIGHT SKY WITH CONTRASTING BUILDINGS

When doing value studies, I always squint my eyes to lose the details and see the large masses. In the study above, I've left the sky area untouched and used a middle value for the buildings on the side and for part of the foreground. The buildings are nearly silhouetted against the bright sky, and interesting light-dark patterns emerge around the church. The dark foreground serves to pull the eye into the composition.

ANALOGOUS VALUES

Effective compositions can be created without vivid contrasts of light and dark, as is evident in my study below. Here the value contrast is very subtle and low key. As in the other studies, the contrasting lights and darks are concentrated around the church. Notice how the various value changes help to create the illusion of three-dimensional form. Also observe the softly diffused shadows under the eaves, which are typical of a day with low light.

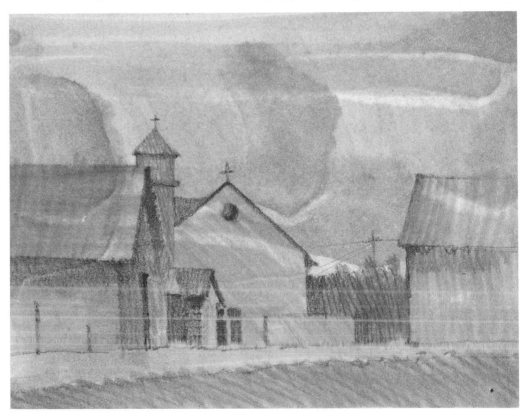

Using a Geometric Motif

The geometric motif is simply the geometric form basic to the composition. There are three main types: rectangular, triangular, and curvilinear. More than one motif may be combined within a composition, but it is best to have one predominate.

RECTANGULAR MOTIF

In the diagram of *In the Bathtub* by Pierre Bonnard, you can see the artist's expressive use of horizontal and vertical lines. Horizontals tend to convey restfulness, while verticals suggest boldness. Here Bonnard's format is a vertical rectangle, and the composition is made up of a series of rectangles of different sizes. In the actual painting, this geometric motif is overlaid with busy patterns, but the color is soft and quiet, and the overall feeling is static. Bonnard often used rectangles in his compositions, and the way they fit together establishes the underlying dynamics of his paintings, although color and pattern were also important to him.

From the linear diagram, you can also see that Bonnard does not offer a literal rendering of his subject. The forms in his painting have been interpreted and exaggerated to make the painting work. Remember this when you start to paint; what you see is not necessarily what you want to use in your painting. Because it interests you, it can be a starting point, but don't hesitate to rearrange the forms.

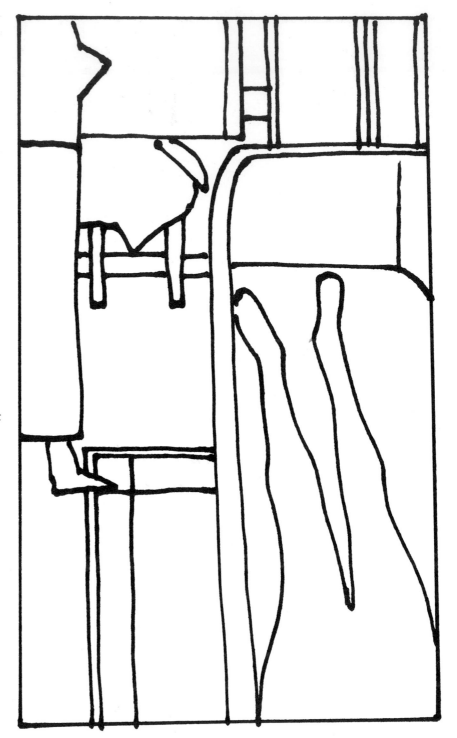

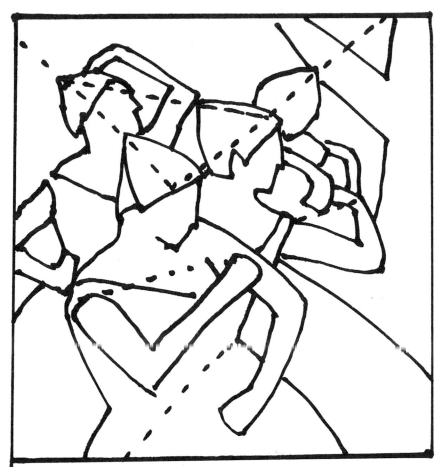

TRIANGULAR MOTIF

Edgar Degas was a master of composition; nothing happens by chance in any of his paintings. The bird's-eye view he chose for his *Ballet Dancers* was unusual for the time and was influenced by Japanese prints. You might experiment with a viewpoint other than eye-level in your own work.

Degas' composition is a series of interlocking triangles created by the figures, arms, and costumes. The different sizes and directions of these triangles create visual interest and excitement. These triangles, however, aren't precise or literal. In the actual painting, for example, three red spots on the heads of the dancers create a triangle, while a fourth red spot leads the eye into the composition on a diagonal. The nearly square format concentrates the action and makes it all work in a visually satisfying way.

CURVILINEAR MOTIF

A curvilinear motif usually, although not always, creates a lighthearted effect. In the diagram of Paul Gauguin's *On the Beach*, notice how the shapes of the hair are repeated in the foreground. Small active shapes repeat and yet contrast with the larger, curvilinear forms. The graceful movement throughout creates a feeling of joyousness.

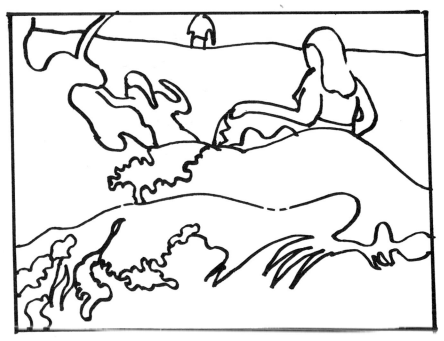

Establishing an Interlocking Spatial Pattern

The two-dimensional spatial pattern of a painting is closely related to rhythm and geometric motifs, and these three aspects of composition should be considered together. When we think of the two-dimensional spatial pattern, we are thinking about how the various parts of the composition fit together and how each shape relates to the others. If all these separate pieces were the same size, it would make for a very dull picture. By varying the size, as well as the shape, you can heighten interest.

Along with size and shape, you must also consider texture and color (see pages 49–55). If you treat a large shape quietly, small, active shapes will be more interesting by contrast. The same large shape, if given too much texture or too bright a color, may become too active and hence obtrusive. Each shape must be considered in relation to the others when creating a successful composition.

To understand how this spatial pattern works, look at the first line drawing of a composition with a predominantly triangular motif, created by the diagonals of the intersecting land shapes. Now look at the second drawing, which shows the same composition, but with the parts separated, as they might be in a puzzle. Making all the pieces fit together unifies the picture plane.

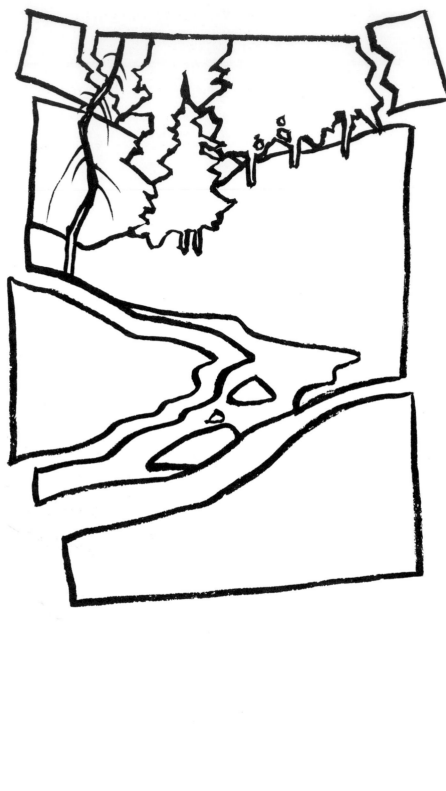

Developing a Composition

There are many different ways to develop a composition. Remember that while your first sketch may record the details, it may fail to emphasize what drew you to the subject in the first place. You must learn how different compositional devices can be used to convey different feelings.

Look at the photograph below, which shows a subject I saw one afternoon when I was jogging in the San Luis Valley. Although my body was active, my mind was in neutral, and I noticed that the building was put together in an unusual way and that there were interesting patterns in the shingles, trellis, and brickwork. Later, after I returned to the site and made a pencil drawing (see page 44), I began to explore a variety of compositional possibilities using the same basic elements: the building, the tree, and the car. The drawings on the next five pages show how I moved these elements around in the composition, changed the format, shifted the perspective, and experimented with positive and negative space. The variety of possible compositions is endless—the choice depends on the effect you want.

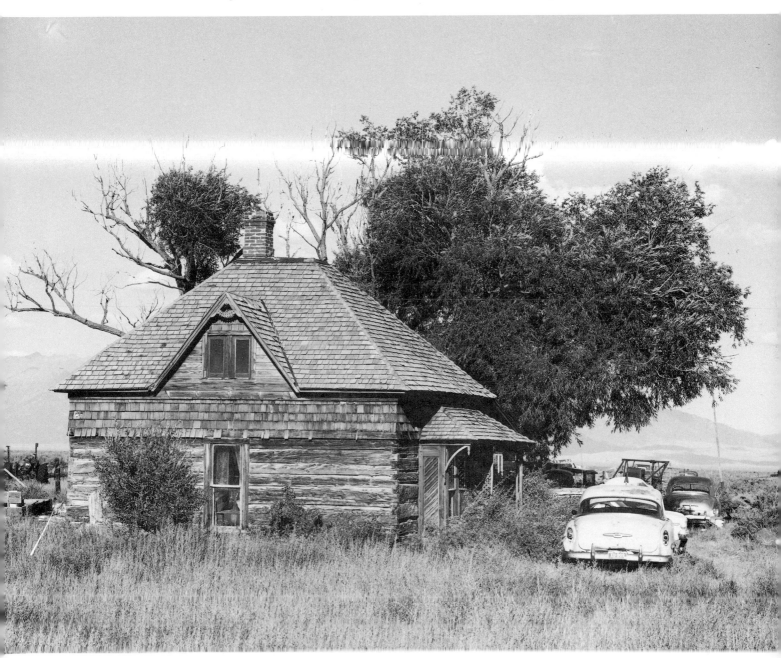

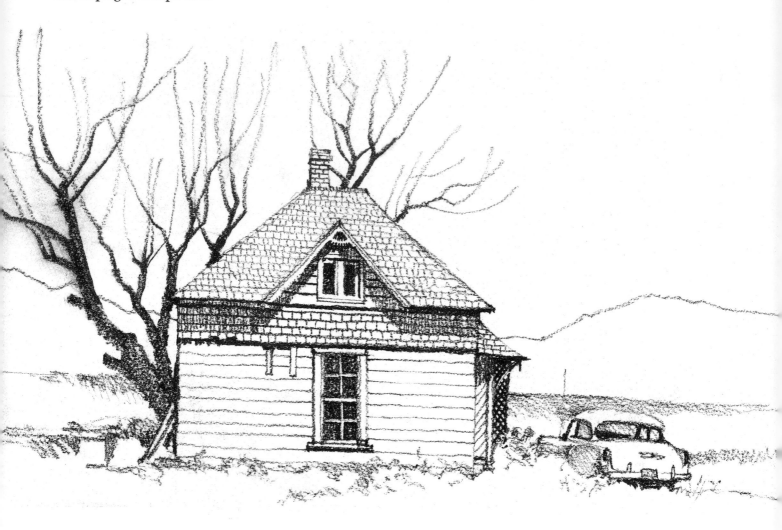

INITIAL DRAWING

This straightforward pencil drawing, done on
the spot, records the subject without much
attempt at interpretation. Note the many
small rectangular shapes repeated in the struc-
ture. Generally, I recommend to my students
that they explore a subject by walking around
it, studying the various angles and textures,
and at the same time giving thought to the
negative spaces. The conscious mind may not
be aware of these negative spaces, but they can
have a profound effect on the unconscious
mind and may even be what made the subject
exciting in the first place.

PITFALLS OF A STATIC VIEW

This wash drawing gives an overall view of the house and its surroundings, but it seems unremarkable, even boring. Why? To begin with, the horizon line divides the picture plane nearly in half; the painted and unpainted areas are also almost equal, creating an even balance between positive and negative shapes. Moreover, the buildings and tree shapes are nearly equal in size and so evenly spaced that we see each unit as a kind of spot. Because there are no overlapping forms, there is no illusion of depth, and no exciting pockets of negative space beguile the eye. Finally, the barn at the far right overweights the composition and seems to go off the edge.

ENLIVENING A STATIC VIEW

Although this drawing has the same compositional elements as the one before, they are used differently. The horizon line has been dropped so there is more negative, quiet space to make the active areas more exciting. Instead of isolated shapes, there are many overlapping forms. The overlapping tree branches in particular create many tiny pockets of negative space. The barn has been moved away from the edge. Also notice that the tree has been moved forward and made larger to connect the foreground with the middle ground. This large tree gives a feeling of depth and also breaks up the negative sky area. Overall, this is a much more interesting composition than the previous one.

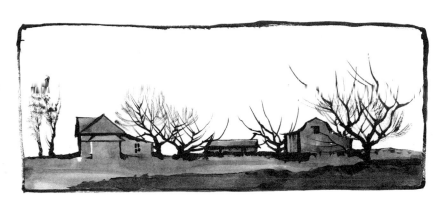

MOVING CLOSER AND BREAKING UP SPACE

Here is an example of how to focus on different aspects of the same subject by handling the positive and negative space differently. I am closer to the subject, and I am thinking about the relationship of the positive, painted shapes to the negative, unpainted space. The negative space separates the positive shapes so that each can be seen as a separate entity. At the same time the tree branches create interesting visual pockets, and the negative space moves down over house and car to a low horizon line. The mountains in the background have been eliminated.

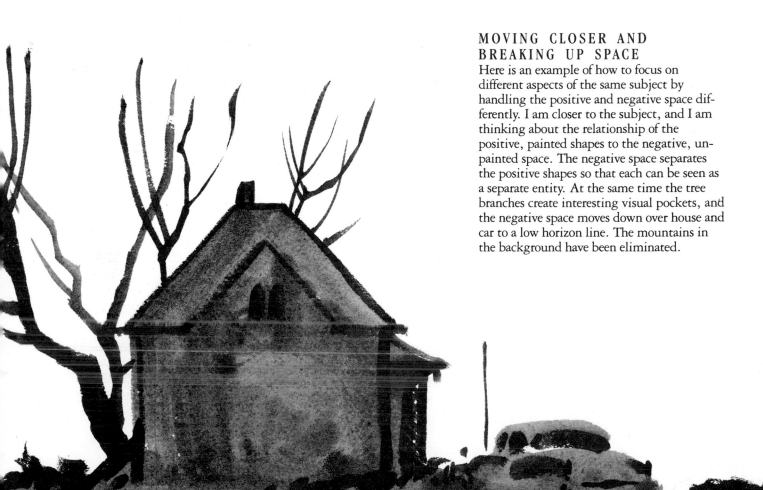

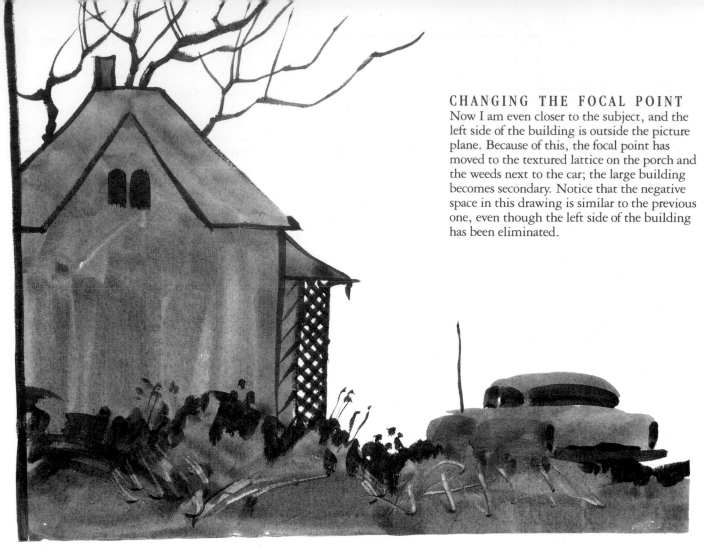

CHANGING THE FOCAL POINT

Now I am even closer to the subject, and the left side of the building is outside the picture plane. Because of this, the focal point has moved to the textured lattice on the porch and the weeds next to the car; the large building becomes secondary. Notice that the negative space in this drawing is similar to the previous one, even though the left side of the building has been eliminated.

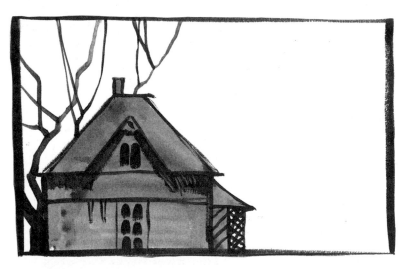

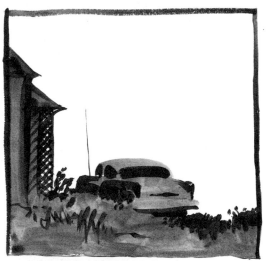

EMPHASIZING EMPTY SPACE

In this composition all the weight of the positive shapes (the tree and the building) is on the left, yet it does not seem off-balance. This is because the negative space is so important that is has a definite weight of its own. This kind of balance is characteristic of much Oriental art, where emptiness, the negative Yin, is as important as what fills the remaining space, the active Yang.

SHIFTING THE SUBJECT

Here the car becomes the subject, while the building and porch break into the upper negative space, moving the eye from left to right. Notice how important the antenna is— a very small thing can make a large difference. The line of the antenna is delicate, but it interacts with the porch support to create an exciting, rectangular negative shape. Imagine the antenna on the other side of the car and visualize the different effect.

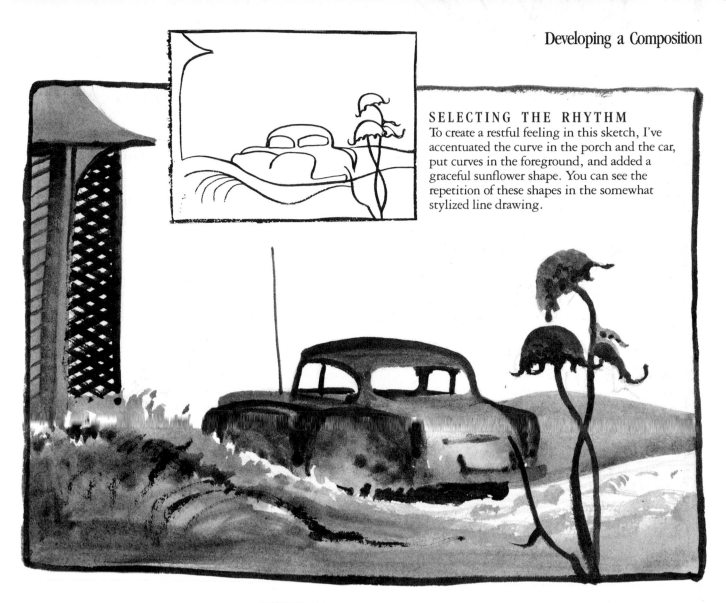

SELECTING THE RHYTHM

To create a restful feeling in this sketch, I've accentuated the curve in the porch and the car, put curves in the foreground, and added a graceful sunflower shape. You can see the repetition of these shapes in the somewhat stylized line drawing.

CHOOSING THE FORMAT

Here's an example of how you can notice different things in a subject. As I moved closer, I concentrated on the contrasting textures of the building forms and the tree branches. In a finished painting I might emphasize the branches by adding more texture. Also notice how as I have moved closer, the proportions of the picture have changed progressively from horizontal to more nearly square to a vertical format. The positive shapes are somewhat to the side, to avoid a symmetrical, static composition. Notice, however, that the positive and negative spaces are nearly equal. Do you feel that this is good or bad?

47

EMPHASIZING THE GEOMETRIC MOTIF

Each of the basic geometric motifs—rectangular, triangular, and curvilinear—expresses a different feeling. A vertical rectangle suggests stability and power, while a horizontal rectangle conveys quietness and restful serenity. A triangle is more active because of its diagonals and thus results in lively, dynamic compositions. Curved forms suggest fantasy and a carefree, lighthearted feeling; they have a kind of softness compared with the rigidity of straight lines.

In this final sketch the format is a long rectangle, and this geometric motif is repeated throughout. The entire study is made up of rectangles of varying proportions and sizes: the building itself, the window and its panes, the shingles, the porch, and the foreground area. Even the car, although it has curves, forms an overall rectangular shape. The building suggested on the left provides yet another rec-

tangle. Along with all these rectangles, however, I've shown some boards leaning against the wall on the left, which create a triangle. There are also double triangles in the diamond shapes of the trellis. The introduction of this triangular motif helps prevent monotony.

Frequently, although students may be able to think of the subject as a geometric motif, they forget to consider the shapes of the negative areas. The line drawing here makes it clear how all these spaces and shapes fit together like a puzzle. Notice, for example, how a rectangular negative space is created by the line of the antenna and the porch upright. Too many different geometric shapes in the negative areas can create a sense of confusion in your painting, so be aware of these negative shapes and try to keep them consistent—they are important in the success of a composition.

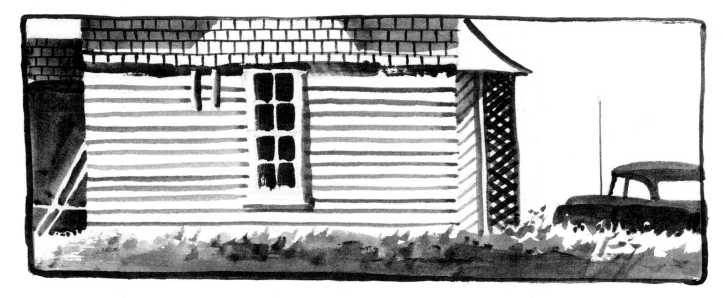

Texture can be either visual or tactile. Generally speaking, texture in the water media is visual—that is, it has the look of texture, although actually it is flat. The effect gained by sprinkling salt or using a sponge is a visual texture. By introducing a collage of rice paper, however, you can add an actual, tactile texture to a water media painting. As with all artistic devices, use texture with discretion. Too much texture can overpower or distract from your subject. It is best not to put a single spot of texture in a painting; instead, try to repeat it somewhere else, with variation.

STAINED TEXTURED PAPERS

Rice papers come in a variety of textures, and staining them makes their texture more visible (see pages 114–117 for an example of how to use this in a painting).

Creating Texture

DRYBRUSH ON ROUGH PAPER

To make the wavy stripes on the left, I use a
⅝-inch single-stroke sable, fairly dry, with the
fibers spread apart, and pull the brush over the
paper in an irregular way. On the upper right,
I take a round, fairly dry no. 8 sable; splay the
hairs; and lightly stroke in brush patterns. By
turning it around, I pull the pigment down
and create the negative grass shapes. The
strokes going off the top edge are made with
the same brush, pointed and using more
pigment. The more graphic strokes on the
right are made with a no. 3 round sable. I
direct the brush by pressing it and moving it
to the side to bring it to a point, creating a
pine-cone form. For the center area, I use a
round no. 8 sable and, for the lower part, a
⅝-inch single-stroke sable. Both are dragged
lightly across the rough paper, which lends
sparkle to the strokes. The crosshatching at
the lower left is done with a ⅝-inch single-
stroke sable turned on its edge, using some-
what more water.

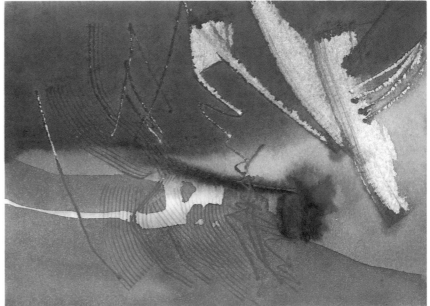

SCARRING AND SCRAPING

After thoroughly wetting my 140 lb. Arches
cold-pressed paper, I wash on the color tones.
While it's still very wet, I use a coping saw (or
a comb) to make the parallel lines. The color
seeps into the scarred area and stains it. When
the paint begins to dry, color can be scraped
off with a mat-knife blade, held like a butter
knife, as I have done on the upper right. A
pocket knife can also be used.

SPATTER

Here you see two kinds of spatter, done on
paper that has been wet on the lower part.
Quite a dramatic difference, isn't it? On the
left, I use a toothbrush loaded with pigment
and tap it lightly on my can of water to
eliminate excess. Then I turn the toothbrush
face down, quite close to the paper, and drag
my thumb across the bristles. On the right, I
load a ⅝-inch single-stroke sable with pig-
ment, hold it in one hand, and tap it lightly
across the back of my other hand. I call this
directional spatter. A round brush will create a
different effect. Keep in mind that too much
pigment on the brush may spoil the effect
with large globs of paint, so get rid of the
excess. Experiment to find out how to get the
effect you want.

SALT APPLICATION

First I wet the paper, then I apply the pigment. When the paper is at a medium wetness, I shake table salt over it. The wetter the paper, the greater the lifting of color. If the paper is nearly dry, it lifts very little. Rock salt can be used for a different effect. While this texture is visually exciting, like other textures, it must not be used to excess or as a crutch when you don't know what else to do.

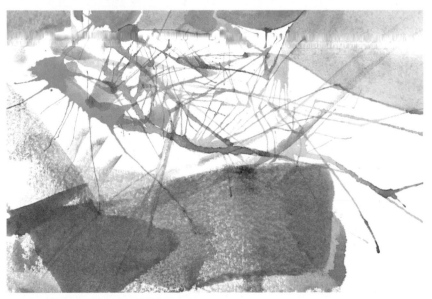

BLOWING AND ROLLING

The delicate fiberlike shapes are made by applying red, blue, and green pigment, and then blowing on this with a straw while it is still wet. The force you use in blowing determines the kind of line produced. Such an unconventional application is ideally suited to unconventional subjects.

Below this, you can see the effect of applying paint with a small brayer, or roller, similar to the ones used in printmaking. Pigment can be rolled on in broad bands, or the brayer can be rolled on its edge, creating the lines you see in the middle and which go off the upper right.

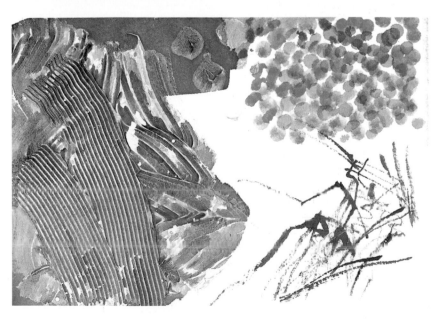

ADDITIONAL EXPERIMENTS

I'd like to urge you to experiment with many different ways of applying paint. You may find some new, unique kind of application, perfectly suited to your way of painting.

Here I create the combed texture on the left by pulling a coping saw across a thick application of titanium white acrylic while wet. I also touch some areas in the upper part with my fingertip. After allowing the acrylic to dry about eight hours, I wash burnt sienna over it, so it seeps into the depressions and enhances the texture. If pigment is washed on the acrylic while it is still wet, it will shrivel, creating quite a different surface.

For the spots of complementary color on the upper right, I use a cotton swab. The irregular strokes on the lower right are made with a small stick, broken to come to a point. This interesting, varied line could not be made with a brush.

Exploring Color

When I talk about color, I'm talking as an artist, not as a scientist or theoretician. From this perspective, I have painted a color wheel that illustrates not only hue (color), but also value (light and dark) and intensity (brightness or dullness).

Around the perimeter of the wheel, I have arranged pure colors at their most intense, just as they come from the tube. The primary colors are red, yellow, and blue; the secondary colors, orange, green, and violet. There are also tertiary colors: yellow-orange, yellow-green, blue-green, blue-violet, red-violet, and red-orange. Complementary colors are located directly opposite each other on the color wheel.

By mixing complements, you can create dull greens, warm browns, and earth colors, as can be seen inside the color wheel. Each primary, secondary, and tertiary color has its complement, and when these complements are evenly mixed, they produce a totally neutral color, one in which neither color can be distinguished. This "mud" color is of low intensity. The lowest intensity of any color is in the middle of the color wheel, in the area labeled *neutral*.

When I am painting with any one color, I am always thinking of its complement. I like to compare the relationship between complementary colors to the relationship in a marriage: the way the colors work together can make or break a painting. A painting generally has a dominant color, which is set off by its complement, used in a subordinate way. A painting of a winter evening, for example, might be predominantly shades of blue. Such a painting could be accented by a flicker of orange light in a window, with warm reflections on the snow. If, however, complements are used in equal amounts, they will compete with one another. The "op art" of the late 1960s made explicit use of the optical vibration of intense complementary colors.

In addition to intensity, every color has a value, which describes its lightness or darkness (see also pages 38–39). Transparent watercolor can be diluted with water to lighten it; other water media can be mixed with opaque white to produce a tint. Both a high-intensity color, such as red-orange, and a low-intensity color, such as a dull brown, can be made lighter in value by adding either water or white paint. Both can be made darker by adding either more pigment or black.

On the color wheel, I show a value scale from black to white of two complementary colors: blue-green and red-orange. For purposes of simplification, I've shown only seven basic shades of each color between black and white. Actually there are an infinite number of values of each color.

When we speak of "contrasting values," we mean values that are far apart on the value scale. Because contrasting values attract the eye, they are very important when developing a composition. Analogous values are values close to one another—for example, the high light, light, and low light in the diagram. The effect of analogous values in a painting is one of subtlety.

As mentioned earlier, it is difficult to work with both value and color at the same time. For this reason, the old masters first did a monochromatic underpainting, followed by transparent glazes of color. Today, an artist might turn a painting upside down to lose sight of the image and to see how it holds together in terms of lights and darks. Or you might try concentrating on value by using only one color or a limited palette of complementary colors, such as cadmium red light (an orange) whose true complement is phthalo blue, or a more neutral orange such as burnt sienna, whose complement is Prussian blue. If you add white to this limited palette, you will have a range of intensities and values.

VALUE SCALE
LIGHT TO DARK

WHITE

HIGH LIGHT

LIGHT

LOW LIGHT

MID-VALUE:
PURE INTENSITY

HIGH DARK

DARK

LOW DARK

BLACK

INTENSITY SCALE
BRIGHT TO DULL

| HIGH | MIDDLE | LOW | NEUTRAL | LOW | MIDDLE | HIGH |
| INTENSITY | INTENSITY | INTENSITY | | INTENSITY | INTENSITY | INTENSITY |

MID-VALUE:
PURE INTENSITY
BLUE-GREEN

Exploring Color

In each of these watercolor studies done near Klamath Falls, Oregon, I have limited my palette to suggest a particular time and to help move the eye through the composition. Although the hues are limited, variations in value and intensity generate excitement.

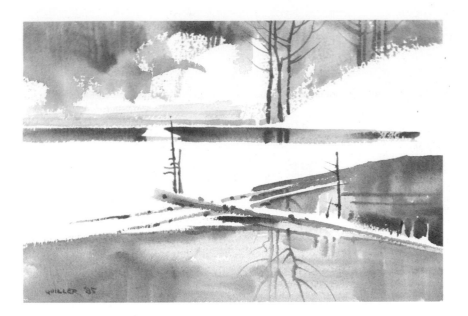

EARLY SPRING

This study, done in early March, right after a fresh snow, emphasizes the geometric pattern of the landforms and reflections in the water. My palette is cerulean blue, cadmium red light, burnt sienna, and Hooker's green. The white, of course, is the paper, which is a very rough Arches. The roughness of the paper enhances the sparkle of the drybrushed areas in the distance, which contrast with the blurry forms of the trees, done wet-on-wet. The colors suggest the strong contrasts of light on a crisp spring day. Notice how I use the strongest value contrasts and the purest colors where I want the eye to go.

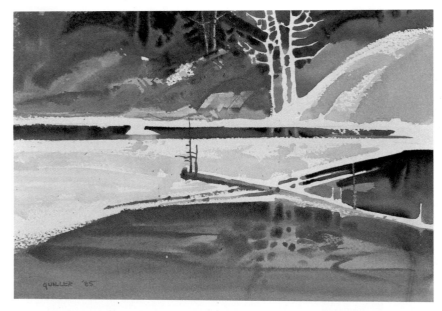

LATE AUTUMN

Here the color creates the feeling of an autumn scene in strong afternoon or evening light. The dark foreground and background set up an alternating value pattern with the light trees and middle ground. Although I use primarily earthtones—cadmium orange, raw sienna, burnt sienna, burnt umber, and cadmium red light—in the background, I add a few areas of cerulean blue, nearly opaque, to bring some relief to an overall warm color scheme.

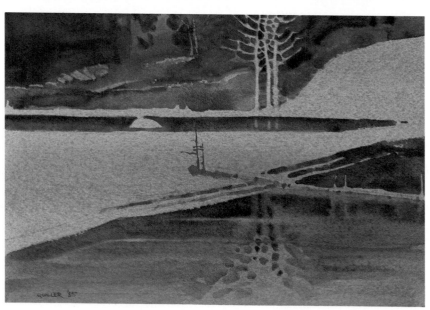

DUSK

To create this effect of late evening, I use only three colors. First I wash on cadmium red light; then, while it is still wet, I come over it with cerulean blue, a very pigmented color, which settles into the paper on top of the red, producing an interesting grainy effect. Brown madder alizarin completes my palette. To enhance the illusion of depth, I add more blue to the dark background and make the dark water area in the foreground warmer. Again, the greatest area of contrast in both color and value is where I wish the eye to go.

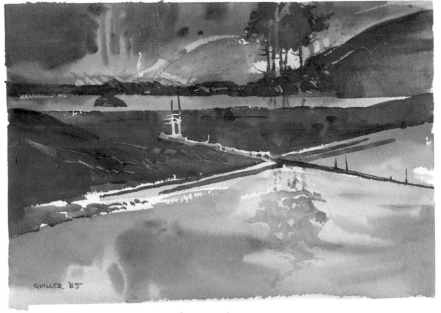

CANYON LIGHT

Using nearly complementary colors creates a strong, bold effect. My palette is cadmium yellow medium, cadmium orange, cadmium red light, brown madder alizarin, and ultramarine blue. Notice that the trees and land-forms are in shadow while the background and foreground water reflections are brilliantly lit—an effect frequently found in Western canyons. There is both variety and contrast between the soft, wet-on-wet approach in the background and foreground, and the precise drybrushed forms in the trees and logs. Literal color has been enhanced and exaggerated.

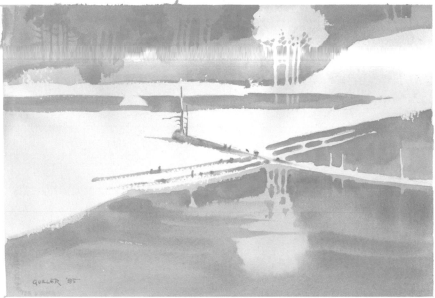

SUMMER MORNING

This basically monochromatic study—using emerald green, Winsor green, Hooker's green, and cerulean blue—conveys the restful, peaceful feeling of an early summer morning. No complementary colors are used, so the value changes within this limited color are very important. When I put the first wash of emerald green on the wet surface to tone the paper, I purposely use less pigment in the central area. This heightens the contrast with the log forms in the center, where I want the eye to go.

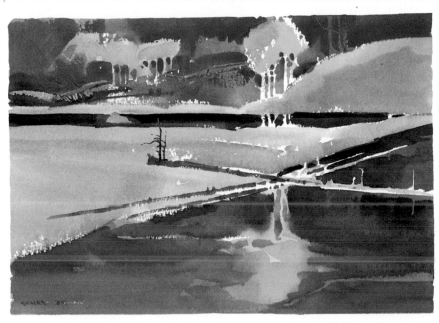

GOLDEN AUTUMN

This contrasting color scheme of complementary yellow and violet is a great favorite of mine. My palette is ultramarine blue, alizarin crimson, ultramarine violet, cadmium yellow, and cadmium orange. The yellow is at its purest intensity in the trees on the distant bank; the golden tones elsewhere are softened with violets. The distant, shadowed area is a blue-violet, while the foreground water is a red-violet, enhancing the illusion of distance. While the color in this study has been inspired by nature, it is exaggerated for a more compelling effect.

Solving Compositional Problems

How do you move from compositional studies to a finished painting? The painting shown here and the two that follow illustrate how the thinking and decision-making process discussed in this chapter must continue.

LATE AUTUMN APPLES

Watercolor on Arches 300 lb. cold-pressed paper
14" × 17" (35.6 × 43.2 cm)
Collection of the artist

Recently, I've been working on a series of paintings having to do with the many small agricultural fields just south of Taos, in the irrigated valley of the Rio Grande. One day, while I was sketching these field patterns, I found myself becoming more and more interested in the character of a pruned and twisted apple tree nearby. Perhaps it was the sound of

birds hopping and twittering among the branches that attracted my attention in the first place. At any rate, I began sketching the tree.

For even a simple painting of this apple tree to be successful, it was essential to become fully acquainted with the nature of the tree and to discover how its character was expressed by the gnarled, pruned, and twisted branches. The pencil drawing shown here was my way of becoming acquainted with this tree. While doing this study, I became aware of the interesting pockets of negative space created by the overlapping branches. I later decided to extend some of the branches beyond the picture plane for further interest.

For my painting, I decided to use transparent watercolor because I wanted a flatness

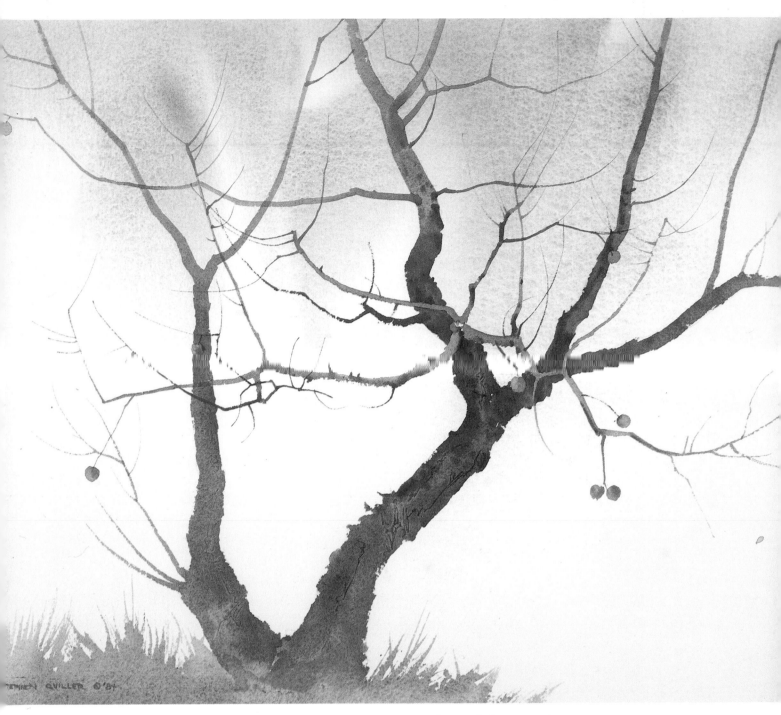

in the background, similar to an Oriental painting. Also, I was most interested in the structure of the tree and the arrangement of the branches—and watercolor is ideally suited for this type of delicate spontaneity. In the finished painting, the flat, faintly toned background enhances the branch patterns.

The geometric motif here is an active one, built on a series of triangles. The painting has a kind of syncopated rhythm, produced by the repeated angular shapes and broken triangles, and punctuated by the irregular placement of the apples. The focus of the composition is the area of greatest value contrast—where the pale red apple is surrounded by the dark tree trunk.

To convey an autumnal feeling, I limited my palette to blue, mauve, cadmium red light, and brown madder alizarin. The sky, which is the negative space, contains echoes of these colors. The red accents of the apples add variety and serve to move the eye around the composition.

This painting is about the character of a particular type of tree. Everything within the painting relates to this character. Color, brush handling, placement of the forms—all work together to emphasize what I wanted to say about this tree.

MOONRISE: SANGRE DE CRISTOS

Watercolor and gouache on Arches 300 lb. cold-pressed paper
17" × 29" (43.2 × 73.7 cm)
Collection of Steve and Cindy Myers

The Sangre de Cristo mountains extend from southern Colorado into New Mexico, as far south as Santa Fe. They were landmarks for the Spaniards and other early explorers, and they define the eastern boundary of the San Luis Valley. One of the ranchers in this valley approached me about doing a painting of the Sangre de Cristos as seen from his ranch. Since I had already been planning to do such a painting, I told him that when I completed it, he could decide whether he liked it or not.

All mountain ranges have their distinctive features, so in my pencil drawing, done on location, I wanted detailed information about the anatomy and configuration of the peaks. As I sketched, I concentrated on the geographical details and eliminated powerlines, telephone poles, and barns; I also moved trees and shrubs around.

Back in the studio, I decided I wanted to

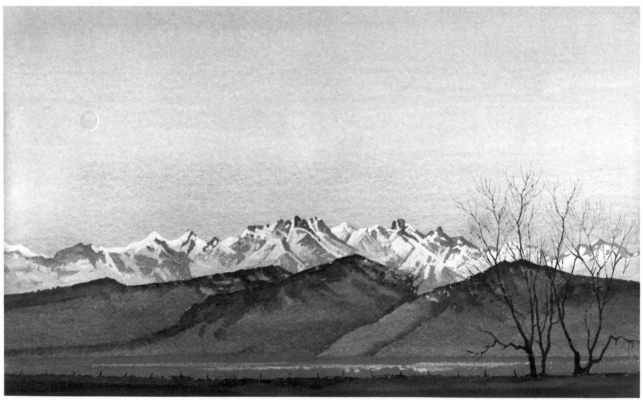

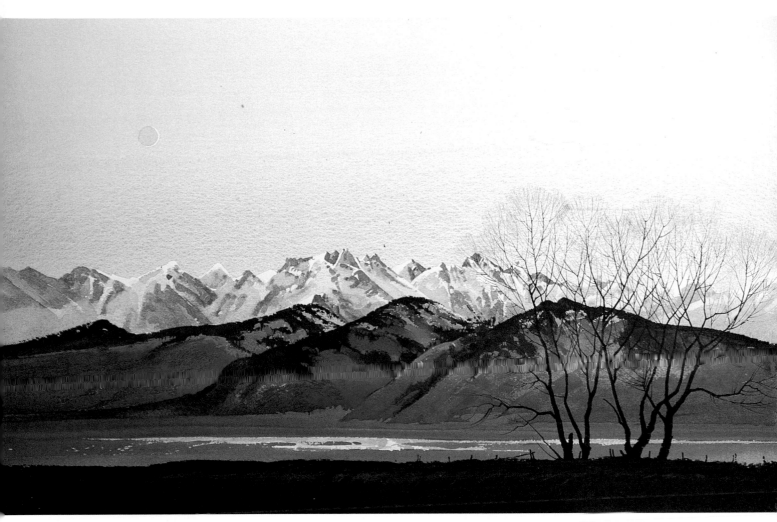

do the scene in an evening light, which would express serenity. From experience, I knew that a combination of transparent watercolor and opaque gouache would be ideal for this type of painting. The contrast of transparent watercolor (ultramarine blue and alizarin crimson) for the glowing evening sky and opaque gouache for the darkening landforms (alizarin crimson, ultramarine violet, ultramarine blue, burnt sienna, permanent white, and a little burnt umber) would intensify the mood.

Because corrections could not be made in the final painting, I did several preliminary color studies. While doing these color studies, I discovered I needed a large expanse of sky. When I tried limiting the sky area, I lost the mood I was after. Usually, I avoid making the negative space nearly equal to the positive space, but here the empty sky area was necessary to enhance the active, positive shapes of the mountains. I did, however, add an imaginary new moon to break up the large area of sky. I also discovered I needed more blue in the foreground and in the mountain forms.

The long, horizontal format of the painting conveys serenity and suggests the continuity of the mountain range. The repetitive forms of the landscape accentuate the feeling of quietness, while the repeated but varied gullies provide an essential rhythm. I purposely lost detail in the foothill area to lessen contrast and to avoid any competition with the active shapes of the mountains, the area of greatest interest.

The reflective area in the center is an invention, although the valley is full of small marshes. It pulls the color from the sky to bring a bit of sparkle to an otherwise quiet area. The tree shapes breaking into the sky area then add depth and variety. Because the trees are darker, they serve to push the lighter areas back. They also help to tie the foreground, middle ground, and background together, and the pattern of their branches creates some interesting visual pockets.

By the way, the rancher decided to buy the painting.

SAN JUAN SUMMER, ELK

Casein on Crescent no. 100 illustration board
15¼" × 14" (38.8 × 35.6 cm)
Collection of John and Sarah Taylor

This painting is based on familiar sights in the mountains near Creede, Colorado. The mood I wanted to convey was one of stateliness and majesty—something one can't help but feel in these surroundings.

If you study the painting, you will see that it is based entirely on the relationship between positive and negative areas. The pale sky, distant mountain, and water are negative spaces, while the foreground, the bank in the middle distance, the trees, and the band of elk are positive areas. In the diagram, you can see that all these positive and negative areas are essentially rectangles. The format of the painting is a solid, vertical rectangle. The herd of elk forms a long, horizontal rectangle, and the bank forms another. The negative water and sky areas are also horizontal rectangles. The aspen trees suggest vertical rectangles, breaking through the horizontal rectangles of the middle ground and background. They connect the two areas and also add interest and depth. All these interlocking rectangles emphasize the quietness and stately majesty of the scene.

There are, however, a few diagonals. They appear in the overall shape of the beaver house, as well as the interlocking twigs, and are repeated very softly in the background mountain form. But these diagonals remain secondary; they create variety without interfering with the overall effect.

For the painting itself, I chose opaque casein because its soft, matte quality seemed to suit the subject. Casein lends itself to the glowing light found in water and sky areas, yet is equally adaptable for opaque overpainting, as in the beaver house and the bank. To enhance the mood I wanted, I selected a palette of titanium white, cerulean blue, terra verte, alizarin crimson, burnt sienna, raw sienna, and a touch of phthalo green.

Notice how the warm red-oranges and cool, greenish blues complement each other. I used warmer tones for the beaver house and repeated them as an underlying color in the river bank beyond. Then I added more raw sienna to my mixture to paint the elk and the aspen. This gives some variety to a color scheme that is quite uniform throughout.

Everything in this painting adds to the effect I wanted. It's a good example of how thoughtful use of the positive and negative space can enhance and emphasize the mood you want to express.

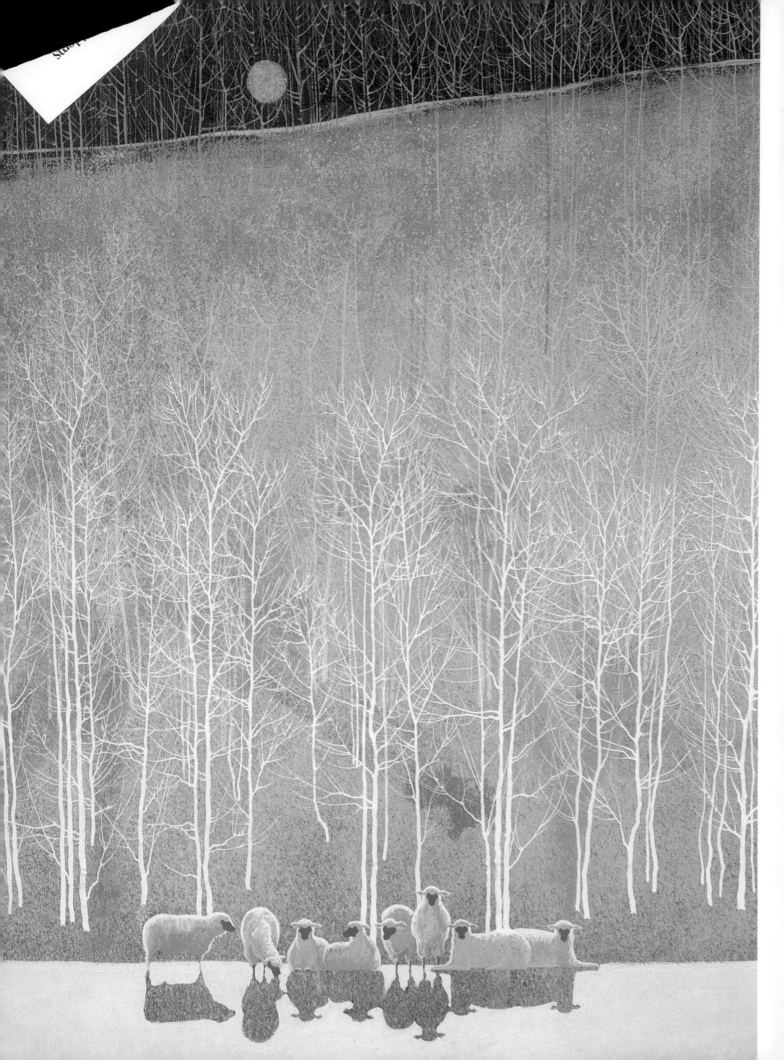

Here is a quick review of the major points covered in this chapter. Ask yourself these questions as you develop your composition through sketches and begin to paint.

How can you focus your subject?
1. What strikes you about this subject? What drew you to it in the first place?
2. Have you eliminated anything that does not enhance what you want to express?
3. Are you absolutely sure that everything in the composition heightens the effect you are after?

Have you considered both positive and negative space?
1. Is there a comfortable balance between positive and negative space?
2. Is there an exciting relationship among negative and positive shapes?
3. Is there enough quiet, negative space to make the active, positive space dramatic by contrast?
4. Do some of the positive shapes extend beyond the picture plane to create interesting negative areas?
5. Are there small, exciting pockets of negative space formed by overlapping positive shapes?

Is the spatial pattern of your composition effective?
1. Have you made a series of small sketches to make sure you've arrived at the most exciting composition?
2. Is the format correct for the effect you desire?
3. Is the geometric motif suitable for the mood and subject you have selected?
4. Is there repetition as well as variety in the size and shape of positive and negative areas?
5. Have you established a rhythm in the composition?
6. Is there a sense of balance, with large, empty areas balancing small, active shapes?
7. Are there overlapping forms that create a sense of unity and depth in the composition?

Have you used color and texture effectively?
1. Does the choice of color emphasize the mood you wish to convey?
2. Are certain colors repeated throughout the composition?
3. Are the values well placed?
4. Is the strongest contrast at the prime focus of interest?
5. If texture is to be used, is it appropriate?
6. Is there enough variety in the color, texture, and size of various shapes to create excitement?

Are your materials and techniques appropriate?
1. Are you using the right paper, the right paint or combination of paint, as well as the proper type of paint application, to say what you want to say?
2. Is there a unity in the paint application? Is it consistent throughout, but with enough variation for interest?

OCTOBER IMAGES

Casein on Crescent
no. 100 illustration board
30" × 22" (76.2 × 55.9 cm)
Collection of the artist

TRADITIONAL APPROACH

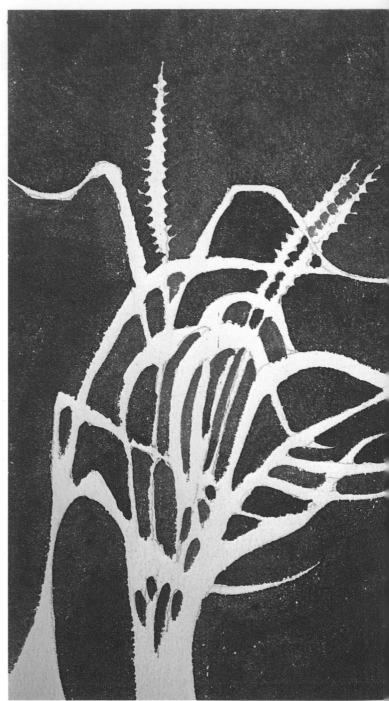

REVERSE NEGATIVE SHAPE APPROACH

Chapter Three

DEVELOPING YOUR VISUALIZING SKILLS

Visualizing means being able to see what you intend to paint on the paper in front of you before you paint it, as if you had a slide projector behind your eyes. It is a skill much honored in the Orient, where traditional painters discipline themselves not to make a mark on the paper until they have the image they want to paint firmly in mind. It is definitely an important skill to have, and it can be developed with practice.

The ability to visualize is particularly important for artists who use the water media, which are the most unforgiving of all the painting media. Spontaneity is essential to attain the fresh, vibrant quality that is one of the primary characteristics of the water media. At the same time, control is necessary because both paint and paper dry quickly and corrections are difficult, if not impossible, to make.

As an artist, you already have the ability to visualize objects to some degree. When you draw, you must remember the image and hold it in your mind for that short span of time between looking at the object and drawing it. To develop this ability, I've designed a series of progressive exercises. The first five exercises will familiarize you with what I call the Reverse Negative Shape Approach, and the last four exercises will enable you to extend this new way of seeing to different combinations of the water media. At the end of the

chapter I've included three finished paintings to indicate how you can combine this new approach with the more conventional, positive method.

To understand what I mean by the Reverse Negative Shape Approach, look at the two figures on the facing page. The watercolor on the left shows the grass forms painted in the traditional manner. But I've also tried to make the unpainted, or negative, areas into interesting shapes and at times extended the leaves of grass beyond the edge of the paper. It is this ability to visualize the forms the background takes around the subject that I call the Reverse Negative Shape Approach. Not only do you visualize the positive shape, in the traditional way of seeing, but you also see how it is formed by the negative spaces surrounding it. For people used to seeing only objects, this can become a new way of seeing, and a new way of painting, too.

In the second figure I've taken the same image, but this time I've created the forms by actively painting the shapes around the grass. With practice, you will find yourself able to visualize not only the object on the paper in front of you, but also the reverse image of the object, created by the forms and light surrounding it or seen through it. And this will help you to see the relationships between all the shapes in your painting.

Exercise One: Focus on Simple Shapes

To develop your confidence and skill at visualizing, begin with simple, repetitive shapes like leaves. Work on as large a piece of paper as is comfortable and in only a few colors, using the largest brush you can handle.

Materials

Surface:
¼-sheet Arches 140 lb. rough paper
11″ × 15″ (27.9 × 38.1 cm)

Watercolor pigments:
phthalo blue
Winsor green

Brushes:
1-inch
1½-inch
¾-inch single-stroke sables

STEP ONE

First simply stare at the paper in front of you, visualizing the leaf forms and their placement. You may wish to lightly outline the shapes in pencil before you begin. Now load your brush with a mixture of the two colors and move this loaded brush across the dry paper, outlining each leaf shape with the edge of the brush. Keep each leaf form large. Notice how I've connected one leaf shape to the next with a kind of stem. This helps lead my brush into the adjacent form. Don't worry if the color of this wash is somewhat uneven; it may add interest to the completed study. When all the leaves are formed, let the paper dry.

STEP TWO

Add more Winsor green to the basic color mixture for a somewhat deeper value. Now visualize leaf forms beyond and behind the white, unpainted ones. Some of these new forms will extend and connect with one another under the initial leaf shapes. Use the edge of a loaded brush to create this second layer of leaves. Take care, however, that the edge of the brush doesn't run over the edges of the white leaves and spoil the shapes. Whenever possible, suggest stem shapes connecting these leaves. Then let the paper dry.

STEP THREE

Now add more phthalo blue to the basic mixture, for the deepest value of all. Using a ¾-inch single-stroke sable, repeat the process described in Step Two to create a third level of leaves, behind the other two. As the overlapping forms become more complicated, you need more skill in handling the brush to maintain the edges of the first two layers of leaves. Finally, work in your deepest blue-greens to intensify a few special areas of dark and add vitality to the overall patterning.

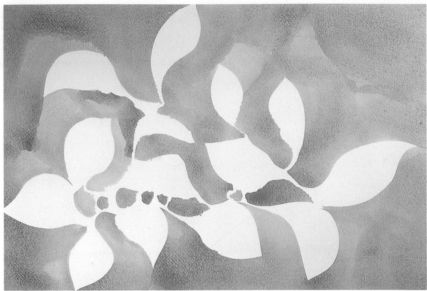

STEP ONE

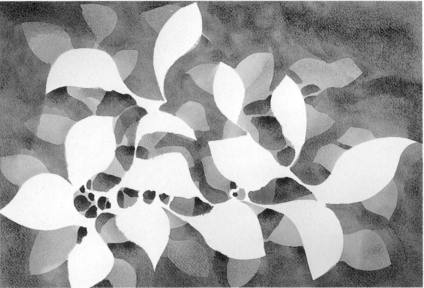

STEP TWO

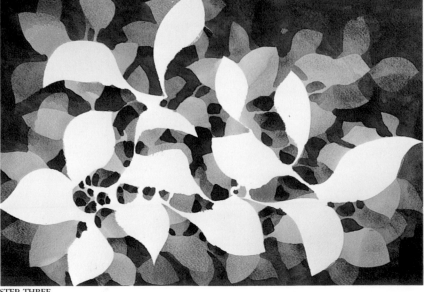

STEP THREE

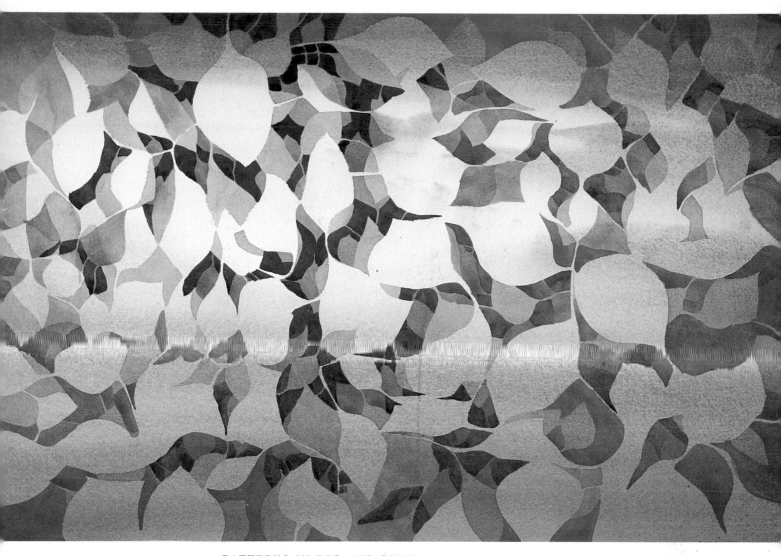

PATTERNS IN RED AND BLUE

Watercolor on Arches 300 lb. cold-pressed paper
16½" × 25½" (41.9 × 64.8 cm)
Collection of the artist

My painting *Patterns in Red and Blue* was developed from the exercise you've just been doing. I began with an overall wash of cerulean blue, wet-on-wet, leaving a highlight of white paper. I made the central upper left area quite pale because I wanted this to be the area of greatest contrast in the finished painting. When the initial wash had dried, I formed the first leaf shapes by painting around them with a very pale mixture of cadmium red, using the edges and sides of the brush. Then, when this had dried, I formed the second layer of leaves by painting around them with cerulean blue. Finally, I used alizarin crimson for the darkest darks, creating the final leaf shapes and intensifying shadowed areas. The value contrast is greatest in the central upper left area and gradually lessens as the eye moves to the outer edges of the paper.

Exercise Two: Practice with Other Simple Shapes

For this exercise, I've chosen another group of simple shapes: a grove of aspen trees. Again, you can pencil in the shapes before you start, if this feels more comfortable. But it is best to try to let your brush do most of the outlining.

Materials

Surface:
¼-sheet Arches 300 lb.
rough paper
11″×15″ (27.9×38.1 cm)

Watercolor pigments:
cadmium red light
cerulean blue
Prussian blue
brown madder alizarin

Brush:
¾-inch single-stroke sable

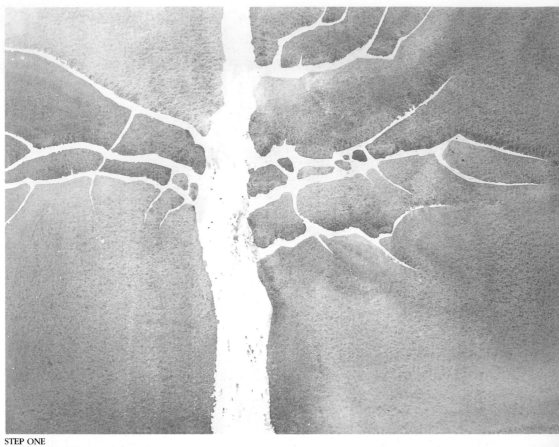

STEP ONE

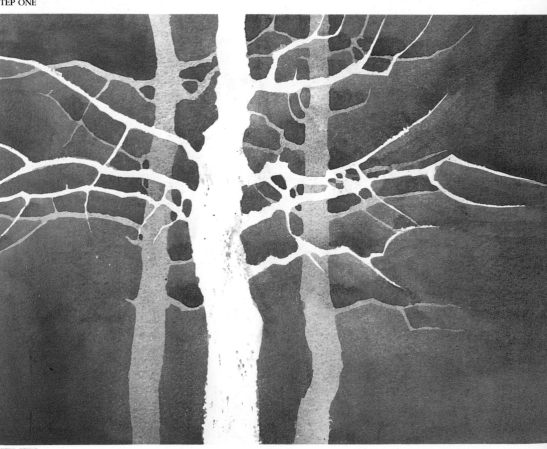

STEP TWO

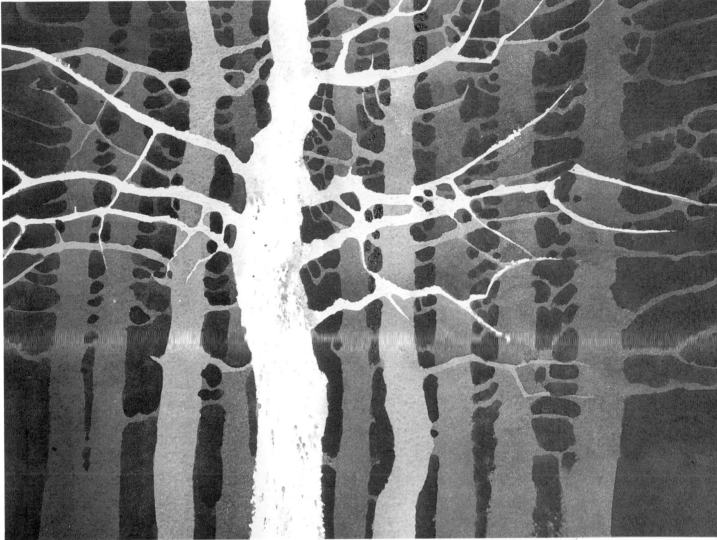

STEP THREE

STEP ONE

First, spatter a mixture of cerulean blue and
cadmium red light on the dry paper for
textural interest. Next, mix a large wash of
cerulean blue and brown madder alizarin in a
big basin—there is nothing worse than run-
ning out of color in the middle of a painting.
While the spatter is drying, study the surface
and visualize a tree form somewhat left of
center, with an interesting arrangement of
branches, some of which extend beyond the
paper's edge. Then load your brush and begin
painting the space around the upper left side
of the tree. Because the branches extend
beyond the paper on this side, the painted
areas form small, enclosed shapes. Move down
the trunk at a fairly leisurely pace, painting
the smaller sections between the branches.
You will have to paint the right side more
rapidly because of the connecting areas of
paint, though it's not important to have an
even wash of color at this first stage. Now let
the paint dry.

STEP TWO

Add more burnt sienna to the basic mixture
for the second layer of color. Visualize the trees
on either side of the first one and create their
forms by painting around them. The area
where the branches overlap requires a lot of
discipline and skill in handling the brush to
ensure that the first branches aren't painted
over. Now let the paper dry once more.

STEP THREE

Add a bit of Prussian blue to your original
mixture for the final layer of color. As you
paint, try not to be rigid about how a tree
looks or its precise placement; instead, let the
flow of the brush suggest the next stroke. This
lack of precision adds to the effect, as we see
the trees less clearly as they move farther into
the darkness. For the final touches, add
pockets of the most intense dark at strategic
locations.

Exercise Three: Explore Varied Forms and Techniques

It's time to move on to a somewhat more complicated subject, with a variety of forms created in several different ways, using the Reverse Negative Shape Approach. The idea is to suggest a field of daisies almost entirely by the unpainted paper. The only part of a daisy you will actually paint is the yellow center. Use a ¾-inch sable for all but the smallest details.

Materials

Surface:
¼-sheet Arches 300 lb. cold-pressed paper
11″ × 15″ (27.9 × 38.1 cm)

Watercolor pigments:
cadmium yellow medium
cadmium red light
cerulean blue
Prussian blue
brown madder alizarin
burnt sienna

Brushes:
¾-inch and ¼-inch single-stroke sable
no. 8 round sable

STEP ONE

STEP TWO

STEP THREE

STEP ONE

Thoroughly dampen the upper two-thirds of the paper on a diagonal, leaving the lower part dry. Wash on a warm mixture of cadmium yellow medium and cadmium red light; then brush in some cerulean blue near the top. With a cadmium red light wash, develop the daisy shapes in the foreground by painting around them with your round brush. Then, in the middle ground, use a wash of cadmium red light with a touch of cadmium yellow medium to develop more flower heads with the Reverse Negative Shape Approach. When this dries, create the yellow centers with the point of your brush.

STEP TWO

To tone down the sky, rewet it with a mixture of brown madder alizarin and a touch of cerulean blue. In the middle distance on the left, suggest more flower heads by painting around them with brown madder alizarin, using a ¼-inch single-stroke sable. Also add a couple of diagonal strokes of cerulean blue to suggest the contour of the slope.

STEP THREE

The final wash is a combination of brown madder alizarin, burnt sienna, and Prussian blue. Visualize the trees at the edge of the meadow and paint around their forms. Use the darkest value of all, painted wet-on-wet, to suggest trees lost in the distance. Then use this deep tone to pick out a few areas behind the first group of trees for heightened contrast

Exercise Four: Work Wet-on-Wet

STEP ONE

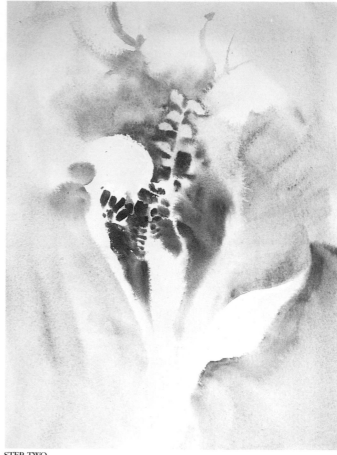

STEP TWO

Materials

Surface:
¼-sheet Arches 300 lb.
cold-pressed paper
11″ × 15″ (27.9 × 38.1 cm)

Acrylic pigments:
cadmium orange
cadmium red light
cerulean blue
Acra violet
raw sienna
burnt umber

Brushes:
1-inch and ½-inch
single-stroke synthetics

In this exercise use a wet-on-wet technique to develop forms with the Reverse Negative Shape Approach. Although I used transparent acrylic here, you can just as easily use transparent watercolor. Choose weed forms like the ones here, so you can place them right in front of you, instead of working from imagination. With the forms in front of you, it may be easier to create them on paper, although more difficult to allow the brush to move freely. The idea is not to be rigid while developing the forms—indeed, it's impossible to be rigid when working rapidly wet-on-wet.

STEP ONE
Wet the paper thoroughly with clear water, except for the lower right, where the light catches the sunflower head and the leaf. Then charge your brush with a mixture of raw sienna, cadmium orange, and a hint of cerulean blue, and wash this tone over the entire paper. While it's still wet, develop the shapes of the secondary weeds by painting around them with a darker mixture of Acra violet and burnt sienna.

STEP TWO
Still working wet-on-wet, using varying combinations of warm tones, develop the different forms in the background. Then mix a deeper value and define the left stem of the sunflower, the foreground leaf, and the ragged shape in the middle by painting around them with the Reverse Negative Shape Approach.

STEP THREE
Using the deepest value, made with burnt umber and Acra violet, further define the forms. For a change of pace, paint a few positive shapes in the lower right foreground. As a finishing touch, add cadmium red light accents on the sunflower head. Can you see how the success of this exercise, more than any of the others, depends on flowing brushwork and a flexible approach?

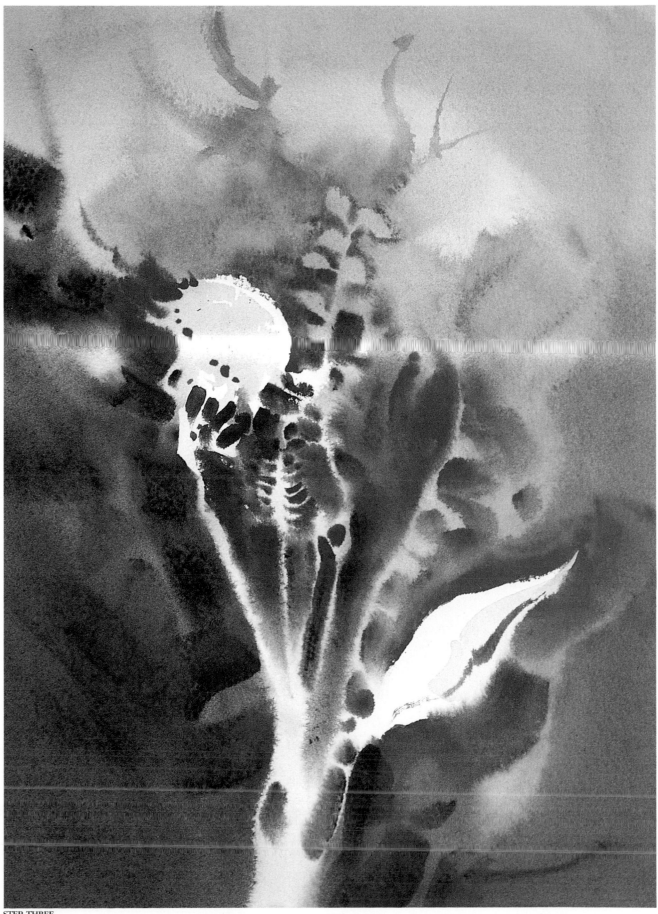

STEP THREE

73

Exercise Five: Paint Negative and Positive Shapes

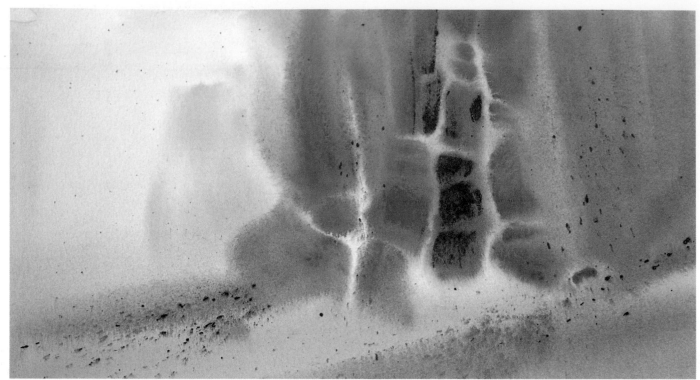

STEP ONE

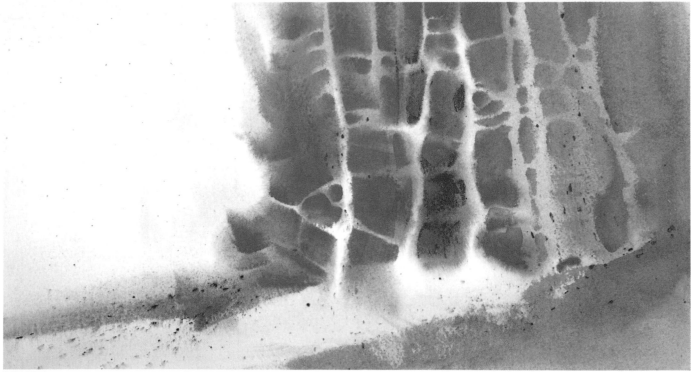

STEP TWO

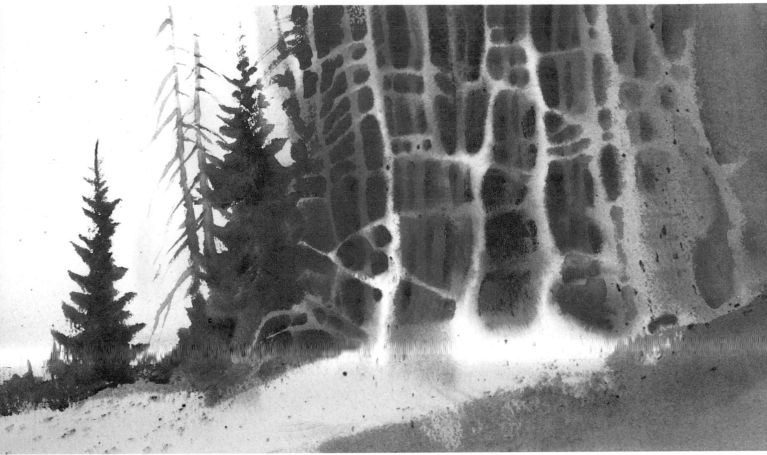

STEP THREE

Materials

Surface:
Arches 300 lb.
cold-pressed paper
8½″×15″
(21.6×38.1 cm)

Acrylic pigments:
cadmium orange
Acra violet
raw sienna
burnt sienna
burnt umber

Brushes:
1½-inch and ½-inch
single-stroke synthetics

This exercise shows how to combine a wet-on-wet Reverse Negative Shape Approach with the more usual method of painting positive forms to add variety and life. You will be painting entirely with transparent acrylic, limited to warm tones.

STEP ONE

Wet the entire sheet of paper thoroughly using a 1½-inch single-stroke synthetic brush. Begin with pale golden tones and gradually deepen them as you visualize and create tree forms by painting around them in a loose, impressionistic way. Add some directional spatter for texture before the paper is completely dry; then let it dry completely before beginning the next step so the first layer of acrylic color will not lift off.

STEP TWO

Rewet the paper and, with a somewhat deeper mix of the basic colors, create the secondary tree forms by painting around them. Vary the color mixture slightly for added interest as you work. Don't be rigid about where these trees are or how they look. Just constantly visualize and paint around the tree forms, letting the brush lead you from one form to the next. But watch both edges of your brush so you don't paint out the previously stated trees. Now let the paper dry.

STEP THREE

Using a mixture of Acra violet and burnt umber, paint the deepest darks around the most distant trees in the forest. With the same mixture, paint the positive forms of the spruces and dead spars on the left. The repetition of these darks through the painting adds interest, and combining forms created positively with ones done with the Reverse Negative Shape Approach keeps a fairly simple composition from being pedestrian.

Exercise Six: Combine Watercolor and Gouache

STEP ONE

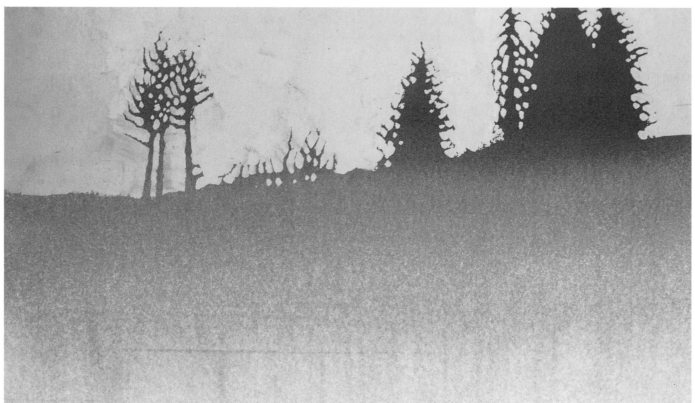

STEP TWO

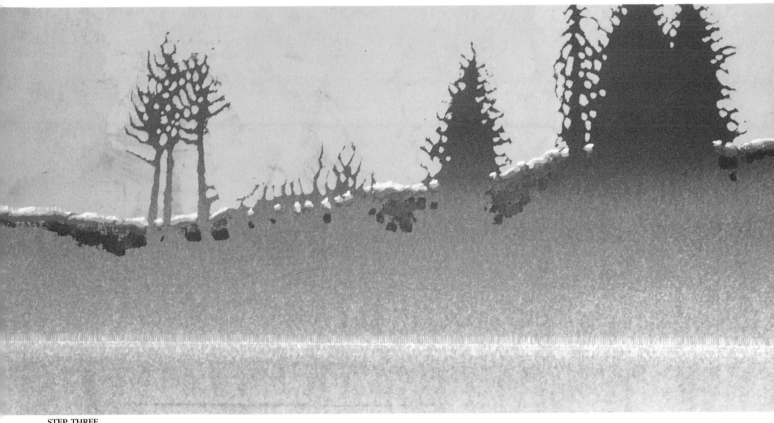

STEP THREE

Materials

Surface:
Arches 300 lb.
cold-pressed paper
5" × 11" (12.7 × 27.9 cm)

Watercolor pigment:
Prussian blue

Gouache pigments:
Prussian blue
raw sienna
burnt sienna
permanent white

Brushes:
2-inch squirrel hair
¾-inch and ¼-inch
single-stroke sables

This study of a winter evening uses one of my favorite combinations: transparent watercolor and opaque gouache. A graded watercolor wash creates a unique luminosity, ideal for light-filled sky or water. You can then use gouache, which is opaque but flows easily from the brush, for fine details.

STEP ONE
Tilt your paper at an angle and wet it thoroughly with a squirrel-hair or large wash brush. While the paper is still wet, apply a graded wash of pure Prussian blue. Make it very dark at the top of the paper, and gradually let it get lighter as you move down. Because the paper is at an angle, the tones fuse together easily. Then let the wash dry.

STEP TWO
In a good-sized container, mix Prussian blue and permanent white gouache. Using a ¼-inch sable, paint the light blue sky in a somewhat textured fashion. As you paint the sky, visualize the dark tree shapes and create them by painting around them with light blue gouache. Use the corners, tip, and edges of the brush to paint around the forms. Then let the paint dry.

STEP THREE
Now use a combination of burnt sienna, raw sienna, and permanent white gouache to suggest a distant ridge on the horizon. Then extend the tree trunks downward by painting around them with this warm deep color. Finally, for a touch of pizazz, mix raw sienna with a lot of permanent white gouache for the brilliant edge of the ridge. Because this is lighter than the sky color, it suggests moon-light. Again, you are painting the light through and around the tree shapes, enhancing their forms.

Exercise Seven: Experiment with Texture

Opaque acrylic and gouache can be handled like oil paint. This exercise exploits the juicy quality of these media, allowing you to brush in wonderful textures and over-lapping colors. This loose, spontaneous brushwork has a very impressionistic ap-pearance, and it can be used to good advantage with the Reverse Negative Shape Approach.

Materials

Surface:
Arches 300 lb.
rough paper
6″ × 18″ (15.2 × 45.7 cm)

Acrylic pigments:
cadmium red light
cadmium orange
Indo orange-red
red oxide
Acra violet
dioxazine purple
burnt umber

Gouache pigments:
cadmium yellow
cadmium orange
spectrum violet
ultramarine blue
permanent white

Brushes:
no. 8 and no. 12
synthetic brights

STEP ONE

STEP TWO

STEP THREE

STEP ONE

Start with acrylic paint and brush in the lighter oranges with a no. 12 synthetic bright. Apply the paint in a loose, impressionistic way, letting it slide this way and that as you play with color and texture. The plastic feel of acrylic takes some getting used to, but it is very durable and binds readily to other paints, making it ideal as an underlayer.

After this warm underlayer has dried completely, begin the sky area. Use a violet gouache mixture, made from ultramarine blue, spectrum violet, and permanent white. To create a scumbled effect, let the edge of the brush slide over the warm, dark underlayer. Vary the tone of the violet as you shape the trees at the right, painting around them.

STEP TWO

Continue to develop the tree forms, trunks, branches, and foliage. Don't just think of the tree forms themselves; also visualize the light coming through the forms and surrounding them. Now you are beginning to perceive both the forms and their relationship to the light. Notice how I constantly vary the violet tone of the sky as I work it around the forms.

STEP THREE

Using cadmium orange, cadmium yellow, and permanent white gouache, mix a very pale yellow and paint the horizon, extending the bottom of the tree trunks by painting around them. Then, with a very dark mixture of Acra violet, dioxazine purple, and burnt umber acrylic, freely brush in some positive shapes in the foreground to suggest vegetation, without too much definition.

Exercise Eight: Explore Flowing Forms

STEP ONE

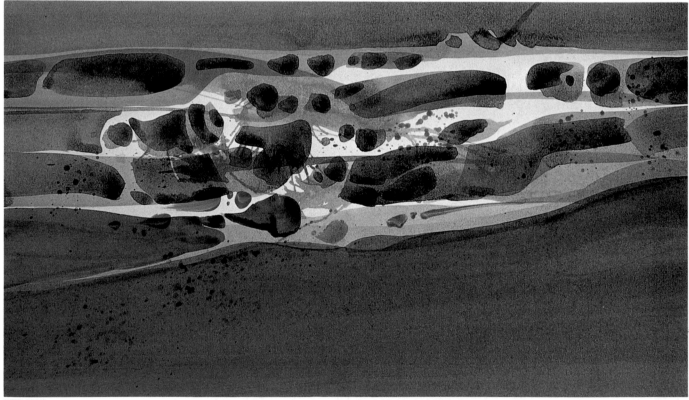

STEP TWO

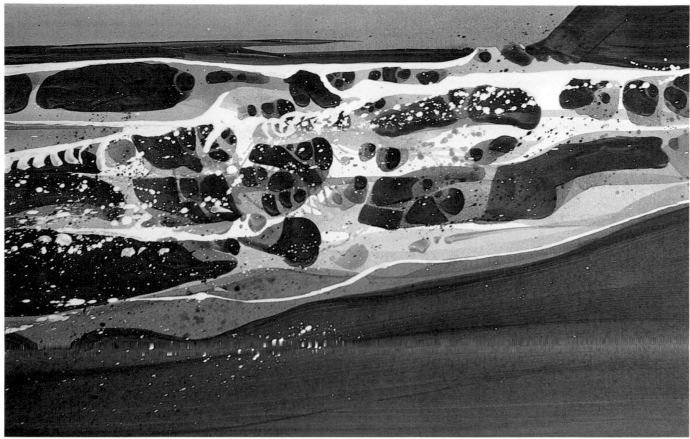

STEP THREE

Materials

Surface:
Crescent no. 100 cold-
pressed illustration board
8½″ × 15″
(21.6 × 38.1 cm)

Acrylic pigments:
Indo orange-red
Acra violet
phthalo blue
Hooker's green

Gouache pigment:
permanent white

Brushes:
1-inch single-stroke synthetic
no. 8 round sable

This is a good exercise to help you loosen up because the image is almost abstract and the forms are intuitive and flowing. You don't have to worry about creating particular objects. I've suggested working with transparent acrylic and opaque gouache on a smooth illustration board because, on this surface, acrylic behaves differently. It goes on easily, sliding around a bit before it sinks into the surface—in a way that is ideal for wave forms.

STEP ONE

Since this study is predominantly cool, give the underlayer some warm colors for interest. Apply a transparent wash of Acra violet acrylic to the dry illustration board. Then, before it has a chance to sink in, bend over it and blow on the wet color to produce interesting streams of warm color. (There's no other way to get quite this effect!) Now load your brush with Indo orange-red and tap it over the opposite hand to create a directional spatter. When these warm tones dry, wash on a transparent mixture of Hooker's green and phthalo blue acrylic in abstract, rhythmic strokes. Visualize interesting patterns suggesting waves, currents, and seafoam, and create them on the dry white paper with the Reverse Negative Shape Approach. Paint over some of the warm tones, but leave others to show in the completed study. Then let everything dry.

STEP TWO

The second blue-green mixture is a bit darker, but still transparent. It looks darker than it is because it is applied over an existing layer of color. Visualizing the positive shapes as you work, let the tip of the 1-inch single-stroke synthetic brush create small pockets of deeper color. Don't make painstaking little circles; instead, as you visualize the forms, let the brush take the lead.

STEP THREE

Mix somewhat more Hooker's green and phthalo blue for the final layer of color. Bring this very dark wash right up to the untouched white areas to create contrast. When this dries, change to a no. 8 round sable to apply opaque white gouache. Although you could use white acrylic, it is not truly opaque, so you would have to go over the same passage several times. No paint is more opaque than permanent white gouache, and because it washes out easily, you can use a good-quality brush instead of a synthetic one.

It may be difficult here to distinguish the areas of unpainted white paper from the areas formed by white gouache, but try to perceive the difference. Notice the small, jagged, dark shape at the extreme left, which has been created by painting white around the form.

Exercise Nine: Contrast Acrylic and Casein

This night-time study of a wharf begins with a very loose, free-flowing approach to provide an abstract background of vibrant color, with a variety of textures. The very opaque, dark casein used for the night sky is applied with the Reverse Negative Shape Approach so as to define the forms of the buildings, telephone poles, and moon. It's exciting to paint this way, and this exercise will show you the advantages of using two contrasting media: brilliant, transparent acrylic and matte, opaque casein.

Materials

Surface:
Arches 300 lb. rough paper
11″ × 15″ (27.9 × 38.1 cm)

Acrylic pigments:
cadmium yellow medium
cadmium orange
Indo orange-red
red oxide
Acra violet
dioxazine purple
cobalt blue

Casein pigments:
alizarin crimson
Shiva violet

Brushes/tools:
1½-inch and ¾-inch
single-stroke synthetics
single-edge razor blade
paper towels

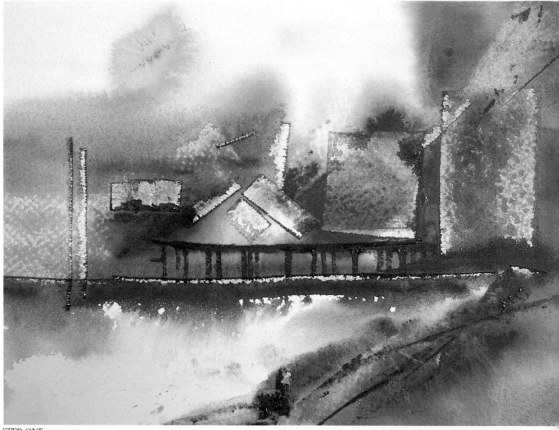

STEP ONE

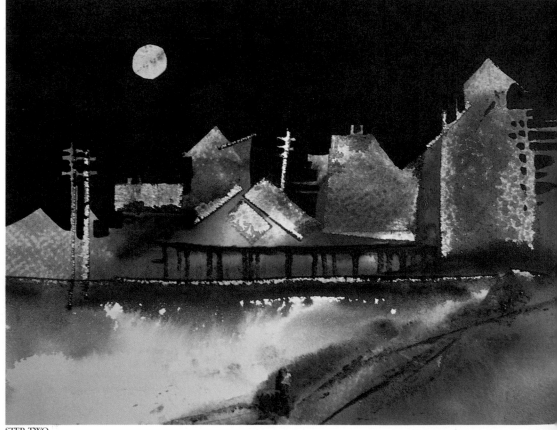

STEP TWO

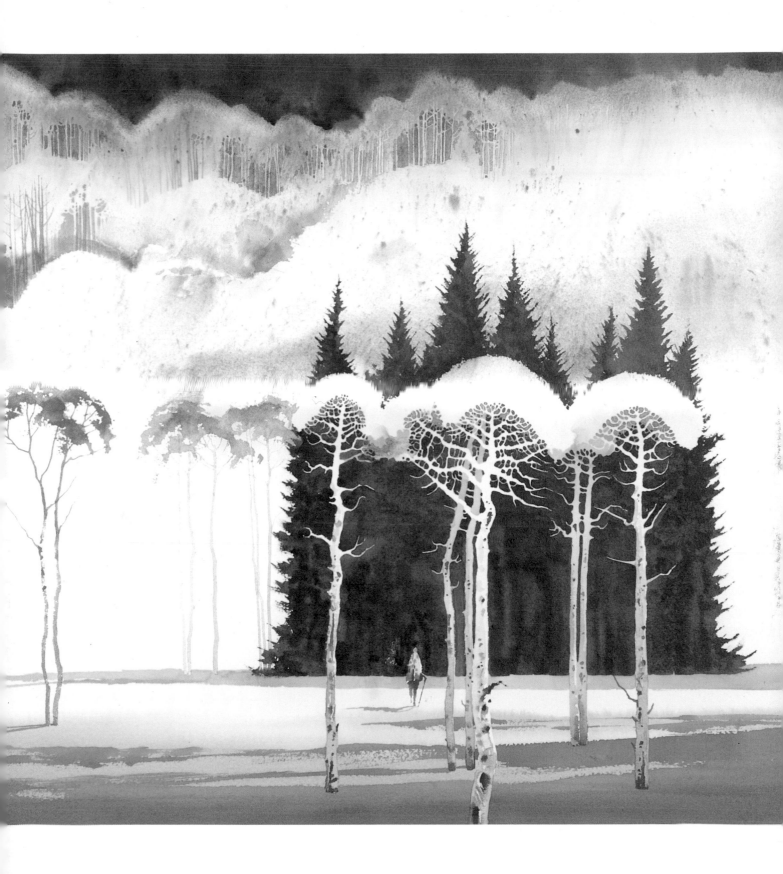

Playing with Color and Contrasting Media

EARLY SPRING, MINER'S CREEK

Acrylic and casein on Crescent no. 100
cold-pressed illustration board
36" × 26" (91.4 × 66 cm)
Collection of the artist

This painting is of the Colorado high country in March or April, when the spring run-off begins. It's a time of brilliant sunlight and intense shadows, of fresh snow and pockets of open water, of melting ice and the sound of rushing streams. It's a time when everything comes alive again, after being locked up and frozen all winter. At this time of year, I like to go out on location—using either cross-country skis or a four-wheel drive—and make sketches. Frequently these sketches have no meaning to anyone else, for they contain only a few suggestions of form, together with written notes on the side. But for me, they are packed with information.

In my sketches for this particular painting, I recall being impressed by the rocky area. The cliff face had a lot of interesting patterns, and I liked the way the fresh snow was held on the ridges. But equally important were the backlighting, the abstract pattern in the stream, and the rich shadows. I made a series of compositional sketches to simplify the scene and eliminate distracting elements, such as some tangled foliage in the left foreground.

Actually, after all this preliminary work, I really used the subject as an excuse to paint. I wanted to have fun playing with the color and contrasting the transparency of brilliant acrylic with opaque casein.

The first stage of this painting was done entirely on an easel, which is very unusual for me. I stapled the illustration board to a sheet of plywood and put it on my easel, with a pile of towels on the floor beneath. Then I saturated the board four or five times with clear water. With a 3-inch squirrel-hair brush, I applied acrylic paint, using cadmium red light, Acra violet, and Indo orange-red in differing proportions and letting the paint run down the board. While the surface was still wet, I splashed on some Hooker's green and phthalo blue, which melted into the warm colors and neutralized them in some areas. After the board was totally dry, I used a 1½-inch single-stroke synthetic to spatter the original colors and add energy to the underpainting. While this was drying, I studied the upper areas to determine which areas held the greatest excitement, as I intended to make use of these when creating the background spruces.

In a baby food jar, I mixed titanium white, cerulean blue, and a touch of Shiva violet casein, stirring it for about fifteen minutes to make sure the color would have no streaks. I added only a little water to the mixture so the paint would be quite thick and give the brushy effect I wanted in the spruce branches. Using a no. 16 synthetic bright, I painted the light blue sky area and created the spruce trees by painting around them with the Reverse Negative Shape Approach.

Next, using a mixture of Hooker's green and phthalo blue acrylic, I painted the large, dark spruces with a positive approach. I painted them carefully in the upper section but more loosely in the lower area, as their outlines would later be defined by the snow and shadow color, using the Reverse Negative Shape Approach. Then, before beginning the rock face, I referred to my initial sketch to choose the appropriate casein colors for the rock patterns. I placed a hint of sunlight on the grass at the upper edges of the cliff. The forms of the spruces on the right were developed in greater detail with the Reverse Negative Shape Approach, using the appropriate background colors in casein. I painted around the bases of the spruces on the left first with blue, then picked out the sunlit areas on the far bank with pure titanium white.

At this stage, the lower part of the painting showed only the warm color of the first acrylic wash and roughly blocked-in areas of dark green to suggest the shapes of spruces. In the area where the pool of water was to be, I began developing the reflections in a loose, impressionistic way, using a deep blue-green acrylic mixture to suggest the reflections of background trees. When this dried, I added the casein colors used in previous passages to suggest additional reflections. I made no attempt at being literal or accurate.

Next, I mixed a large quantity of cerulean blue and white casein for the middle bank and refined the outline of the spruce on the left with the Reverse Negative Shape Approach. Pure titanium white casein was used to suggest the sunlight on the bank and to further develop the lower branches of the spruce on the right, again using the Reverse Negative Shape Approach.

As a final touch, I painted the small spruce in the middle distance, using the conventional positive approach and working entirely in casein. Highlighting the left side of the tree added a touch of sparkle to the somber face of the cliff and also gave an impression of depth.

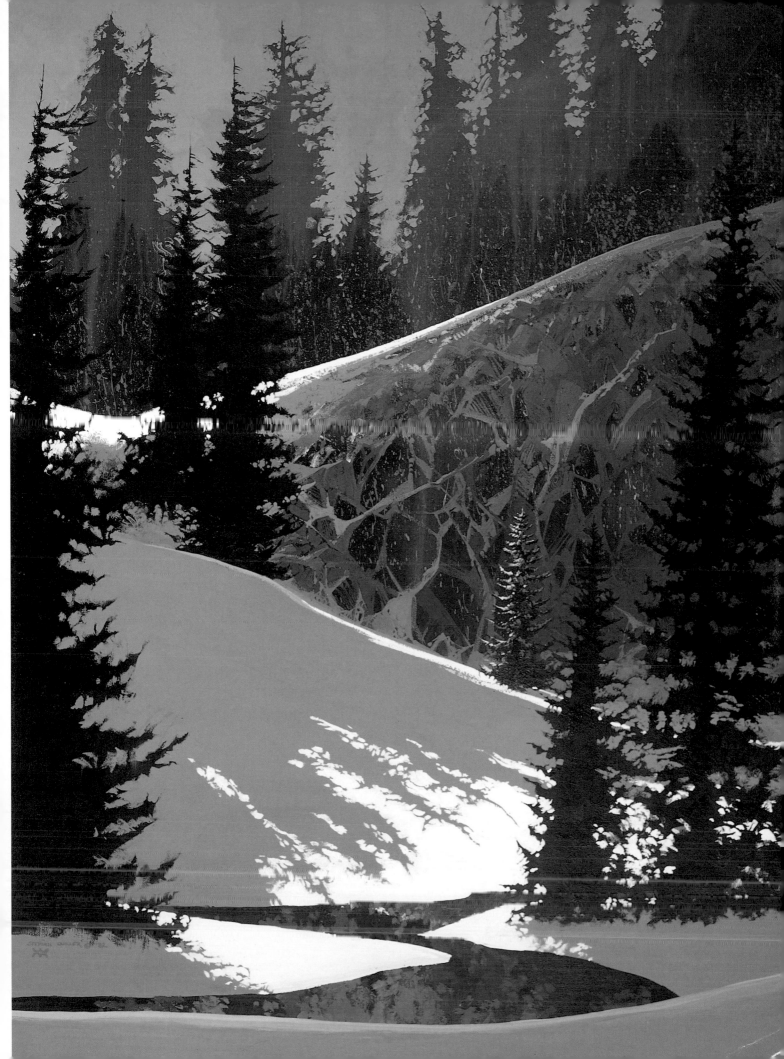

Creating a Warm, Peaceful Scene

AUTUMN FIELD PATTERNS, VALDEZ

Acrylic and casein on Arches 500 lb. rough paper
22" × 36" (55.9 × 91.4 cm)
Collection of the artist

This painting was based on a sketch I made in November, my favorite time of year in the lower Rio Grande Valley. The colors of the countryside were absolutely incredible. I was on a ridge, north of Taos, looking down on plowed and fallow fields, hedgerows and irrigation ditches, orchards and pastures, all spread out under the warm winter sun. When I finally sat down to draw, I noticed the group of sheep and heard the faint tinkle of a bell. This peaceful scene, with its warm colors and interestingly patterned fields, made a powerful impression on me, which I wanted to convey in paint.

To convey the warm feeling of my experience, I first washed on a warm orange undertone of transparent acrylic. While I gave the lower area an even wash, I painted the upper area in an uneven way to suggest the shapes of the cottonwoods. While this was very wet, I rapidly painted around the lighter tree forms using a 2-inch synthetic brush. Then, changing to a ¾-inch single-stroke synthetic and using a darker, transparent acrylic mixture of burnt sienna, Acra violet, and dioxazine purple, I visualized the trees with greater precision and again painted around them with the Reverse Negative Shape Approach. At the same time I blocked in the willows of the hedgerow in the middle background, keeping the forms very loose and painting wet-on-wet.

After all this acrylic paint had dried, I shifted to casein for the rest of the painting. Using a mixture of raw sienna, cadmium yellow medium, titanium white, and a bit of burnt sienna, I painted the farthest horizontal field, between the distant cottonwood trees and the hedgerow. By painting around the hedgerow with this golden color, I defined the willow shapes, which had already been roughed in with the dark acrylic. When this had dried, I added opaque lime green and a touch of violet at the base of the hedgerow and cottonwoods, plus a line of cerulean blue to suggest a distant stream.

I then began to concentrate on the field patterns. A casein wash can be graded from opaque to translucent simply by adding more water—which is what I did in the large field to the right, using a mixture of terra verte and titanium white with a faint hint of Shiva violet. You can see that it is more opaque at the top and gradually becomes more and more translucent toward the bottom. To suggest the dry stubble of the field, I applied an opaque mixture of titanium white and raw sienna with a drybrush technique.

The remaining field patterns were underpainted with the complement of their final color. The yellow field on the left, for example, was given a preliminary wash of translucent violet casein. Having the complement of any color glimmering through the surface enriches the effect.

The truck became a lesson in patience and perseverance. I painted it over three times. Fortunately, this is one of the many virtues of casein: painting over is very easily done.

To paint the sunlit parts of the figure and the sheep, I used a mixture of titanium white and raw sienna, and then added Shiva violet to this mixture for the shadowed areas. They were handled simply to fit in with the rest of the painting. Finally, I carefully added the delicate branches, as well as the posts and their shadows, using opaque casein.

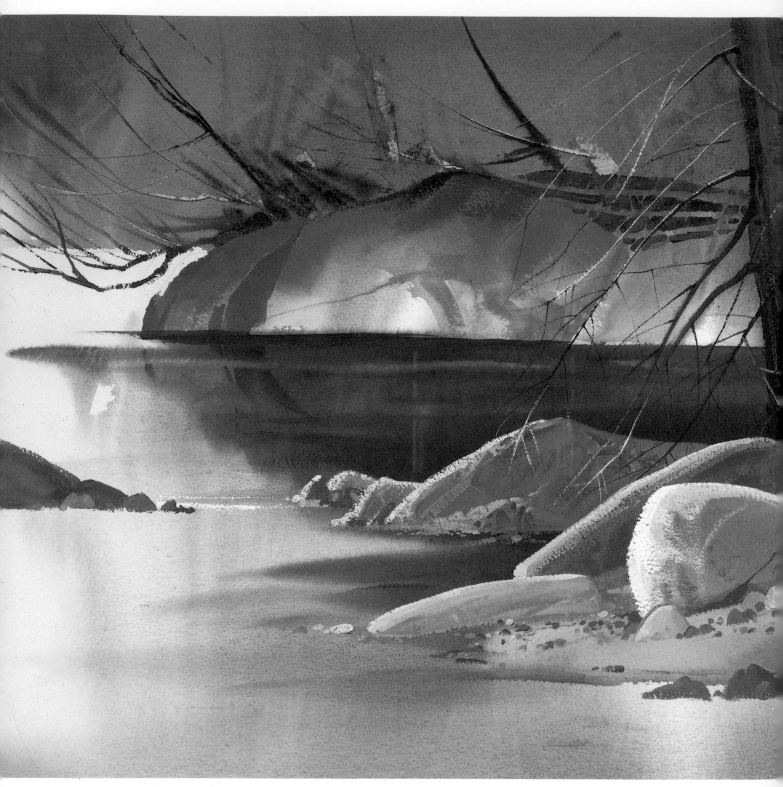

NORTH CLEAR CREEK POOL

Acrylic on Arches 300 lb. cold-pressed paper
21" × 27" (53.3 × 68.6 cm)
Collection of Charles and Nancy Wallick

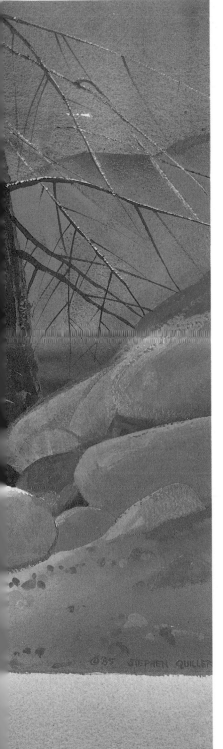

PUTTING IT ALL TOGETHER

The twelve finished paintings in this chapter have been selected to illustrate the different points discussed in the previous two chapters. Obviously, the success of each painting depends on more than one thing, but for the purpose of clarity, I have emphasized only one.

Each painting is presented differently, and there's a good reason for this: there is no one set formula, no single rule that will guarantee success. Some of my paintings have been carefully planned through a sequence of sketches and color and value studies, while others have developed more intuitively and spontaneously.

Each painting also uses a different water medium or combination of water media. One uses only transparent watercolor; another combines watercolor with gouache. Casein is used alone, as well as in combination with acrylic. Watercolor has also been used in a collage made with rice papers. Each medium or combination of media has been selected because it is best suited for the subject.

The themes for these paintings come from three areas: the San Juan mountains of southern Colorado, northern New Mexico, and the Oregon coast. These areas offer me great variety in subject matter, and it's clear how these different areas influence my painting. I've always contended that where you live will influence you and that there's little to be gained by trying to impose your will on your surroundings. Instead, you must accept that your environment will dominate you and change your paintings as well.

In the mountains, my compositions are frequently vertical and seldom have a horizon. As snowy winters last seven months, my palette contains many shades of blue. There is also the enchantment of moving water, brilliant sunlight, and intense value contrasts.

In New Mexico, my compositions seem to be mostly horizontal. Because I enjoy looking down on the fields, my compositions have a more Oriental, bird's-eye perspective. I'm interested in the patterns created by the irregularly shaped fields, as well as by the great clumps of cottonwoods and willows that dot the landscape. The clarity of light and intensity of color unique to this area are also of immense importance.

By contrast, the seascapes of the Oregon coast are muted with mist and fog. Here I am more concerned with atmospheric effects, with the way objects became paler and paler, until finally they are lost in the distance. This loss of focus contrasts with the textured details and sharp value contrasts in the foreground, which may show rocks, tidal pools, sea grass, or a pebbled beach. I frequently make use of diagonals in these coastal compositions.

While it's obvious that I'm the artist who did all these paintings, each area has imposed its demands on me and each has required a different type of handling. Being aware of the unique qualities of each area, of the individual differences, prevents me from falling into a repetitive formula. Otherwise, I would be bored, and the resulting paintings would be boring.

Developing Positive and Negative Space

On a fishing trip with friends, I admired the stillness and the beautiful reflections in Poage Lake. The dead spruce trees in the water and along the bank created interesting patterns against the dark mountains and the light sky. Then, as the light faded, the tree forms became ghostlike and gave an eerie feeling to the landscape.

A couple of days later, I returned with a friend to do some sketching. I made a pencil drawing (Study 1) for reference, in which I concentrated on the forms of the spruces and their tangled branches, and how they created interesting positive and negative spaces. Then I made another rough drawing in my sketchbook and decided to lengthen the format. I followed this up with an hour's worth of painting on location.

On location I like to use acrylics because they are so versatile and can be used from transparent to opaque. This helps me make decisions. Moreover, if it starts to rain, it won't harm the painting. I thus did a loose, acrylic sketch on location (Study 2), using the long format. The relationship of the positive and negative elements were uppermost in my mind as I concentrated on light, middle, and dark values.

Back in the studio, I cut my paper to the proper size and laid a transparent acrylic wash of Acra violet over the entire sheet. This wash, although only apparent in its full strength in small pockets along the skyline, suffuses the entire painting and creates the effect of trans-

parent evening light. My limited palette of greens, reds, and soft violets was selected to give the feeling of evening.

After the first acrylic wash dried, I applied a mixture of alizarin crimson and cadmium red light casein to the middle distance, using a 1½-inch single-stroke synthetic brush. While this was wet, I used a coping saw blade to create texture. Later, when this had dried, I mixed a middle value of violet and burnt sienna casein and loosely brushed in the forms of the dead spruces. The trees on the right were painted in the same loose way with a dark value, made from terra verte, burnt sienna, and Shiva green casein.

After everything had dried, I defined the forms by painting around them with the Reverse Negative Shape Approach. I used a dull green for the background forest, where the dead spruces were light against dark, and a pale violet tone for the sky, where they were dark against light. I then wet the water area before painting in the violet tones; the reflections were made with a dry brush.

During the entire painting process, I focused on the relationship between positive and negative spaces—how the trees broke up the space and formed pockets with the overlapping branches, how the lighter and darker forms broke up the area at the water's edge, and how the tops of the dead spruces broke into the negative area of the sky. The patterning of these positive and negative areas is what generates excitement in this painting.

POAGE LAKE

*Acrylic and casein on
Arches 300 lb. rough paper
17½" × 30" (44.5 × 76.2 cm)
Collection of the artist*

STUDY 1

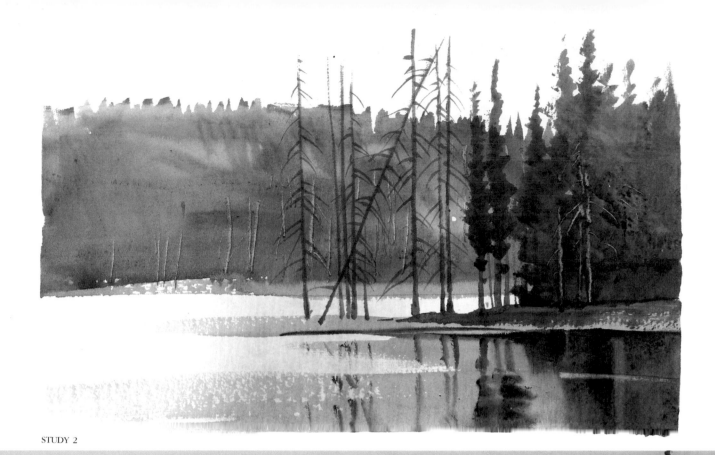

STUDY 2

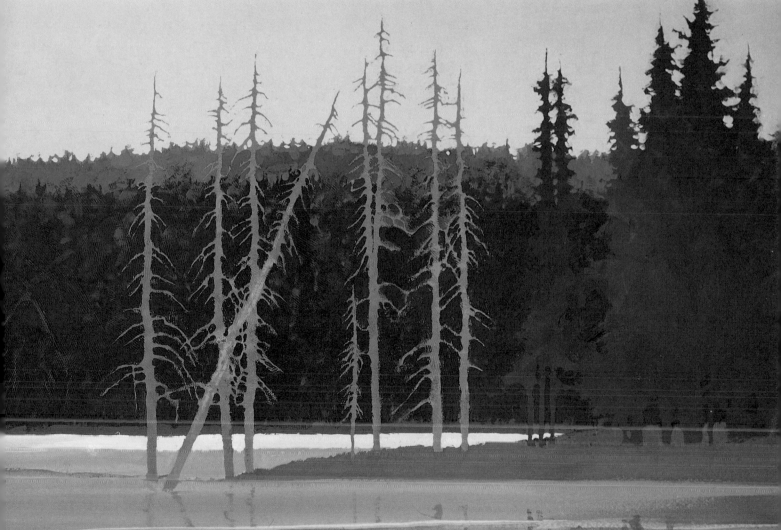

Making Use of Preliminary Studies

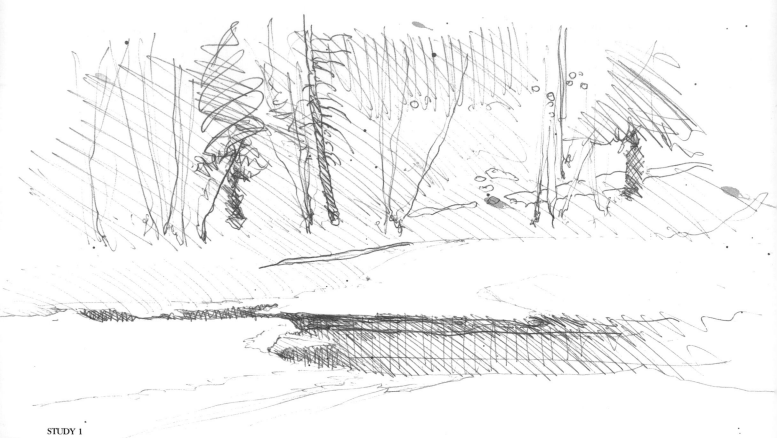

STUDY 1

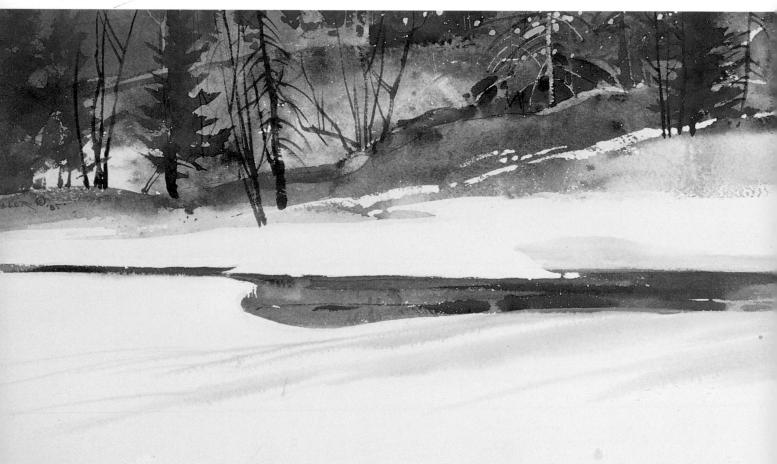

STUDY 2

Although some of my paintings use a more intuitive approach, usually I develop a painting through several preliminary studies to make certain that the original idea comes across in the best possible way. Here my subject was a river in southern Colorado in late winter. I was driving along, "resting my soul," when I approached a small bridge. To the left, water was visible here and there between the snow and ice, and I noticed the sharp contrast between the brilliant sunlight and the dense shadows. Something about the simplicity of the scene—the movement of the water and the rhythm of the dark shadows—affected me. So I took out my pen and made a sketch on the spot, recording the scene in a very calligraphic way (Study 1).

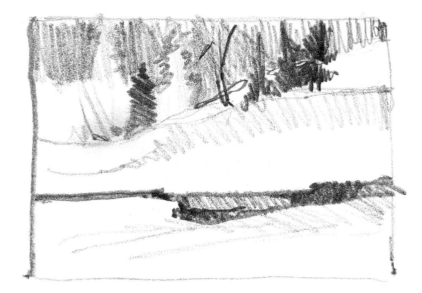

Often my first sketches are meaningless to anyone else, but they serve to set off a chain of memories and associations when I look at them later. Here the small circles indicate pockets of light to me. Notice the area in the middle, where the lip of ice and snow hangs over the water. I knew I would want to emphasize this, so I drew it more precisely and with greater contrast of values.

I then did a very loose, impressionistic color study in transparent watercolor and gouache (Study 2). Somehow all the spatters helped create the character and texture of the trees and the sunlit background. Looking at this color study and my initial sketch, I began to get a clearer idea of the direction I wanted to take. The composition, however, needed some editing, so I made a series of thumbnail sketches (Study 3). Each of these sketches suggested a different painting possibility, but I decided on the one at the upper left because it emphasized the movement from right to left and contained more character in the background.

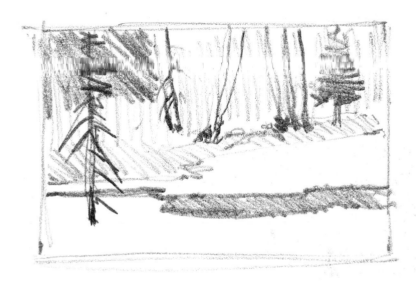

All this preliminary work enabled me to visualize the painting more clearly and to decide on the media I would use. I chose acrylic for its rich color and contrasting values, combined with casein because of its flowing capabilities, as well as its opaque and translucent visual qualities. After stretching my paper (see page 114), I placed it upright on my easel with the sketches and the color study nearby. I did not intend to copy these preliminary studies, because I know copying can make a painting look dead. Instead, I referred to the studies occasionally, but essentially I let the painting have its own way. There are many differences between the final painting and the studies—differences that occurred during the painting process and add a fresh quality to the work. Spontaneous interaction between the artist and the painting is an essential ingredient of success.

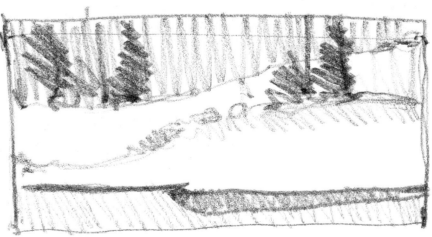

STUDY 3

Making Use of Preliminary Studies

I began by saturating the paper with clear water and washing on acrylic colors. As they flowed down the paper, the transparent darks and lights created different forms and movements, which I made use of. While the paper was still damp, I used dark violets to define the spruce forms at the upper left with the Reverse Negative Shape Approach. After this had dried, I continued to develop the background trees, using lights and darks, working both positively and with the Reverse Negative Shape Approach.

I then changed to casein for the translucent and opaque snowfields. Using a mixture of titanium white, cadmium orange, and cadmium yellow medium, I painted the sunlit ridge in and around the spruce trees on the right. Immediately in front of these trees I created a transition between the transparent acrylic and the opaque casein by casting a translucent casein veil of cobalt blue and titanium white over the acrylic underlayer, followed by an opaque streak of light blue closer to the base of the trees.

Finally, using titanium white, cadmium yellow medium, and cadmium orange, I painted the foreground very opaquely and added the lavender shadows. Because these shadows were painted wet-on-wet, their edges became soft and blurred, as they are in nature.

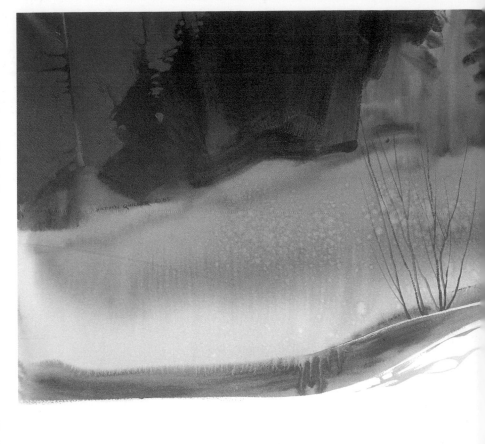

WINTER: CONEJOS RIVER

Acrylic and casein on Arches
140 lb. cold-pressed roll paper
35" × 55" (88.9 × 139.7 cm)
Collection of Diane Willeford

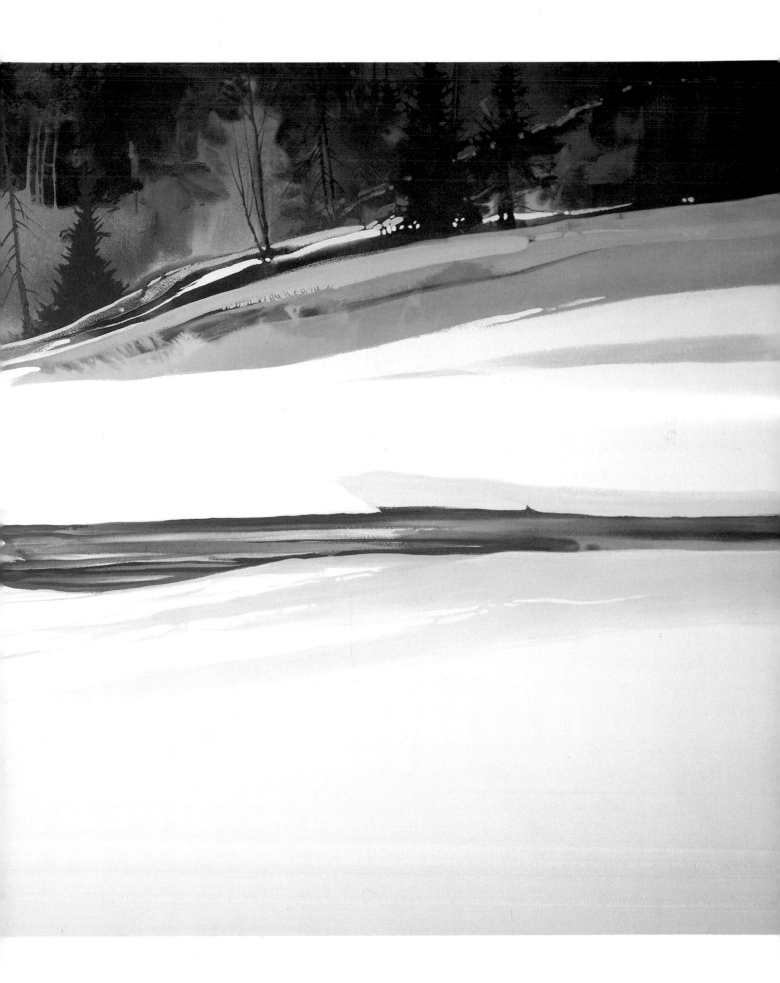

Choosing an Unusual Format

There are several reasons why water media artists stick to the traditional sizes. First, it is economical and thrifty to use a quarter, half, or full sheet of watercolor paper. Also, frames and mats are pre-cut to these sizes. But, by restricting yourself to certain proportions, you may cut out a lot of opportunities. I've learned that there is always one, and only one, ideal format for expressing what I want to say; this painting is an extreme example.

Already in my first sketch (Study 1), I used two pages of my sketchbook, as I felt the need for horizontal extension. There was a stillness and restfulness to this warm, hazy scene that I wanted to catch. I was particularly interested in the rock forms and the jetty projecting into the ocean. Notice the small cluster of buildings at the bottom of the sketch, which I repositioned in the final painting.

A year later, I came back to this subject and did another quick sketch, adding a rock in the left foreground, some driftwood, and the shape of the dune on the right. I then did a compositional study, using a brown brush pen on two pieces of paper taped together to create the long, horizontal format I wanted (Study 2). Notice how the rock on the left projects above the jetty to suggest depth and how the soft diagonals of the driftwood lead the eye through the composition.

For my value study (Study 3), I used black and sanguine conté crayons, which can be dragged flat across the paper to create halftones and are thus ideal for suggesting a hazy atmosphere. The ends of the crayons can be used for intense darks, as you can see in the rock forms.

I measured this final value study to calculate the proportions of my larger painting, and then cut my paper to size. Because I chose a 72 lb. paper, I had to soak it in the tub about half an hour, blot it, and then staple it to a plywood board to prevent buckling. But I especially wanted to use this paper because its warm undertone would shine through the watercolor and gouache, lending a feeling of unity and helping to create a warm, hazy atmosphere.

After rewetting the paper, I washed on a transparent watercolor mixture of burnt sienna, cadmium red light, and cerulean blue for the sky area, leaving lots of paper untouched. When this had dried, I penciled in the rock, jetty, and building forms. Then, for the jetty, I used a wash of the same colors as the sky—slightly warmer but still very transparent to suggest the haze. With a somewhat deeper mixture of these colors, I painted the shadow side of the buildings, roofs, and telephone poles. I let this dry before using a translucent application of permanent white gouache for the sunlit side of the buildings. I also painted around the windows to suggest some architectural definition, but I kept the

STUDY 1

STUDY 2

STUDY 3

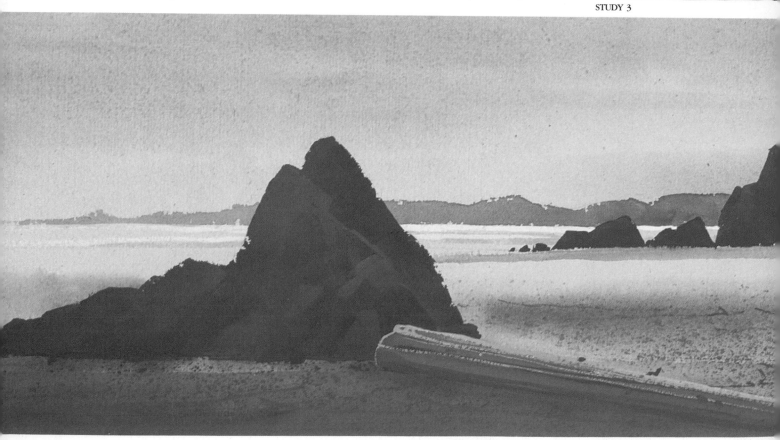

98

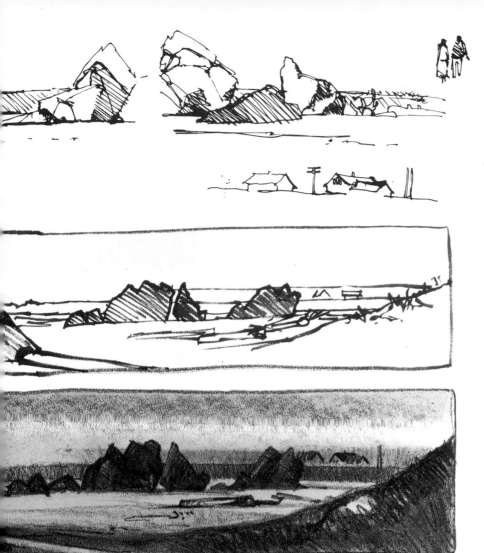

treatment soft, so it did not come forward too much.

When this was dry, I used an opaque mixture of burnt sienna and ultramarine blue gouache to paint the rocks to the left of the buildings. By making these forms more solid, as well as warmer and darker, I pushed the buildings into the distance. Then, for the beach area in the middle and the driftwood, I used transparent watercolor. The light reflected from the water was painted with opaque white gouache. It added a sparkle to the subdued scene and, because it was lighter and brighter than the houses, served to push them back.

Finally, working on wet-on-wet, I painted the rock form on the left with opaque gouache, in a more detailed fashion than the rocks in the middle distance. The right bank and the foreground log were then simply stated in opaque gouache. For finishing touches, I used a series of light watercolor washes and a light spatter for texture.

The result is a scene of peaceful serenity, and the long, horizontal format is the key to this effect.

COASTAL HAZE

Watercolor and gouache on
de Wint 72 lb. beige-toned paper
7¾" × 29" (19.7 × 73.7 cm)
Collection of the artist

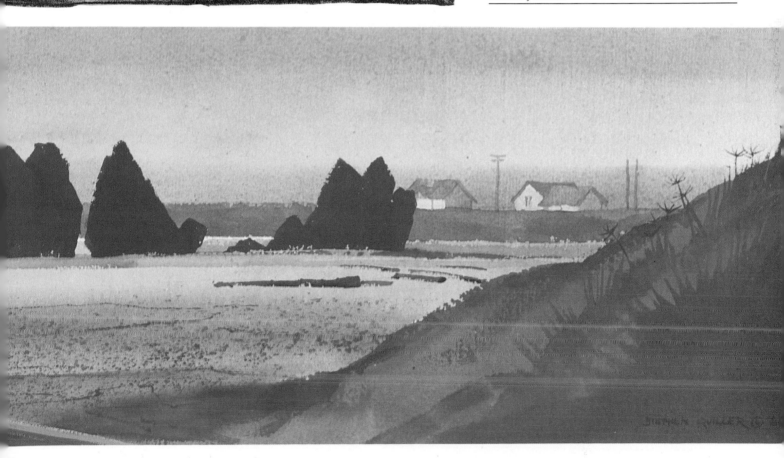

Developing Overlapping Forms

Creede, Colorado, is located at the mouth of an unbelievable gorge, with precipitous rock walls on either side. Mining structures can be seen everywhere up and down this narrow canyon. It seems incredible that human beings once clambered up the vertical walls.

My sketch of one of these mines (Study 1) describes the forms of the buildings with enough detail to reveal their structure, yet it still gives me freedom to express my feelings about the subject. The forms of these buildings have been dictated by function, not aesthetics. Although the trestles connecting the upper building to the slope create exciting shapes, they were designed, not to delight the eye, but simply to carry ore in and out.

To clarify the pattern of overlapping forms that intrigued me in this scene, I've included a diagram (Study 2). Anytime there are overlapping forms, there is an illusion of depth. Overlapping forms are, by definition, connected; they are not isolated shapes. And because they are connected, they create a pattern of movement, which can lead the eye around the composition.

In my painting, I wanted to emphasize the feeling of depth created by the overlapping forms of the buildings, as well as the movement from front to back set up by the diagonals of the overlapping landforms. To accentuate these forms, I decided to use contrasting values and limited my palette to two colors: Prussian blue and brown madder alizarin. I also wanted to capture the clear, evening light, so I chose watercolor.

Because the architectural forms had to be quite precise, and also because I wanted a few white areas for the roofs, I made a careful line drawing on the dry paper first. Then, with my paper propped up about 4 inches, I saturated it with clear water, leaving the white areas untouched. I mixed a large batch of Prussian blue and washed it over the wet paper. While this was still wet, I washed in some areas of brown madder alizarin to lend warmth to the buildings and the foreground. After this dried, I washed in the darker blue of the distant mountain and then developed the upper building using shades of blue.

Essentially, I completed the painting by moving forward in the composition. Note that I made the left corner of the foreground building darker, so it would stand in front of the pale area. The other corner of this building was next to a dark area, so I made it lighter. To avoid drawing too much attention to the rubble in the foreground, I kept the values relatively close and simplified the patterns. At the same time, however, I repeated the diagonals of the overlapping landforms in this passage, which adds to the overall unity.

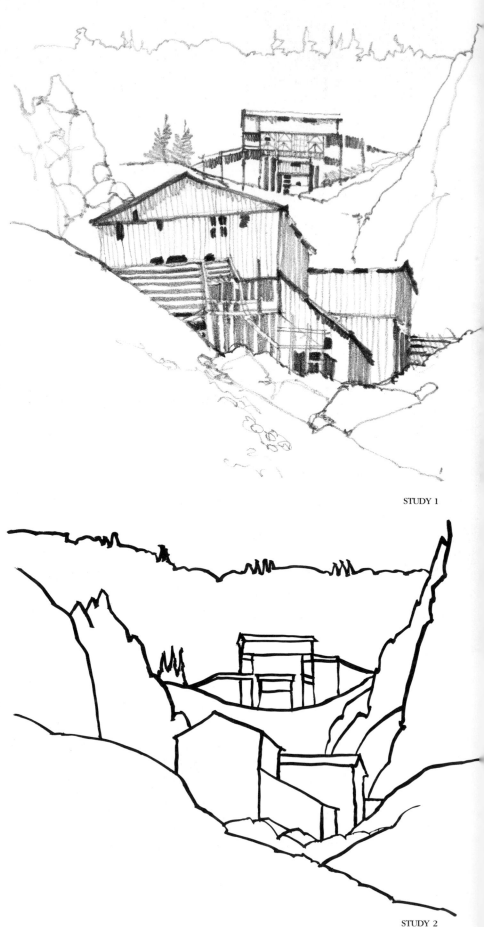

STUDY 1

STUDY 2

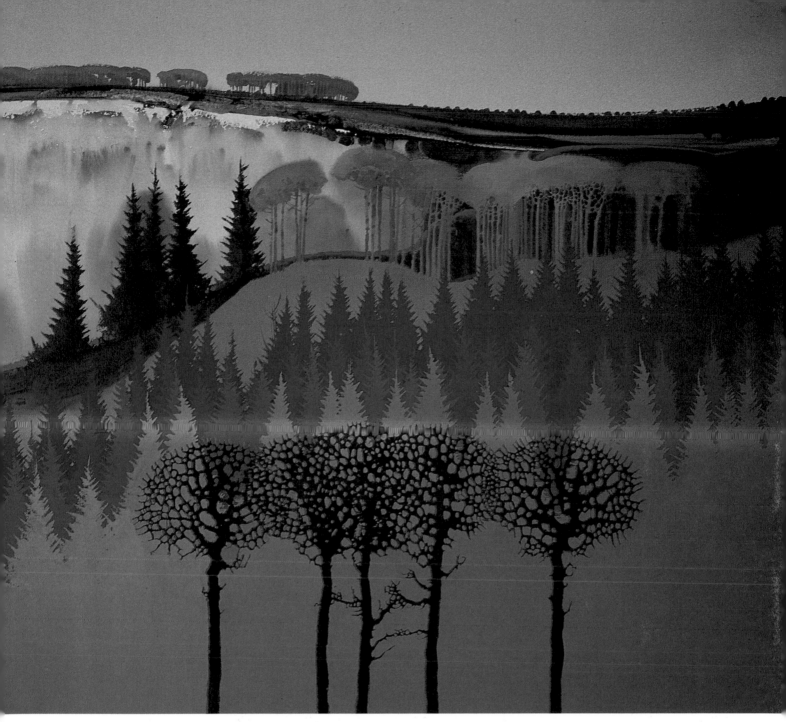

THUMBNAIL SKETCHES

Working with a Geometric Motif

It was a warm September day in the high country of Colorado, after the first frost had bronzed some of the foliage, and there was a smell of dead leaves in the air. Driving along a steep mountain road, I looked down into a small canyon and saw this view. From my bird's-eye perspective, the slanting trees, the rocks, and the moving water made a very interesting composition. So I stopped the car and made a quick pencil sketch (Study 1). Although this sketch indicates my interest in the pattern of the water cascading over the rocks and in the angles formed by the not-quite-perpendicular trees, there is very little detail. I had good reason for this: I find that too many details in a sketch tend to inhibit my creative process.

Back in the studio, I made a thumbnail sketch (Study 2), in which I resolved the problem of format and created a series of diagonal and triangular shapes to project the energy I felt in the scene. In the diagrammatic drawing shown here (Study 3), you can see the geometric motif of triangles and diagonals more clearly. Notice that there are large as well as small triangles, overlapping and intersecting one another.

My preliminary sketches helped me decide on a long, vertical format to emphasize the diagonal movement and convey the energy of the stream and the mountains. The trees were not truly vertical in the canyon, and I decided to make them even less so in my painting to

STUDY 2

STUDY 3

exaggerate the sense of movement I wanted.

I began by soaking my paper in a tub of water for about an hour before stapling it to a board and allowing it to dry overnight. While this is a bit of a nuisance, I find it worth the trouble, as this paper responds so well to washes. As it is a rolled paper, very large sizes are possible; it also stores easily.

My initial wash was a warm tone of transparent acrylic—a tone I wanted to suffuse the entire painting, conveying my response to the warm September day and autumn colors. It is a real advantage to be able to tone paper with acrylic washes in any shade you desire. You're not limited by the color of a particular paper, and the acrylic color will not lift off, once dry.

I developed this painting by working wet-on-wet from the background to the foreground, doing some scraping, and establishing the darks and lights as I progressed. Each diagonal I put in formed yet another triangle. I had intended to leave the right foreground bank as an empty space, a kind of "rest area." Although I did not want to use the foreground tree shown in my original sketch, there was a definite need for something more on that right bank. So I painted in a tree, making it smaller and moving it to the right. This improved the balance and formed yet another triangle. At the very last, I sharpened the central white trees with white casein. These two verticals gave a needed stability to the composition.

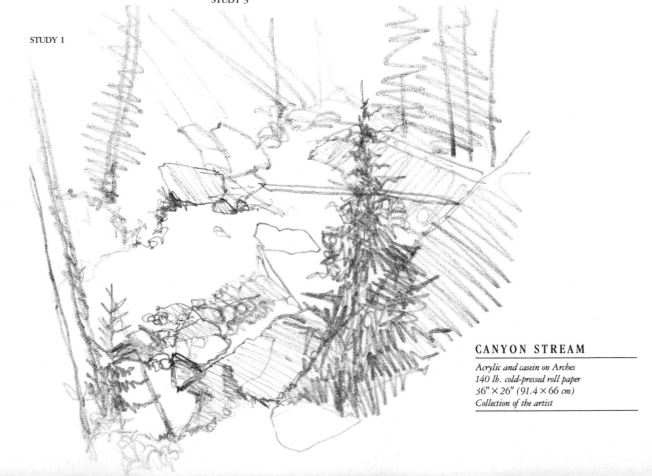

STUDY 1

CANYON STREAM

Acrylic and casein on Arches
140 lb. cold-pressed roll paper
36" × 26" (91.4 × 66 cm)
Collection of the artist

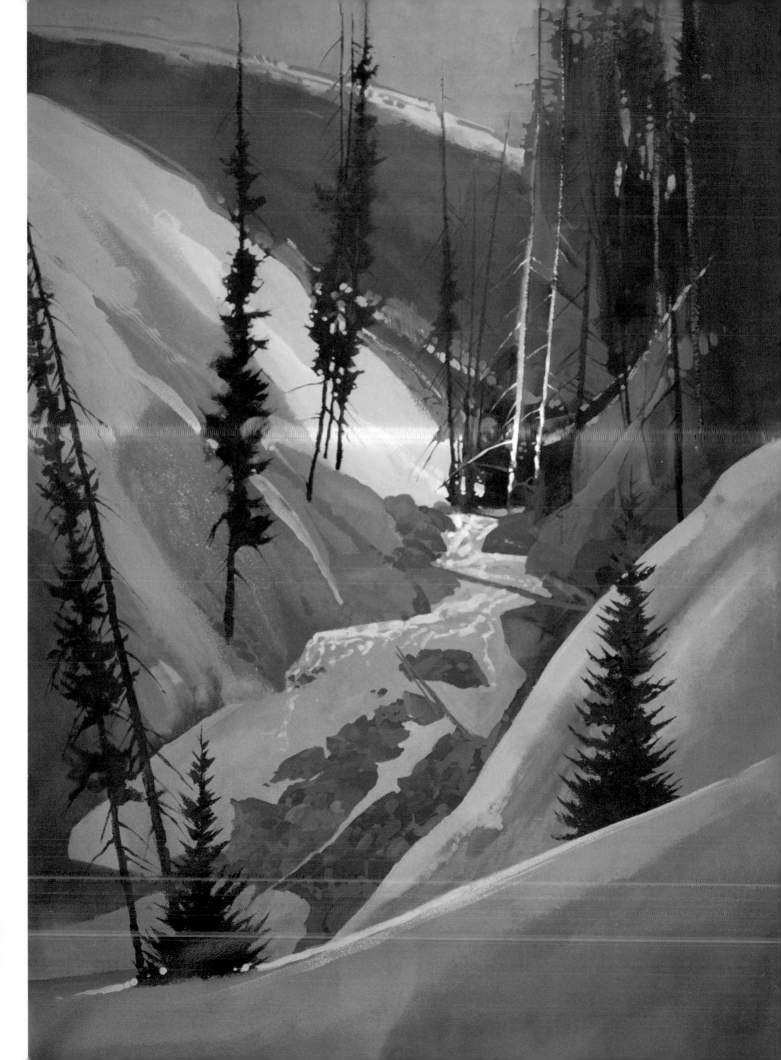

Unifying the Picture Space

Autumn lingers in the Taos valley. Even in November the colors are rich and varied, with many different ochers and umbers, as well as some greens left in the field. And it was on a November afternoon that this view appeared, as I was driving along near the farming community of Dixon. I wasn't really looking for any particular subject, I was just perceiving the landscape in the unfocused way of seeing the Indians call "soft eyes." I wasn't forcing anything, but rather just "let it come."

I parked my car near an apple tree and made a sketch on the spot (Study 1). It was a warm, still afternoon, and the silence was so intense you could hear it. This was the feeling I wanted to capture.

As I was drawing, I thought about the changes I would make to intensify the feeling of warm stillness. At the top of my sketch, I noted that, while the sky was a light blue, I wanted to darken it in the painting, to hold the eye in the composition. There was a house in the distance, which I knew would be distracting, so I left it out. I also knew that the silver trailer in the foreground could be converted into a fine adobe house.

In the diagram (Study 2), you can see how I organized the picture space so all the various parts of the painting fit together as in a jigsaw puzzle. The variety in the size and shape of the pieces makes for an interesting puzzle. There is also, however, a continuity to the shapes, and there are not so many different shapes that the composition becomes busy. Each shape is quietly and independently important to the final painting. You can also see a series of soft diagonals, repeated through this composition, which creates an easy movement.

In the completed painting, notice the rectangular shapes between the willows in the hedgerow. These small visual pockets of light suggest a field in the background and break up the space in an interesting way. They may seem insignificant, but the painting would not be the same without them.

Because I wanted a visual relationship among the colors in the fields, I did not use the colors I saw. Instead, I made the central field lighter to provide a contrast with the tree and adjacent hedgerow and to pull the eye into the composition. The color of the field behind the adobe house is only slightly different from that of the house; just enough to make the house stand out and come forward.

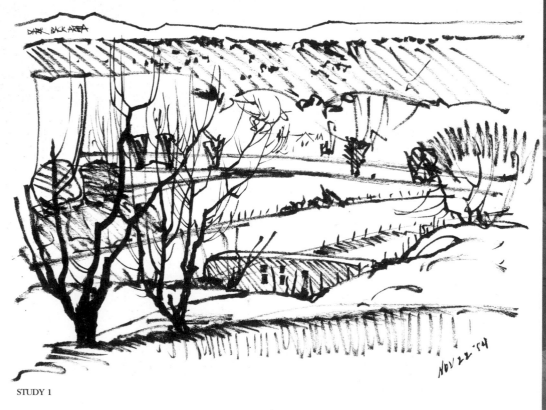

STUDY 1

AUTUMN: TAOS VALLEY

Acrylic and casein on Arches 550 lb. rough paper
28" × 36" (71.1 × 91.4 cm)
Collection of Joan Pechman

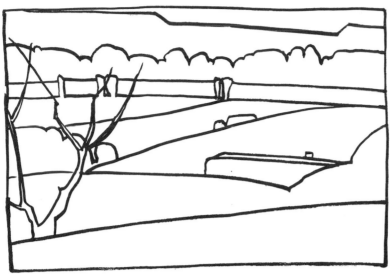

STUDY 2

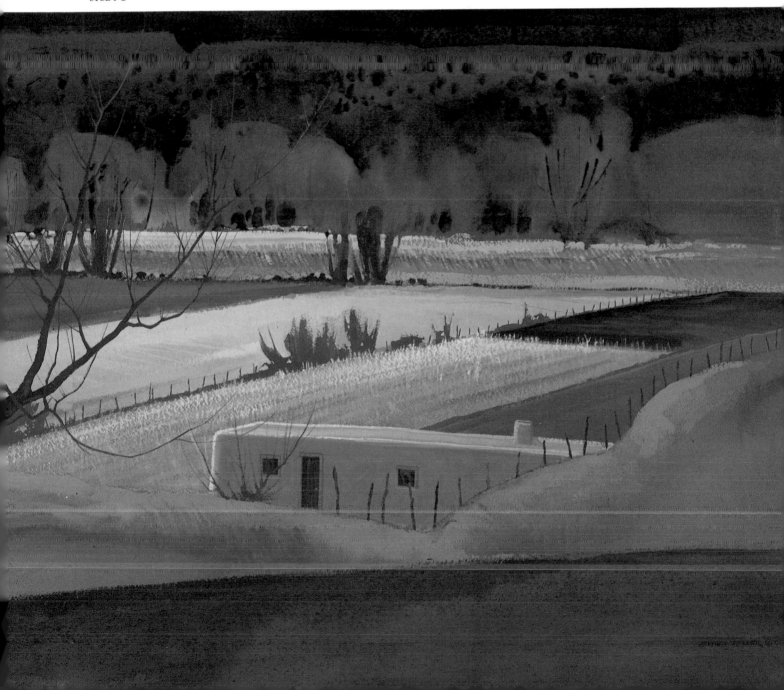

Using Strong Value Contrasts

At Eastertime in New Mexico, ill and handicapped people make a pilgrimage on foot to a particular church at Chimayo, north of Santa Fe. The idea for this painting came from seeing these people walking along the roads, through the cold, bleak landscape, converging on this church in search of spiritual and physical salvation. Yet the church in this painting is not the Chimayo church. Instead, the architectural forms are based in a sketch of the Ranchos de Taos church from a distant vantage point (Study 1).

Unlike many of my paintings, however, *Pilgrimage* is not based on a series of preliminary sketches. Instead, I let the flow of the paint dictate the images and their placement. I wanted to "listen" to what the painting said to me. Letting the painting take its own direction is probably the most exciting kind of painting there is, because it's so unpredictable.

To emphasize the spiritual quality of the scene, as well as the barrenness of late winter, I concentrated on the sharp contrasts of dark and light. I also limited my palette to four watercolors (cerulean blue, cadmium red light, burnt sienna, brown madder alizarin) and permanent white gouache.

After laying in an overall wash of the transparent watercolors, I sprinkled some salt over it. This was a rather unusual thing for me to do, but I wanted the texture it would provide, as well as the forms it might suggest. In the finished painting, you can see the sense of motion it creates near the base of the tree, as well as the contrast with the crisply outlined figures and branches.

After all this had dried, I sketched in the building forms and, using a cerulean blue wash, painted around them with the Reverse Negative Shape Approach. When this was completely dry, I used a mixture of cadmium red light and burnt sienna to paint the mountain form and to give further definition to the buildings. By this time some unexpected images began to emerge, and I painted in the somewhat surrealistic figures, using both a positive approach and the Reverse Negative Shape Approach. To create the lightest figures, I cut a stencil from masking tape and used a toothbrush to lift off the pigment.

Because I liked the movement these figures set up, I decided to repeat it in other areas. Using opaque permanent white gouache, I created the fence by painting around the latillas with the Reverse Negative Shape Approach. I also defined the curve of the bank on the right. Then, because this use of opaque white demanded repetition elsewhere in the painting, I used opaque and translucent permanent white gouache to create the fore-

ranchos de Taos

STUDY 1

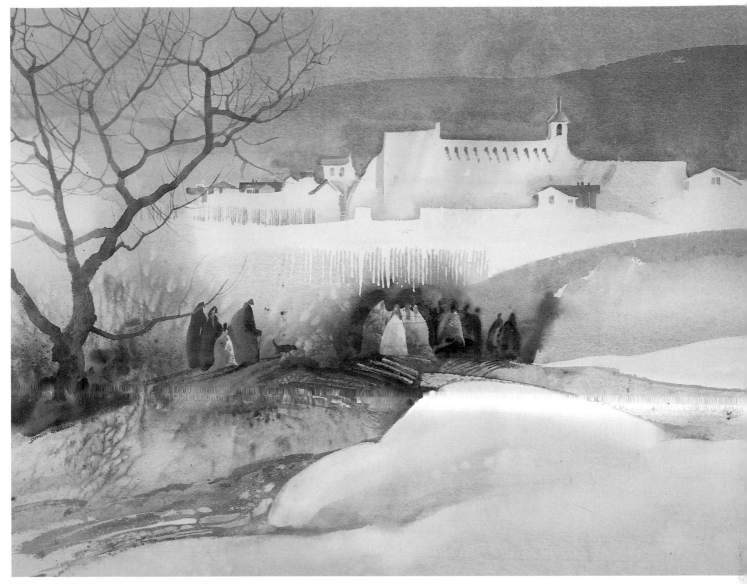

WINTER PILGRIMAGE

Watercolor and gouache on
Arches 300 lb. cold-pressed paper
21" × 29" (53.3 × 73.7 cm)
Collection of Cloyde and Donna Snook

ground snowbank. The diagonal of the road, formed by the snowbanks on either side, shows the underlying transparent watercolor wash.

Finally, the creek itself was painted, and, because weight was needed on the left, I added the leafless tree—all crisp, sharp angles. The diagonal thrust of the branches directs the eye to the center of the painting.

If you look now at the black-and-white photograph of the painting, you can clearly see how important value is. The focal point, to which the eye is directed, has the greatest contrast of lights and darks. The lighter areas in the foreground and the diagonal of the road move the eye toward the figures. The buildings in the background are defined but not emphasized. They seem to provide a restful "backstop" for the intense activity and contrast in the foreground.

Controlling Intense Color

The idea for this painting developed from a sketch I made of a small valley town in southern Colorado (Study 1) and another painting—*Winter Field Patterns, Valdez* (shown on page 119). I was attracted to the lit-up shape in the background of the first painting, so I decided to do another painting, focusing on this brightly lit area of hills, surrounded by a shadowed landscape. This lighting effect is frequently seen in the Southwest when a setting sun breaks through the cloud cover and, like a spotlight, illuminates sections of a darkened landscape.

Although my sketch provided me with the inspiration for this painting, it was only a starting point, a springboard to other ideas. You'll notice that the mesas and cottonwoods of the sketch are not visible at all in the final painting, and the church has metamorphosed into an adobe dwelling. If I followed my drawings slavishly, it would inhibit my painting process.

To make the brilliantly lit hills the focal point of the painting, I chose an intense orange-red. To further intensify the color, I surrounded it with complementary colors: cool blues and violets. Although warm tones were subtly repeated in the tree and building forms, I intentionally dulled them to a burnt sienna color. For the sky, I first used a transparent wash of cadmium orange acrylic, followed when dry by transparent washes of Acra violet and dioxazine purple to neutralize the first color. So, while the sky is intense, it is nowhere near as intense as the brightest hill form.

The juniper-covered hills were essentially painted with the Reverse Negative Shape Approach. After loosely brushing in the dark, blotchy shapes and letting them dry, I modeled the hills in light and deeper blues, creating their contours as I defined the juniper shapes by painting around them.

The foreground is a mottled texture of neutrals, suggesting bushy forms covered with snow. It has been designed not to compete with other elements in the painting. Intense color is concentrated in the one area I was most interested in. All other colors have been subdued to enhance this area.

STUDY 1

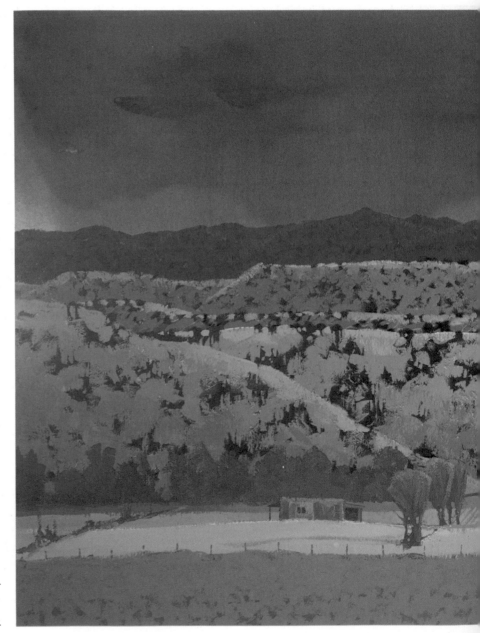

NEW MEXICO SUNSET

Acrylic and casein on Arches 550 lb. rough paper
25″ × 38″ (63.5 × 96.5 cm)
Collection of Edwin and Mary Ann Clemmer

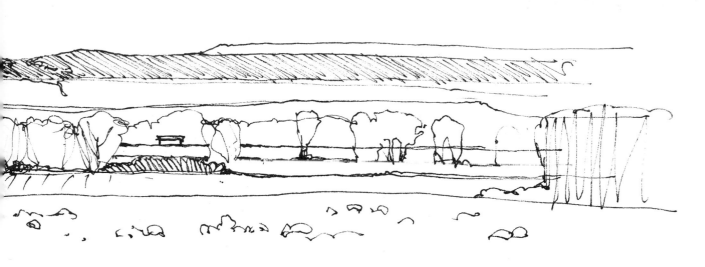

Using Color for Mood

This painting is an example of how a subject can grow on you and how your surroundings can influence your painting. This building is across the road from where I'm living at the moment. I found myself noticing how it looked after sunset, when the streetlight was turned on and the right side of the building was sharply lit, contrasting with the darkness of the leafless trees in the background. I also found myself enjoying the way the tops of the distant mountains would catch the light of the setting sun and seemingly reflect it into the sky.

Twilight is my favorite time of day; it's a time to be by yourself, a time to reflect on what's been happening. To capture this feeling of pleasurable solitude on a late fall evening, I selected a very limited palette of warm and cool colors. Perhaps you might not select the colors I did. Color choices are very subjective, influenced as much by our emotional responses as our visual acuity. I only want to point out that it is worth your while to consider which colors will best convey the mood you want to suggest. The palette you select is another way to intensify the impact of your painting.

To understand the darks and lights of the main shapes, I did a pencil drawing (Study 1). I found that the spiky, rough textures of the tree forms offered an important contrast to the smooth, quiet areas of building and sky. Using my drawing for reference, I lightly drew the building forms and indicated the road's placement on my paper. I wanted to

have lots of activity in the branches, but leave plenty of quiet areas in the sky. Too much activity might take away from the sense of solitude I wanted.

Turning my paper upside down, I wet the area from about the horizon line to the edge of the paper and washed in a mixture of cadmium orange and cadmium red light, letting it bleed and grow lighter as it moved across the paper. When this was dry, I turned the paper right-side-up and washed on a mixture of ultramarine blue and ultramarine violet, taking care to leave plenty of the warm sky untouched. Then, after this had dried, I scumbled in the background ridge and the tree forms and also defined some of the branches.

For the lit-up side of the building, I first washed on cadmium red light, diluting it with lots of water and applying it very lightly so the paper would sparkle through. When this had dried, I painted the shadowed sides with a mid-value ultramarine blue. The darkest value was used for doors and windows.

The foreground was a mixture of ultramarine blue, ultramarine violet, and brown madder alizarin, scarred while wet with a pocket knife. As the pigment slid into these crevices, it suggested a tangle of grass and weeds. Once this had dried, I painted the foreground trees using ultramarine blue and brown madder alizarin. As a final touch, I mixed some gouache colors and picked out the light on the ridge, glimpsed here and there through the trees.

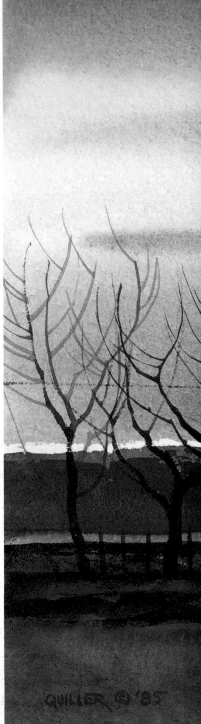

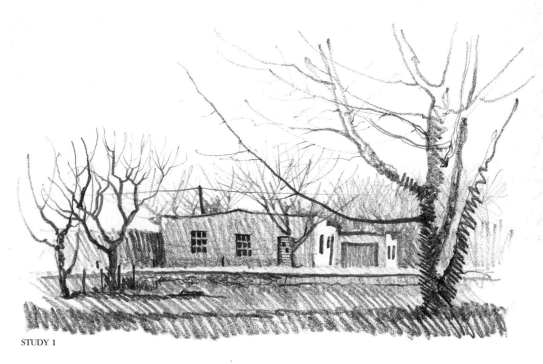

STUDY 1

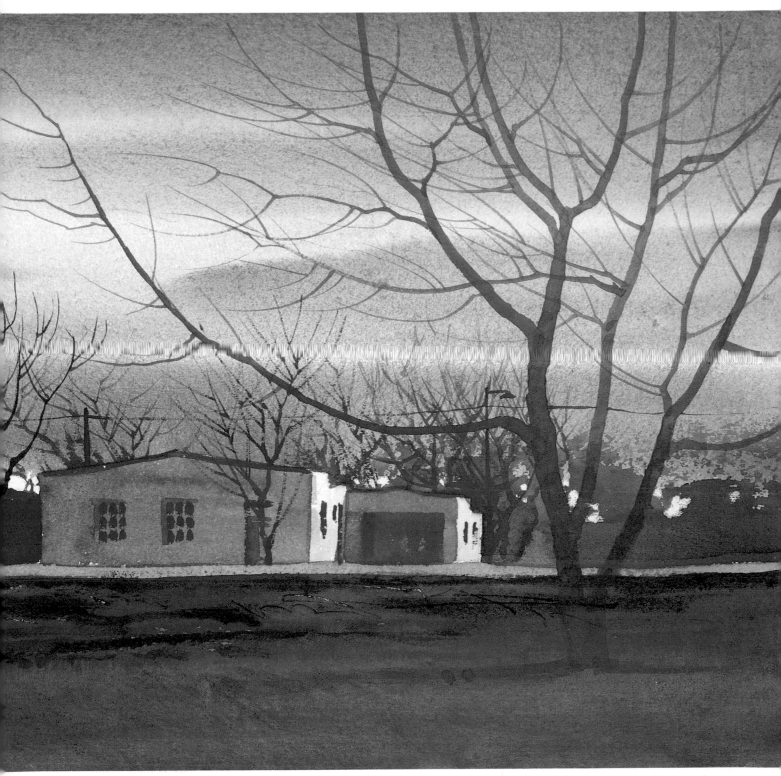

VIEW FROM MY WINDOW

Watercolor and gouache on Fabriano 300 lb. rough paper
8½" × 12" (21.6 × 30.5 cm)
Collection of Philip and Lori Williamson

Emphasizing Texture

The idea for this painting came from one of many sketches I'd done along the Oregon coast (Study 1). Right from the beginning, I knew I wanted to create an illusion of depth through a contrast in texture, using a smooth background and a heavily textured foreground. I also decided to limit my palette to concentrate attention on the texture.

In my studio I did a series of paintings to explore the textural effects created by adhering stained rice papers to the painting surface (Studies 2 and 3). Although these paintings were done on nearly a full sheet of watercolor paper, I still consider them studies. In addition to learning about suitable collage effects, I was also practicing painting the swarms of small shorebirds that added so much interest to the beach.

After cutting my roll paper to size, I soaked it in the bathtub for about 45 minutes, blotted it with towels, and stretched it on reinforced canvas stretcher bars. When dry, it was tight as a drum. I then put the stretched

paper on my easel, because, when working this large, it's important to be able to step away from the painting to look at it.

After wetting the paper, I washed in the smooth, distant sky with cerulean blue and a little cadmium red light. When this had dried, I painted the most distant rocks, using only cerulean blue, and the nearer rocks, using cerulean blue and brown madder alizarin. You can see where I scraped some areas with a pocket knife to give them character.

At this point I referred to my sketches and preliminary studies to help me decide how to develop the rest of the painting. I knew I wanted to leave the large white area in the middle distance untouched to suggest the bay at low tide, and I knew the foreground would be a collage. For the collage, I tore several types of rice paper into different sizes and shapes. The larger pieces were paper with a relatively smooth texture, while the smaller pieces were very fibrous. These I put beside my easel.

STUDY 1

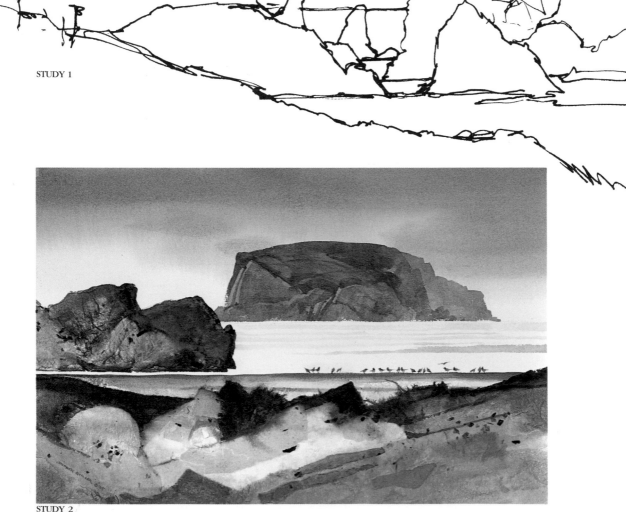

STUDY 2

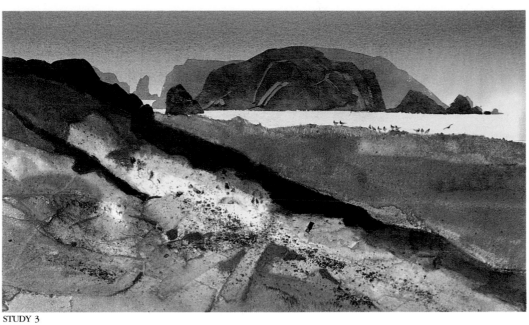
STUDY 3

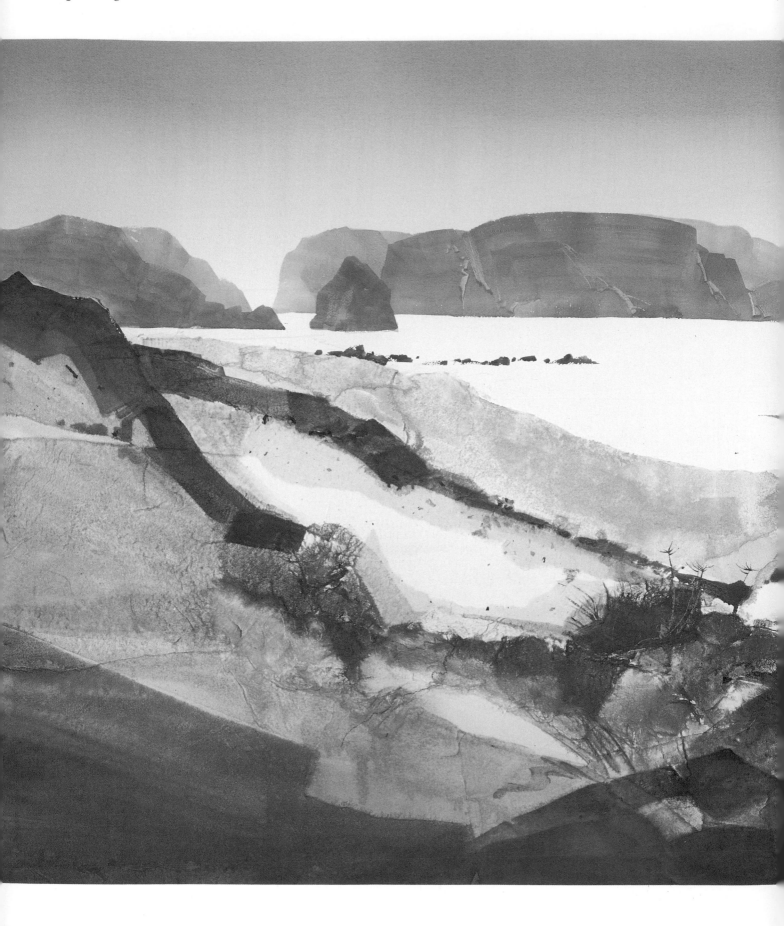

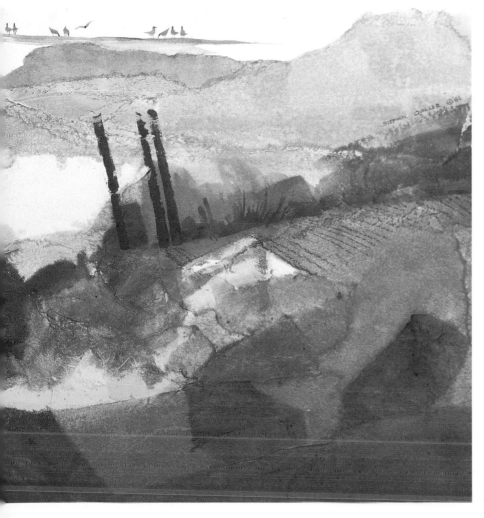

To begin the collage, I first saturated the lower two-thirds of the watercolor paper with polymer matte medium, diluted 50/50 with water. This would be my adhesive. Next I washed on large masses of varying mixtures of burnt sienna, cadmium red light, burnt umber, and cerulean blue, taking care to leave some areas white. Because I was working on an upright surface, this paint began to suggest forms as it flowed down. As I began to see something happen, I reinforced it by applying a piece of the torn rice paper, working rapidly. If I obliterated some color, I added more. I continued working spontaneously back and forth, alternating paper collage with color washes, until I reached the definition of forms I wanted. Then I stopped—it is easy to kill a painting by going too far using texture of this type.

When everything was dry, I strengthened and darkened the values throughout the composition. One light area in the lower left foreground seemed too similar to other shapes nearby, so I toned it down with a wash of cerulean blue. This is the kind of thing that can be done only during the final moments of painting.

My last touches were the pilings and the small shorebirds. I'm willing to confess that perhaps the birds were more important to me than they were to the success of the painting, but there is something about their forms and quick movements that adds life to a coastal landscape.

TIDAL POOLS

Watercolor and collage on Arches
140 lb. cold-pressed roll paper
33" × 51" (83.8 × 129.5 cm)
Collection of the artist

Visualizing as You Paint

This painting was developed almost entirely by visualizing the forms and creating them by painting around them. It is also an example of how a painting can be derived from a location without being a photographic rendering. Although the initial sketch (Study 1) was made in November, the painting suggests a warm February day, with long shadows. I've also changed the location of trees and hills and rearranged the field patterns. As for the distant mesas, they weren't visible from this spot. My sketch was used as start, and really the sketch became an excuse to paint.

I began by stapling my paper to a plywood sheet and taping around the edges to prevent moisture from seeping underneath, where it might cause uneven dampness or even "balloons." With my paper upright on my easel and my various sketches arranged around me, I was eager to dive in. First, I saturated the paper with clear water, except for the narrow white area near the top, and covered the entire paper (except the white area) with a transparent mixture of cadmium yellow medium, cadmium orange, and Indo orange-red acrylic. I used my whole body, moving rapidly back and forth as I applied the paint. I let it flow down the paper, and some of the color did run across the white area in the process.

With the paper still damp, I took a matknife blade, picked up a mixture of Acra violet and dioxazine purple acrylic, and scarred and scraped the paper, creating the distant mesa forms with the paint-laden blade. Some of the paint was opaque, but some was more transparent and seeped out and "bloomed"

into the surrounding damp areas. I let the color go where it wanted. For the distant horizon, I used cadmium red light acrylic. Then, after all this had dried, I cleaned up the white area by scraping the paper clean with a razor blade. Throughout this process, I frequently stepped back to make decisions from a distance so the whole background would work together.

Next I applied a transparent wash of Indo orange-red and cadmium red light acrylic over almost the entire painting, from the lower part of the distant mesas to the bottom of the paper. I let this dry completely before applying dioxazine purple in ragged blotches in the background area.

Try to imagine what the painting looked like at this stage. The distant background of the sky, mesas, and white area was complete; the rest of the painting was a warm transparent orange; and in the middle distance there were large, blotchy areas of deep purple. It was not a "pretty picture." This may help you understand how valuable it is to be able to visualize the completed painting.

I now shifted to casein because I wanted its soft, matte quality to contrast with the intensity of the acrylic. I also wanted the vibration that is always set up by different qualities of transparent and opaque paint. Using a mixture of titanium white and cerulean blue, I painted in the contours of the hills. By painting around the purple blotches, using the Reverse Negative Shape Approach, I created the scrubby shapes of juniper and pinyon trees. A lighter shade of blue further defined the hill contours, and the hills in the middle

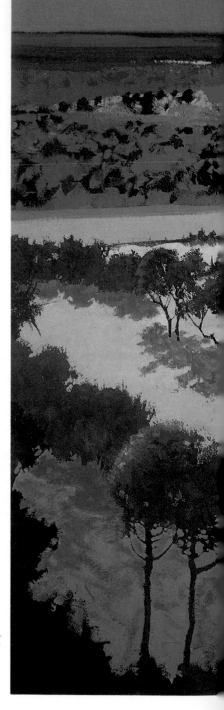

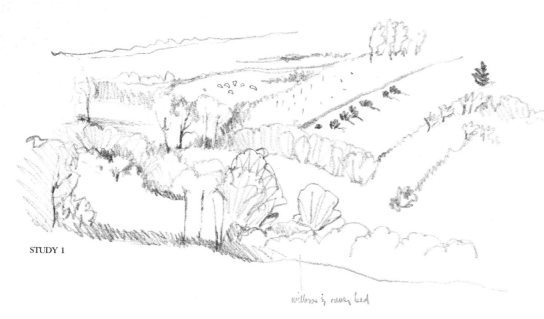

STUDY 1

willows & river bed

118

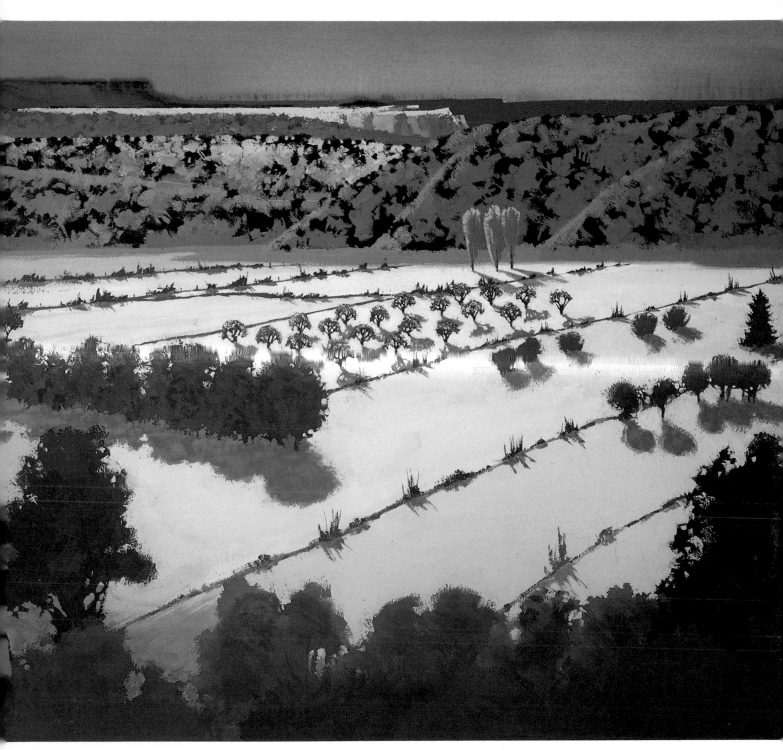

were painted in the same way with a golden tone.

Most of the features of the valley floor were done using the Reverse Negative Shape Approach. The perspective was a bit tricky, so I referred to my sketches and penciled in the forms with care. There were so many things to consider as I worked that I did one field at a time. If you study these fields, you can see many subtle changes in value as well as in color. The pale gold in the center becomes a darker, warm peach tone on the sides.

After loosely brushing in the tree shapes and their shadows, I refined their forms by painting the field color around them. The three poplars in the distance were painted positively, although their shadows were created with the Reverse Negative Shape Approach. These three trees, bright against dark, provide a necessary balance for the foreground trees, which are dark against light. The entire painting is suffused with warmth, created by glimpses everywhere of the initial acrylic underpainting.

WINTER FIELD
PATTERNS, VALDEZ

Acrylic and casein on
Arches 550 lb. rough paper
28" × 39½" (71.1 × 100.3 cm)
Collection of the artist

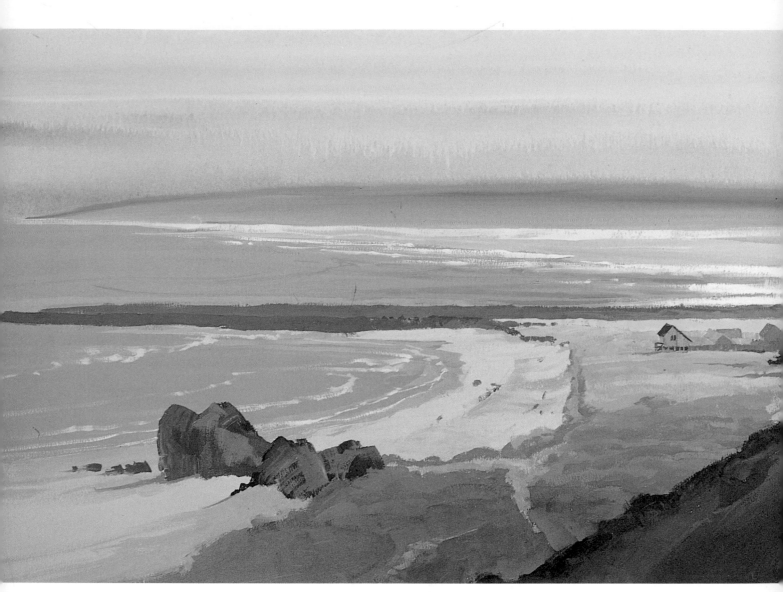

COASTAL JETTY

Acrylic and casein on
Crescent no. 100 illustration board
17″ × 29″ (43.2 × 73.7 cm)
Collection of the artist

LEARNING FROM CONTEMPORARY ARTISTS

The twenty artists whose paintings are shown in this chapter have all made an indelible impression on me through their work. Many are artists I have met or know personally. Others I know only through their work, which I've seen in exhibitions around the country. Space limitations, of course, eliminated many others I would have liked to have included.

No single style is represented. The work ranges from representational to totally abstract. Each artist has evolved a unique way of painting, which is a personal expression. The only element the paintings have in common is that they are all done in water media.

Although this was not planned, these artists come from every part of the country. They also represent every stage of career development. Some are just beginning to win national recognition, while others are established artists whose work is internationally known.

When Barbara Whipple and I invited these artists to participate in this project, we were overwhelmed by their enthusiasm. Each artist sent several transparencies for us to study. As we looked at the paintings projected on a screen, it was like viewing a private exhibition. Often it was difficult to choose which painting would best represent an artist and at the same time illustrate some of the points in this book.

After making our selection, we returned the slides to the artists with a questionnaire. Their responses were as rich in content as they were individual. Character, dedication, and sincerity shone through in the replies, as well as a good deal of wry humor. Every page, therefore, includes a quotation from the artist. We believe it is important to hear these artists speak in their own voices, expressing themselves in words as well as in their paintings.

Looking at and reading about these artists' work has been extremely rewarding for us. Each artist has evolved a highly personal method of expression. The techniques used, however, are not attention-getting gimmicks. Rather, they are techniques developed from long hours in the studio, trial and error, and constant experimentation. These techniques fit the individual temperament, interests, and philosophy of the artist. The process itself is part of the artist, an expression of his or her personality.

Working with Brilliant Color

John Maxwell
ANCIENT MARINERS II

Acrylic on Masonite panel
20" × 26" (50.8 × 66 cm)
Collection of Mrs. Gayla Stewart

John Maxwell, a Pennsylvania artist who specializes in land and seascapes, works experimentally in all the water media as well as in oil. "It is always my hope," he indicates, "that in my own work the myriad applied facets will go unnoticed at first, and that the viewer will only be aware of a pleasing surface, conventionally covered by brush and paint. The more urgent hope is, that upon closer scrutiny, the viewer will detect the subtle, articulated textures—giving off (with luck!) an aura of brilliant, cryptic colors and forms. It would be hard to envision how these effects could possibly be achieved by conventional methods."

"I suspect," he continues, "that if all other approaches were denied me, color would carry the day. In *Ancient Mariners II*, my hope was somehow to express the ambiguous nobility one senses in such wretched old scows— finally mired in some polluted old harbor. I cannot really justify the colors of this (or any) painting—except that I wanted to cloak these

decrepit hulks in a certain aura of enduring dignity."

Through many years of experimentation, Maxwell has developed a process in which he takes fragments of previously painted, high-quality rag papers and fuses them with acrylic adhesives to a painting done on gessoed Masonite. When dry, this is reworked conventionally with brushes and acrylic pigments. Maxwell repeats this process many times, until he is satisfied. The result is a surface of tissue-thin papers, permanently colored, quite unlike a conventional collage.

Although Maxwell based this composition on familiar subject matter, he developed it with his own creative imagination. His uninhibited use of intense color is especially exciting. See how he has enhanced the brilliant areas by setting them off with neutral tones. His use of color has very little to do with reality; instead, it has to do with what Maxwell wanted to do with color. The color is what makes this painting dance.

Mark Adams
OUTRIGGER

Watercolor on Arches
140 lb. cold-pressed paper
20¾" × 22¾" (52.7 × 57.8 cm)
Collection of Marcus, Millichap, Inc.,
Palo Alto, California

Mark Adams is a San Francisco artist whose stained glass and tapestry designs can be seen in a number of public buildings in the West and Southwest. He explains, "I am intrigued with light and transparency. After years of working with the large scale and strong color of tapestry and stained glass, I wanted a more subtle and personal form of expression."

Adams has selected watercolor as the perfect medium for his lucid statement and limited his palette to complementary relationships of warm red-oranges and cool green-blues. A carefully controlled series of washes, laid on with sable brushes, creates the subtle transition from the warm tone in the foreground to the cool of the distance. It suggests not only the movement back in space, but also the change in the water from shallow to deep.

Adams based this painting on a drawing made on location at a lagoon in Bora Bora, using a slide for reference. The format is nearly square, with the subject placed slightly above and left of center. The strongest value contrast and the most intense color are at the stern of the boat, the focus of the painting. But notice how the outrigger forms and their reflections break up the picture space and how the many small pockets of negative space generate interest.

Every part of this composition fits together to create a pleasing, restful painting. Yet the seeming simplicity of this painting is very difficult to achieve. Adams has captured the essence of his subject through a process of elimination; what has been left out is as important as what has been included.

Capturing a Moment in Time

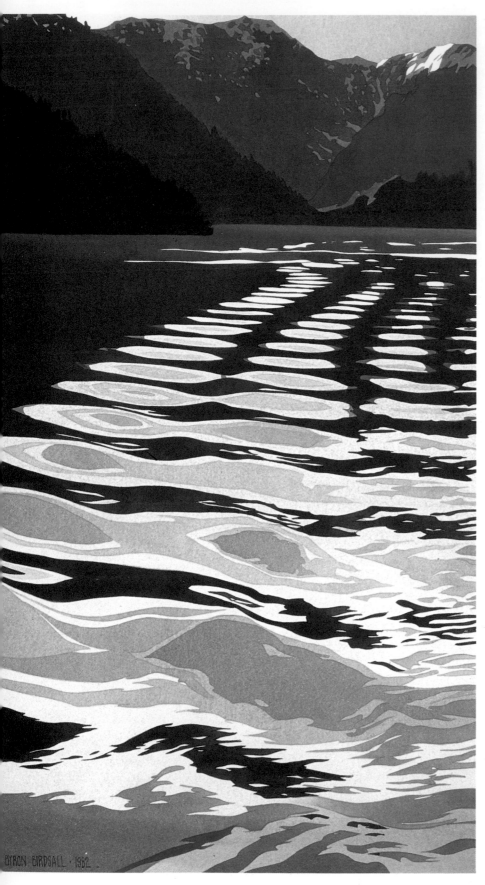

Byron Birdsall
WAKE

Watercolor and acrylic on Arches
140 lb. cold-pressed paper
24" × 13½" (61 × 34.3 cm)
Collection of the artist
Photograph by Chris Arend

Byron Birdsall is an Alaskan artist well known for his ability to capture the essential in a landscape. "Color and spatial relationships interest me a great deal," he points out, "especially hard-edged abstract shapes of color, interlocking to create effective representational images. The unique slanting light of Alaska is also an element that influences all my work."

"*Wake* is a captured moment," Birdsall continues. "After twelve hours running in a fishing boat, we pulled into a cove in Rudyard Bay in Southeast Alaska. The last rays of the sun were still brilliant, the engine had just been turned off, and all we could hear was the gentle slap slap of the wake against the hull."

Birdsall states that watercolor suits him as he is impatient and wants to see results quickly. But the word *patience* best describes the way he applies his color. His perfect graded washes are the result of absolute control. With his paper on a slant, he applies the color, stroke by stroke, with round sable brushes, allowing gravity to pull the pigment evenly down over the surface of the paper.

Once, by accident, Birdsall substituted white acrylic for Chinese white, and he liked the results so much he has used it ever since. Here he has also added silver acrylic to the lighter areas to give them a subtle sparkle very much in keeping with the Alaskan landscape. Although specific colors are suggested by the subject at hand, Birdsall nearly always uses Naples yellow, rose doré, and cobalt blue to capture the unusual, dramatic light of Alaska.

Wake is a predominantly cool painting, but the hint of warmth in the sky and the upper part of the wake add life to the painting. The repetition of the hard-edged reflections in the wake sets up a rhythm that guides the viewer into the painting and creates an illusion of depth. At the same time the long, narrow format accentuates the feeling of being in a narrow fjord, surrounded by precipitous mountains. There is a feeling of approaching darkness and of rocking gently in a boat.

Virginia Cobb, ANA, AWS
JOURNEYS

*Watercolor, acrylic, and colored pencil
on four-ply rag museum board
32" × 32" (81.3 × 81.3 cm)
Collection of the artist*

An abstract painter, Virginia Cobb, works with mixed water media. "All my paintings are symbolic of my own life," she says. "I feel I have nothing else unique or meaningful to give to my work. The techniques which I use have been developed over a period of time, because of their relationship to my expressive needs. Painting is my way of reaching for an awareness of my innermost thoughts and feelings."

This painting, aptly titled *Journeys*, is one of a series painted when Virginia Cobb was moving her studio from Houston to Albuquerque. She always begins a painting with a series of transparent watercolor washes, which she builds at random, until the meaning of the piece becomes apparent to her. In effect, she listens to the painting, letting it tell her what to do.

For *Journeys*, the artist first broke up the picture space with these transparent washes. She then alternated layers of acrylic, light and dark, opaque and transparent, to build the shapes. Sometimes these layers were blotted, scrubbed, or scratched to give richness and added dimension to the final surface. The colors were intuitive; they suggest desert landscapes, distant skies, and roadways.

The painting is square in format, and most of the overlapping forms are rectangular. There is an intriguing interplay between the vertical and horizontal rectangles, as well as between the brilliant blues and warm, dulled hues. Note how the vivid blue vertical is somewhat to the right of center, and think of how different the painting would have been if the vertical had been centered.

The interesting textures in the central area help to focus our attention and contrast with the smoother surfaces of the periphery. Some of these textures were created with colored pencil. The artist also made use of the Reverse Negative Shape Approach to form the steplike mesa forms to the right of the center.

Selecting an Unusual Viewpoint

Peter Holbrook
THREE SISTERS II

Watercolor and acrylic on
Arches 140 lb. rough paper
38" × 40" (96.5 × 101.6 cm)
Collection of the Chemical Bank of New York

An artist living in comparative isolation in northern California, Peter Holbrook uses watercolor and acrylic in large-format paintings predominantly concerned with landscape. "This painting," he comments, "is about flying and about the bizarre forms of the desert (in this case Monument Valley), and about seeing, and ecology, and about finding ways to revitalize the art of landscape painting, a form they told us was finished—and some other things. A successful painting is capable of expressing so many things to different people it cannot and should not be reduced to statements."

Holbrook uses his own slides for his paintings, and frequently they are aerial views. Here the photograph was taken from an offbeat position, but instead of taming it with a more conventional treatment, Holbrook decided to go with the tilt and to emphasize the resulting pattern by cropping the edges.

The result is a composition formed of a series of chevrons in a nearly square format. The rock spires and their shadows can be considered the positive shapes, while the desert is the negative. Notice how the bright, negative desert areas form active shapes of their own. The interaction between the positive and negative areas is what makes this such a dynamic composition.

Holbrook prefers an acrylic gessoed surface because of its luminosity and the ease of lifting paint. He uses watercolor for transparent darks and acrylic for opaque brights. The paint is applied in separate layers, and midtones are created by overlapping the different layers.

Working with the image projected on his gessoed paper, Holbrook begins with naturalistic color. Gradually, however, he adapts the color until it seems "right" for the painting. Here he enhanced the warmth of the reflected light on the shaded side of the spires.

Holbrook has used texture to contrast the slick rock surfaces with the rough, rock-strewn desert. Texture is also used to suggest perspective: the desert gains detail as it comes closer, and the small rocks become clearly defined. The sparkle of sunlight is everywhere, highlighting the spires, dancing off rocks, and leading our eyes around.

Pat Wolf
RANCHOS DE TAOS—
SAN FRANCISCO #5

*Watercolor on Crescent no. 114
cold-pressed watercolor board
20" × 30" (50.8 × 76.2 cm)
Collection of the artist*

Pat Wolf, a New Mexico artist, focuses closely on her subjects to emphasize their surface textures. "All of my work," she says, "has been deeply influenced by the powerful light and color of the Southwest. Saturated colors, definite edges, and rather dense compositions are very important elements in my work, along with the abstract development of shapes. Through the techniques I use in watercolor, these paintings become almost abstract studies in surface and natural textures."

Wolf's knowledge of the subject shown here is thorough. She has photographed and sketched this church repeatedly, and she even helped to "re-mud" the exterior of the ancient building. One could hardly have a more intimate acquaintance with one's subject.

After blocking in her drawing, Wolf used Maskoid extensively. The Maskoid gave her the freedom to lay on flat washes and to work on areas later. Her interest in textures has led her to develop a process of blotting and lifting colors with paper towels and brushes. Areas that have the color removed in this way acquire depth and translucency, due to the rich, remaining stain. This kind of color

cannot be obtained by pre-mixing paint.

Two elements about this painting immediately warrant attention: the first is the geometric motif, which is rectangular; the second is the pattern of dark and light. The strong value contrast is what holds the painting together, and it serves to translate a realistic subject into a virtual abstraction. Color has been severely limited to further emphasize this abstract quality.

Now look at the many varied textures. Some were achieved by repeated blotting and lifting; others were made by a very subtle spatter of Maskoid, which created the glittering dots seen throughout the warm brown surface. Several of these dots have been painted the same transparent blue as the sky. Notice, however, how the mottled texture of the building offers a sharp contrast to the absolute smoothness of the sky. Also notice the bit of blue sky in the top right corner, which relates to the large sky area. And, something to think about—what would the painting have looked like if the artist had painted the shadows of the vigas slanting in the opposite direction?

Developing a Lyrical Abstraction

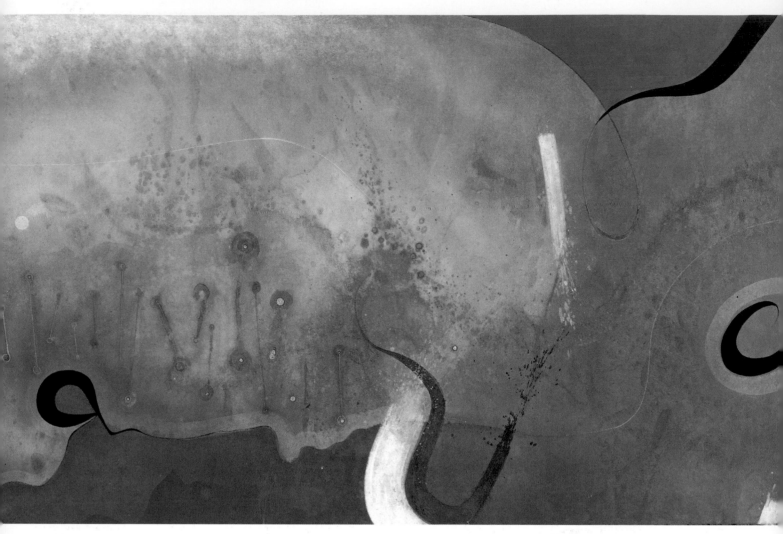

Glenn Bradshaw
BIRDSONGS
REMEMBERED:
REDWING BLACKBIRD

Casein on Sekishu rice paper
25″ × 39″ (63.5 × 99 cm)
Collection of the artist

Glenn Bradshaw, Professor of Art at the University of Illinois, is well known for his abstract paintings in casein. "My paintings are lyrical abstractions," he explains. "They usually deal with contrasting elements and usually grow out of an interpretation of nature. Carefully orchestrated and often colorful, they are, I feel, positive, and I hope that the viewer will find pleasure in seeing them. I hope also to make them complex and rich enough so that the familiarity with them will continually bring new discoveries and insights."

Bradshaw's inspiration for this painting was audible sound—specifically, the call of a redwing blackbird. He was interested in the way the seemingly random sounds formed an orderly progression and became woven into a particular segment of time. He set himself the task of interpreting these sounds through color, rhythm, and texture.

At first Bradshaw rapidly applied gestural marks all over the paper. He then developed other marks and forms slowly, in relation to the initial marks. Working on both sides of the textured rice paper, he applied diluted casein color and blotted frequently with paper towels. This slow process of building layer after layer, on both sides of the paper, created an extraordinarily complex surface.

The soft, matte quality of casein is evident in the finished painting and adds to its lyrical quality. Rhythm is established through curvilinear forms, repeated in different sizes throughout the composition. Bold, direct strokes of black and white set up a counterpoint to the graceful notes of the veiled forms at the right. As Bradshaw intended, the richness and complexity of color, texture, and surface invite the viewer to keep looking and discovering new relationships.

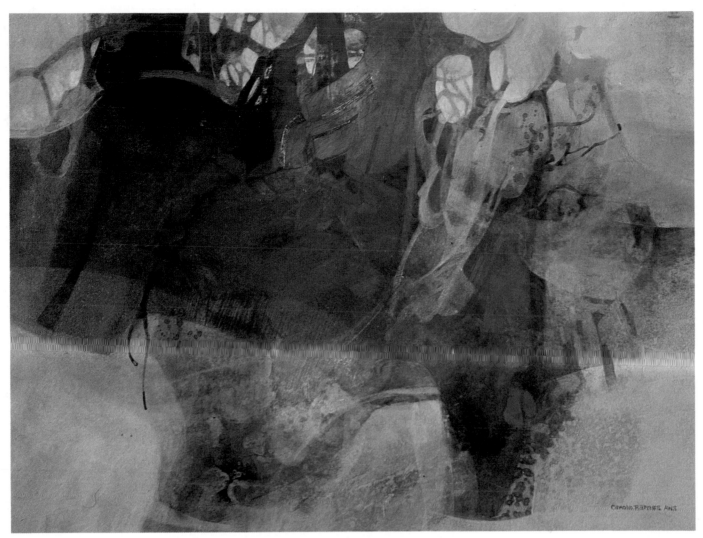

Carole D. Barnes, AWS
SYMPHONY OF
A LANDSCAPE

Acrylic on Strathmore Aquarius II
21" × 27" (53.3 × 68.6 cm)
Collection of the artist

Carole D. Barnes, a Colorado artist and teacher, works in experimental and abstract ways. "Although this particular painting was begun with trees or a landscape theme in mind," she comments, "I usually enjoy starting a painting by thinking only of color, line, shape and texture, and try to keep the process intuitive for as long as possible. I often will turn the painting around or upside down, and in that way find an excitement I might otherwise have missed. As the painting progresses and begins to have a 'life,' I proceed more and more slowly and evaluate and think about it more and more."

Even with her general idea of tree forms or a landscape in mind, Barnes used her acrylic paints intuitively—pushing them around, pulling some shapes up through the glazes and suppressing others. A lively red was her dominant color at the beginning. Veil-like layers of lighter, cooler color were used to

create successive intertwining and overlapping forms. Gradually, the color moved from warm to cool, and quiet negative areas were created by applying light acrylic over dark with the Reverse Negative Shape Approach. You can see how the root forms were created in this fashion and how these overlapping forms weave through the composition to create their own rhythms. Throughout the painting there is a constant repetition of soft, curvilinear forms, some very large and some very small.

The many variations in texture add excitement to this painting. In some areas, paint has been scraped off with a plastic scraper; in others, opaque whites have been worked in gently with a brush. Sometimes the paint has been washed off when partially dry, while here and there a spatter of alcohol has produced a grainy effect. Contrasts of color and striking changes in value also add to the impact of this painting.

Discovering the Patterns of Shadows

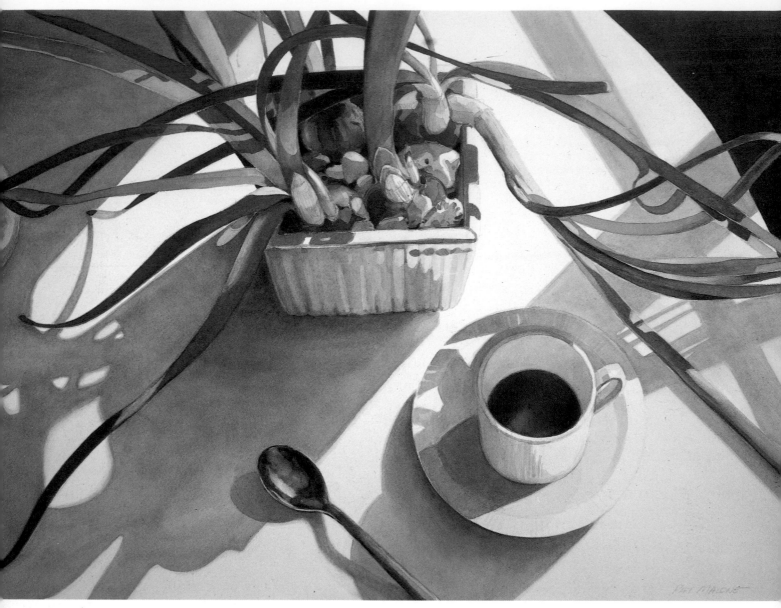

Pat Malone
COFFEE BREAK

Watercolor on Arches
140 lb. cold-pressed paper
17½" × 23½" (44.5 × 59.7 cm)
Collection of the artist

Pat Malone is an Oklahoma watercolorist whose intimate paintings of everyday objects disclose a fine, selective eye. "Most of my paintings," she notes, "are inspired by light and shadow as they turn an everyday object into a unique design. By changing my viewpoint, more and different patterns are created. In *Coffee Break* I was interested in the effect of sunlight as it fell across form. The shadow patterns are as important a part of the painting as the plant, cup and saucer, or spoon. The shadow not only defines the form but also creates its own design."

Malone was inspired by the drooping narcissus leaves and spent much time arranging and rearranging the other objects to achieve the desired composition. Then, to enhance the interesting patterns of the foliage and shadows, she decided on an unusual perspective.

Her view from above shows the curved edge of the table on the right, and the curvilinear motif is repeated throughout the composition—in the table, the drooping foliage, the spoon, the cup and saucer and their shadows—leading our eyes through the painting.

The overlapping forms of the foliage and shadows create interesting negative spaces and small pockets of brilliant light. Notice how the foliage, as well as the handle of the spoon, extend beyond the picture plane. Also notice how the tangle of foliage at the upper left balances the shapes of the spoon and cup at the lower right.

Although the color is naturalistic, Malone has used a series of transparent watercolor glazes to build its brilliance. Study the hard, shiny quality of the spoon, and see how it contrasts with the translucent coffee.

John Stuart Ingle

STILL LIFE WITH EIGHT TULIPS

Watercolor on Arches 300 lb. cold-pressed paper
40″ × 30″ (101.6 × 76.2 cm)
Courtesy of Tatistcheff Gallery, New York City

John Stuart Ingle, Professor of Painting at the University of Minnesota at Morris, specializes in still lifes, painted in transparent watercolor. "My painting is about knowing—the process of knowing," he comments. "It is not really about the *things* I know as much as it is about the *way* I know. It is about how I organize the data of my experience in order to understand it."

Ingle's still lifes are arranged with great care, and his selection of colors depends on these arrangements. As he works, he varies his color, depending on the demands of both the medium and the composition itself. In this painting, the large area of warm beige-gray acts as a foil for the bright, clear tones of primary color. And consider how much less interesting the painting would be without the red border of the linen cloth, which repeats the colors in the flowers.

The format is also of prime importance. Put your hand over the upper part of the painting and see how this changes it. The upper empty space conveys a pleasurable sense of solitude, an airiness. Studying this painting can become an exercise in understanding the importance of negative space. Look at the spaces around the forms, rather than the actual forms themselves. Look at the small pockets of light seen through the tulip flowers and their foliage. Consider the blurred shadows on the wall. All of this negative space suggests empty air and the light surrounding these simple objects. In this painting the "nothingness" is at least as important, if not more important, than the "things."

Expressing the Spirit of Nature

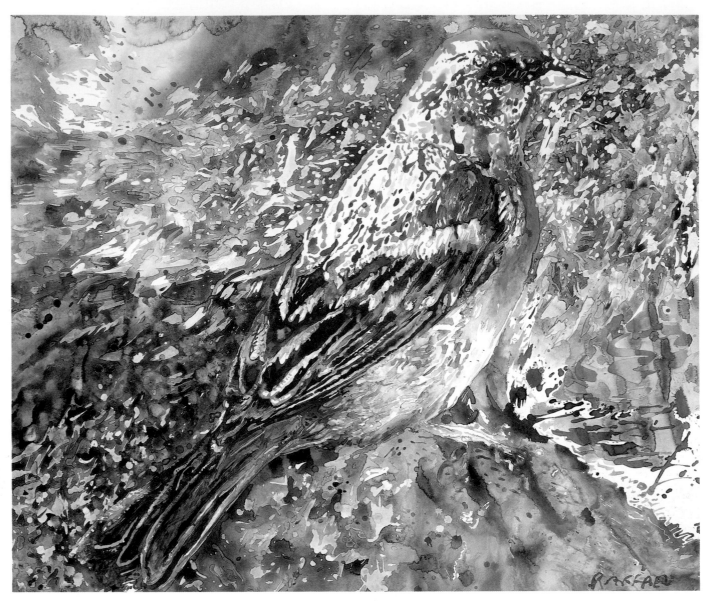

Joseph Raffael
SPIRIT BIRD

Watercolor on Arches
140 lb. roll paper
42″ × 50″ (106.7 × 127 cm)
Courtesy of Nancy Hoffman Gallery,
New York City

Joseph Raffael is a painter who portrays subjects from the natural world in a very personal, expressive way. "My work," he explains, "is an opportunity for me to make visible the invisible; to take the white page or canvas and have, in an almost alchemical way, new life issue forth as evidence of something more than how we, as a collective, usually relate to nature's energetic. My intent as an artist and being is to flow within a higher pattern, and hopefully leave an image which harmoniously may assist myself, as well as others, to remember wholeness and our integral participation in *all* of nature."

An intuitive, mystical painter, Raffael chooses watercolor as a medium because, he says, "Watercolor expresses flow, life as transparency, the ineffable, the transient, and, with the artist as conduit, it expresses air, motion, life moving. It can do what it wants. Watercolor is itself a force in nature. Watercolor is nature."

This painting may seem quite simple: the format is nearly square; the subject is a bird; and the composition consists of two intersecting diagonals. Yet the results are neither simple nor straightforward. *Spirit Bird* suggests more than bird, more than spirit, more than air and energy—it suggests a combination of all of these.

To achieve this, Raffael uses watercolor to create a textural field that vibrates through the entire painting. This unified texture, built with brushstrokes, spatters, and washes of color, gives the painting its shimmering quality. Because of the close values, the bird and the air around it seem almost to merge.

Color is also all-important. The largest areas of intense blue and red-orange are in the body of the bird, but these colors are repeated everywhere in the painting. Raffael feels that the red splotch on the right, in front of the bird, is the "heartbeat" of the work. In fact, it was the final touch.

Guy Pederson
EAGLE RIDGE II

Watercolor and acrylic
on Arches 300 lb. paper
20" × 30" (50.8 × 76.2 cm)
Collection of Mr. and Mrs. Karl Kujac

Guy Pederson, who lives in relative isolation in Oregon, paints birds, landscapes, and coastal subjects in all the water media. He notes, "Birds, as subjects, interest me for their abstract forms, patterns, and colors. When painting birds, I also try to express some feeling for the symbolism that birds and flight evoke in all of us."

Many sketches from life, as well as a series of paintings, were preliminary to this work, as Pederson searched for a bold but simple arrangement of forms. A photograph was used for reference only when detailing the head of the bird. Realism, while important, was secondary, as each brushstroke was intuitively placed to continue the rhythm of previous strokes. Once the painting was well under way with transparent watercolor, Pederson decided to add white acrylic. This allowed him to strengthen the positive-negative patterns within the painting, as well as freeing him to work more intuitively, knowing he could redefine certain areas with the acrylic.

If you study this painting, you will see how

it is very nearly divided into two equal squares. Pederson then chose diagonal lines to emphasize the sharp, angular forms in his composition. The diagonal made by the back of the bird divides the negative white space on the right. The left area of negative white is formed by the nearly vertical left side of the bird and is broken at the bottom by the bold strokes suggesting the edge of the nest. The large area of textured white paint on the left balances the weight of the bird on the right. This strongly textured, unusually shaped area of white paint creates the drama of this composition.

The eagle is painted in varying shades of brown, and feather patterns are suggested in the simplest way. Strong texture has been created with a lot of vigorous scraping with razor blades and brush handles, as well as the coarse brushwork used when applying the white acrylic. If you look closely, you will see a cluster of the three primary colors around the beak of the bird. This serves to focus our attention.

Designing Rock and Water Patterns

Gerald F. Brommer
PACIFIC RHYTHMS

Watercolor and collage
on Arches 300 lb. rough paper
15" × 22" (38.1 × 55.9 cm)
Collection of Mr. and Mrs. Phil Dike

Gerald F. Brommer is a California painter, writer, and teacher. Many of his paintings deal with coastal scenes, but they vary in handling from traditional and realistic to experimental and abstract. Brommer comments, "I try to convey a sense of order in nature, something that intimates that God is in control of things in our natural environment. Often, things may seem to be out of control, but looking back a century or more, one can see evidence of order and plan. I hope my landscape interpretations suggest something of this order and plan."

This painting is one of a series dealing with rock and water patterns on the Pacific coast. It is based on a series of sketches and paintings, as well as memory and imagination. But here Brommer set up a specific artistic challenge: he wondered whether he could use vertical and diagonal movements to stabilize a composition that was made up primarily of horizontal elements.

Brommer adhered Oriental rice papers to his surface and moved them this way and that to enhance the thrust and movement he wanted in the composition. Notice that the white areas are filled with the textures of the rice paper collage. If you study these white spaces, you can also see how Brommer has used the white, negative areas to create an exciting pattern, which is equal in importance to the dark, positive, painted areas. The negative areas establish a rhythm that leads the eye through the composition. They also serve to enhance the positive, more detailed areas.

Brommer's limited palette helps to unify the many complex and exciting patterns. There is also a strong spatial unity. Notice how the value and texture contrasts are most intense in the foreground and how distance is suggested by the gradual loss of detail and contrast as you move to the upper part of the picture plane.

Edward Betts, NA, AWS
SEA MOVEMENT #10

Watercolor and acrylic
on Arches 300 lb. rough paper
22" × 30" (55.9 × 76.2 cm)
Courtesy of Midtown Galleries,
New York City

Edward Betts, Professor of Art Emeritus at the University of Illinois, has conducted workshops throughout the United States and written several books. His approach is based on years of close and careful observation of the sea, so the ocean forms are internalized and become intuitive.

"This picture," Betts observes, "was meant to be a purely painterly, gestural, equivalent to the movement, colors, shapes, and textures of the ocean itself; an experience in paint, not a prosaic rendering. In a case like this, photographs of the ocean are almost a hindrance; the flow felt in the painting has to come out of the action of the paint itself—to look natural, inevitable—not consciously or carefully delineated by the human hand."

This painting is the tenth of a series painted in a spirit of technical experimentation. Betts wanted an interplay of transparent and opaque passages, although the final look was intended to be primarily transparent. He devised a way of using highly diluted acrylic gloss medium as a resist for transparent watercolor washes in the early stages of a painting. Then, since watercolor has a tendency to bleed through opaque acrylic whites, he sprayed on three additional coats of highly diluted gloss acrylic medium. This served as an isolating coat between the watercolor and the acrylic whites. The interesting textures you see stem partly from the resist process and partly from splashing and spattering both water and pigment directly on the surface.

If you study this composition, it is clear that the strong diagonal accentuates the action of the wave. The contrast of light and dark creates movement and leads the eye along the sweep of the water forms. The textures of the opaque and transparent spatter further suggest the froth and foam of the ocean.

The success of this painting lies in the combination of intuition and discipline. The artist was so familiar with his subject that he could create the forms intuitively. He also knew that the watercolor and acrylic, combined in methods of his own invention, would produce the results he wanted.

Building a Strong Composition

Rolland Golden
FALL FRAGMENTS

Watercolor on Fabriano 140 lb.
cold-pressed mold-made paper
30" × 22" (76.2 × 55.9 cm)
Collection of the artist

Rolland Golden is a Louisiana painter who maintains a summer studio on Cape Cod. His work in watercolor and acrylic reflects his interest in the relationship of seemingly unrelated objects, as well as his concern for human surroundings. Golden remarks, "I attempt to use my art to express my feelings about things, life, and the way I see objects; to visually communicate ideas which I would otherwise be unable to express. I try to do it as creatively as possible, yet within the framework of my academic training—especially through the use of strong composition and the control of space."

Referring to a black-and-white photograph, Golden first did a value study in pencil to resolve compositional problems of placement and the handling of space. When he began the painting, he concentrated on the color, which revolved around the yellow highway stripe and its relationship to the autumn fields and foliage.

Because of its strong value contrasts and well-thought-out composition, this painting has great impact from a distance. Yet on closer inspection, it reveals great riches. The primary curvilinear pattern created by the road and the hills is very obvious. But note the subtle texture in the pavement and the curved shadow shapes, which repeat the rhythmic curves. Golden has also painted the horizontal expansion joints, which establish a different kind of rhythmic beat.

Color is essentially naturalistic, fading away into the distance. But see how the broken patterning of the curved highway stripe becomes brighter and lighter in the middle of the painting. This draws our eye to it. Here Golden has used his color in a nonrealistic way to enhance the impact and to focus our attention.

Study the negative shape created by the sky. See how it is broken by the vertical of the distant telephone pole and the ragged edges of the trees to the right of the house. The foliage, however, does not extend beyond the picture plane at the top, thus preserving the wholeness of the negative space there and making the sky an area of rest in a very active composition.

Don Coen
YORKSHIRES

Acrylic on canvas
72" × 96" (182.9 × 243.84 cm)
Collection of the Reiva Corporation,
Denver, Colorado

Don Coen recently completed a series of paintings pertaining to the area of eastern Colorado where he spent the first twenty-one years of his life. "I wanted to make a statement about rural America that was contemporary," he explains. "I had not seen any painting about the West that spoke to present-day experiences. Paintings with rural images were either about the 1930s, or else showed the turn-of-the-century 'cowboys and Indians.' I want to show the real world of rural America today without any attempt to sentimentalize."

For his series, Coen took more than three thousand slides. He then decided that the only way to get the effect he wanted was to use only airbrush. Although he kept the color quite close to what he saw in his slides, he did not use any white. His technique involved airbrushing up to sixty layers of acrylic color

over a canvas primed with seven layers of acrylic gesso, sanded in between the layers.

For this painting, Coen chose a rectangular format and divided it horizontally into three nearly equal rectangles. The upper rectangle of empty, negative space conveys the crystalline light typical of the eastern Colorado prairie, while the lower rectangle is blurred and textured, suggesting an out-of-focus foreground. It is the middle rectangle that is full of activity, with pigs, fences, and buildings.

The repeating and overlapping rectangles of the fences also help to structure this painting, and they create an almost hypnotic effect as they recede into the distance. In addition, the pigs overlap, generating some ambiguity and interest —far more so than if there had been only one pig in the first pen. The backlighting on the hairs of the pigs gives them a soft aura, in contrast to the fence.

Conveying the Magic of a Scene

Judi Betts, NWS
QUIET MAGIC

Watercolor on Arches 140 lb. cold-pressed paper
30" × 22" (76.2 × 55.9 cm)
Collection of the artist

A Louisiana artist, writer, and teacher, Judi Betts works exclusively in transparent watercolor and specializes in the landscapes and buildings of the South. "I am fond of palm trees and other tropical foliage," she says, "and although this was almost the dominant factor in the painting, I wanted to create for the viewer a glimpse at the house as I saw it through the patterns made by the shapes in the foreground. The tall palm trees seem to echo the tall and stately building. I also wanted to express the awe I felt for the house, which was enormous."

In addition to preliminary sketches and drawings, Betts makes written notes, which record her emotional reactions to the scene. These notes tell her what she hears, what she smells, and what the temperature is. She noted, for example, that it was extremely hot when she sketched this house, that the splendid old building was in good shape, and that, although the grounds were a bit shaggy, there was a sense of order about the place.

For this painting, Betts chose a full sheet of watercolor paper to convey the sense of "bigness" she wanted. After lightly sketching in the building, she used a flat brush and clear water to paint around the larger white areas. While this was wet, she put on a transparent midtone wash, in effect creating the brilliant white architectural forms of the house with the Reverse Negative Shape Approach. It is important that Betts never wets the entire paper at one time; instead, she wets it only where she wants the paint to go and develops her forms by painting around them. She also does a lot of lifting with wet sponges and filing cards to suggest forms and create value changes. In general, she avoids using masking fluid, as she feels it can stain or tear the paper and thus ruin a painting. In this painting, however, she did use it in a few places—for example, across the palm tree trunk at the lower left.

Notice how the overlapping palm foliage frames as well as hides the building. The strongest contrast of values is in the porch area, and it draws the eye there. The sharp foreshortening of the building, coupled with the strong diagonals of the trees, adds drama. Small, broken areas of light suggest the shimmer of sunlight moving through tropical foliage and enhance the magical quality of this painting, which was created almost entirely with the Reverse Negative Shape Approach.

Lee Weiss
WINTER LANTERN

Watercolor on Morilla watercolor paper
36" × 46" (91.4 × 116.8 cm)
Collection of Mr. and Mrs. Weber L. Smith

Lee Weiss is a Wisconsin artist who has developed a very personal technique, using transparent watercolor with a monoprint procedure. "Always," she says, "I try to find a magical element or moment in my work—the thing that makes you remember something about a scene, or that seems the essence of a subject. Nature is my base, but imagination is my fuel."

The interesting process Weiss has developed allows her to use her imagination as well as the many beautiful "happenings" of watercolor to the fullest. First, she paints wet into wet on one side of her paper, then, while it is still wet, she turns it face down on a Plexiglas sheet. Again, she paints wet into wet on the "back" side of the paper and then flips it over on the Plexiglas, picking up pigment deposited by the first painted side of the paper. This process is repeated again and again, layering color and texture, using large, flat bristle brushes. Weiss strives for interesting color

abstractions, warm on cool and dark on light. Each addition alters her perception of the ultimate image. Finally, one of the sides of the paper becomes an interesting beginning for a painting, and she completes it.

Weiss had done a series of paintings of trees in the snow with backlighting before she began this one. Some were very strong, while others were very subtle. This painting combined both approaches. Her colors, for the most part, were nonstaining earth colors, which lift easily. To create the backlit trees, Weiss painted around them with clear water and then defined their forms by lifting off the color in an interesting variation of the Reverse Negative Shape Approach.

In the final painting, a strong rhythm is set up by the repetition of vertical tree shapes, but there are subtle variations in shape, color, and value, which are extremely important. Notice, for example, how the area of greatest contrast is in the center of the painting.

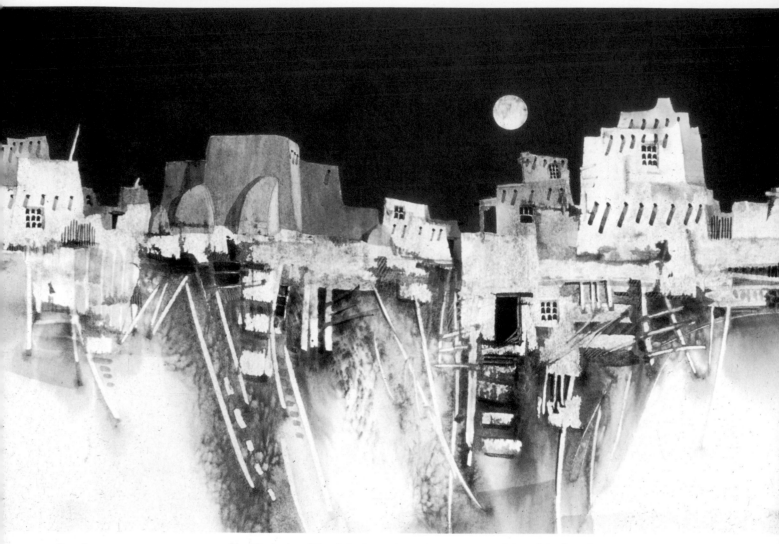

Fran Larsen
TAOS NIGHTWATCH

Watercolor, gouache, and acrylic on Crescent no. 114 cold-pressed watercolor board 30" × 40" (76.2 × 101.6 cm) Collection of the artist

Fran Larsen, a New Mexico painter, interprets the architectural forms of the Southwest in watercolor, gouache, and acrylic. "My current work," she says, "is based on cross-cultural themes inspired by the Indian-Spanish-Anglo context of today's Southwest. In each painting, I am looking for my direct and honest reaction to my love of the land and the people around me. I look for a strong interplay of forms and images, surface interest, and intense contrasts."

Larsen continues, "To me, a good watercolor must be attractive at a distance of twenty feet, with strong design pulling the viewer in closer and closer to find that the painting, like life, is ever-changing the closer one comes to examine it."

This particular painting is based on a series of photographs Larsen took at the site, as well as her memory of the shapes of the buildings against the night sky. Her approach, once she began, was totally free and intuitive, based primarily on her memory of the experience. She wanted to bring out the warm earthtones of the adobe buildings contrasting with the midnight blue of the sky.

Larsen began by applying many transparent washes of watercolor. As the paint set up, she scraped and pulled it with cards, brush handles, and razor blades; she also applied salt and spatters of paint. In this way she suggested ladders and poles, buildings and stairways, as well as generating a lot of textural interest. Then, to define the shapes of the buildings, Larsen used opaque acrylic and painted the night sky around them. She created the windows in a similar way, but took care not to overdo architectural details.

The arrangement of the buildings, while intuitive, is not in the least haphazard, and the location of the projecting poles and of the moon has been carefully thought out. Notice how the contrast of opaque and transparent paint creates excitement and how the immense value contrast gives the painting drama. But also notice how the restfulness of the dark sky and the unpainted lower corners serves to set off the great activity elsewhere.

Millard Sheets
NIGHT OF THE DEAD

Watercolor on Arches 300 lb. rough paper
22" × 30" (55.9 × 76.2 cm)
Collection of the artist

Millard Sheets, a landmark figure in the use of watercolor and a well-known teacher, paints all over the world, although he maintains a permanent studio on the California coast. He states, "I believe serious painting requires a happy balance between thorough discipline and knowledge of the language of painting, and the kind of observation that leads to an emotional expression of the subject. After sixty years of painting, I am no longer interested in merely reproducing places, or skillfully rendering subject matter; I believe it is important to understand the purpose of painting, which is to reflect the deepest concern for the importance of the subject and its spirit."

Because Sheets did not wish to intrude upon the privacy of the Mexicans communing with the spirits of their dead, he worked quietly on a series of pen and ink studies throughout the night, an inconspicuous witness to a dignified spiritual rite. To communicate the dignified, spiritual quality of this

experience, he chose a horizontal format for his painting, as well as a horizontal and vertical placement for the primary pictorial elements: the figures, church, and candles. Although the overlapping forms create a sense of depth, the placement of the figures keeps our interest centered. Notice the interesting negative spaces created by the candlesticks, none of which is quite vertical, and observe the rhythm they set up, which leads the eye through the composition. The brilliant contrast of light against dark immediately attracts the eye, and the differing sizes of the lights add a rhythmic counterpoint. These dancing, brilliant shapes provide relief for the overall somber mood.

Sheets began this painting with a series of transparent washes, over which he applied broken color in a series of dry-on-dry applications. This creates the texture and great richness of transparent color so typical of this artist's work. The dark, limited palette then generates an appropriate night-time mood.

141

Epilogue

Christopher Quiller
UNTITLED

Here is a painting done by my son Chris when he was two years old. I love to look at his paintings and to watch him work. He takes the brush and paint, and creatively explores texture, color, and space. Young children have an innate ability to explore and create.

But most children want to become adults and to conform and be like other adults. In the process, the individual's creativity is likely to be stifled. Consequently, as adult artists, we strive to reacquire that special ability we had as children. We want to take away our inhibitions in order to free ourselves to explore and be creative as we did in our childhood. I hope that some of the information I've given you in this book will help you to regain this spirit.

Index

All paintings are by Stephen Quiller unless otherwise specified.